MANET, MONET, AND THE GARE SAINT-LAZARE

W9-BKJ-585

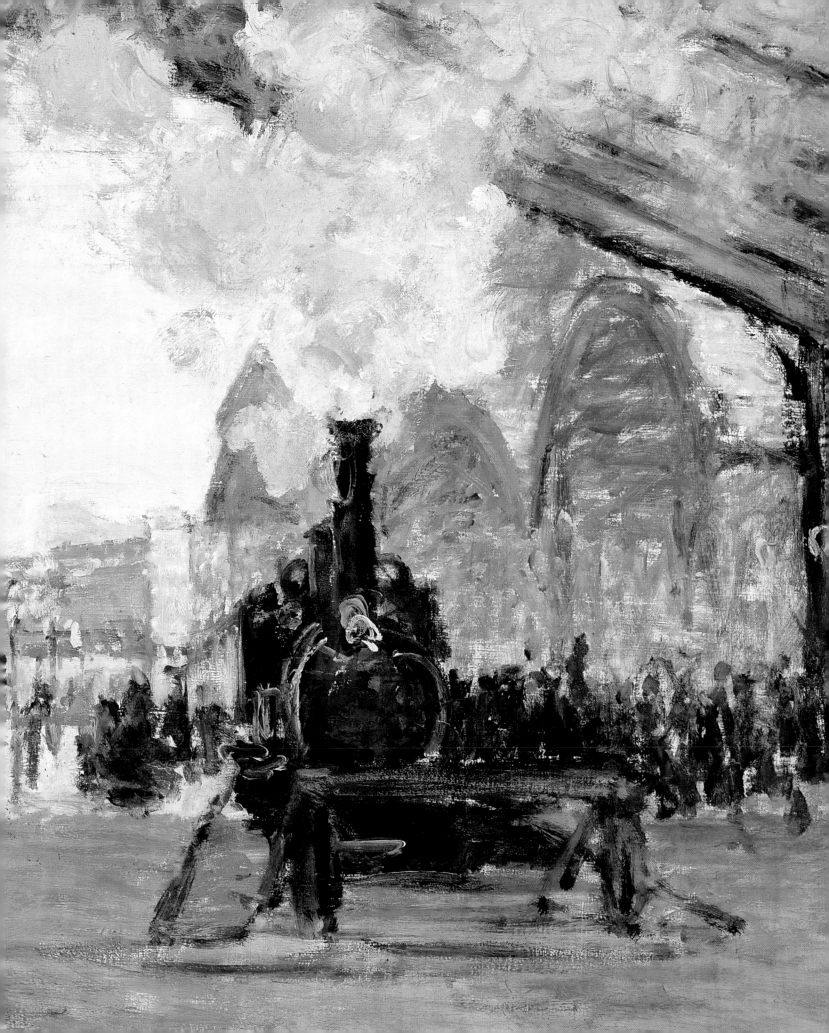

Manet, Monet,
and the
Gare Saint-Lazare

Juliet Wilson-Bareau

NATIONAL GALLERY OF ART, WASHINGTON

YALE UNIVERSITY PRESS, NEW HAVEN & LONDON

The exhibition is made possible by a grant from
THE FLORENCE GOULD FOUNDATION

The exhibition is supported by an indemnity from
the Federal Council on the Arts and the Humanities.

The exhibition was organized by the National
Gallery of Art, Washington, and the Réunion des
musées nationaux Musée d'Orsay, Paris

Musée d'Orsay, Paris
9 February–17 May 1998

National Gallery of Art, Washington
14 June–20 September 1998

Copyright © 1998 Board of Trustees,
National Gallery of Art, Washington

All rights reserved. This book may not be
reproduced, in whole or in part (beyond that
copying permitted by Sections 107 and 108 of the
U.S. Copyright Law, and except by reviewers for the
public press), without written permission from the
publishers.

Edited and designed by Sally Salvesen
Typeset in Garamond by Servis Filmsetting,
Manchester
Printed in Italy by Conti Tipocolor, Florence

The hardcover edition of this book is published by
Yale University Press, New Haven and London

FRONT COVER: detail, fig. 1, Edouard Manet, *The
Railway*, 1872–1873, National Gallery of Art,
Washington.

BACK COVER: fig. 94, Claude Monet, *Interior View of
the Gare Saint-Lazare: the Auteuil Line*, 1877, Musée
d'Orsay, Paris.

FRONTISPIECE: detail, fig. 99, Claude Monet, *Arrival
of the Normandy Train, Gare Saint-Lazare*, 1877, Art
Institute of Chicago.

Library of Congress Cataloging-in-Publication Data

Bareau, Juliet Wilson
Manet, Monet, and the Gare Saint-Lazare / Juliet
Wilson-Bareau
 p. cm.
Catalogue of an exhibition held at the Musée
d'Orsay, Paris, Feb. 9 – May 17, 1998, and the
National Gallery of Art, Washington, June 14 –
Sept. 20, 1998
Includes bibliographical references
ISBN 0–300–07510–3 (cloth)
ISBN 0–89468–230–x (pbk.)
1. Manet, Edouard, 1832–1883. Gare Saint-Lazare.
2. Manet, Edouard, 1832–1883 — Criticism and
interpretation. I. Title.
ND553.M3A67 1998
759.4–dc21 97–44389
 CIP

CONTENTS

FOREWORD

Edouard Manet first exhibited his *Chemin de fer* in 1874, at the Paris Salon, where it met with derisive criticism. It was eventually acquired, just one hundred years ago, in 1898, by Mr. and Mrs. H. O. Havemeyer, and remained in their family until it was given to the National Gallery of Art in 1956 by their son Horace Havemeyer, in memory of his mother Louisine W. Havemeyer. *The Railway*, or *Gare Saint-Lazare*, has become one of the National Gallery's best loved and yet most enigmatic works. The subject of numerous studies on Manet and impressionism, and the focus of a ground-breaking exhibition *Manet and Modern Paris,* organized by the Gallery in 1982, it continues to intrigue scholars and art lovers worldwide.

At the initiative of Philip Conisbee, curator of French paintings at the Gallery, and with the aid of Florence E. Coman, assistant curator, *Manet, Monet, and the Gare Saint-Lazare* presents Manet's masterpiece in a new light, cast on this occasion by our guest curator and the catalogue's author, the eminent Manet scholar Juliet Wilson-Bareau. Ms. Wilson-Bareau's re-reading of the picture leads us on a fascinating tour through the "Europe" district of Paris, newly developed around the Saint-Lazare train station—the site of *The Railway*, and the neighborhood in which Manet lived and worked during the 1870s. Here he was joined by fellow artists such as Claude Monet, who captured the energy and excitement of the train station itself in a series of dazzling canvases executed down on the tracks, and Gustave Caillebotte, who painted dramatic perspectives in the nearby streets. These and other impressionist painters celebrated life in the modern city—symbolized by their particular corner of Paris—in the years of hope immediately following the degradations of the Franco-Prussian War and the divisive Paris Commune. The exhibition also explores the development of Manet's work through the 1870s in his studio on the Rue de Saint-Pétersbourg—prominently visible in the background of *The Railway*—and the

influence of his new friendship with the poet Stéphane Mallarmé, who was also a neighbor.

Manet, Monet, and the Gare Saint-Lazare is made possible in Washington thanks to the generous support of The Florence Gould Foundation, and we also thank the Federal Council on the Arts and the Humanities for granting us a U. S. Government Indemnity for the exhibition. We would also like to warmly acknowledge the support of the Zeneca Group for the presentation of the exhibition in Paris.

Such an enterprise could not have been brought to realization without the generosity of all our lenders, acknowledged individually elsewhere, but whom we are pleased to thank collectively here.

Earl A. Powell III
DIRECTOR
NATIONAL GALLERY OF ART
WASHINGTON

Françoise Cachin
DIRECTOR, MUSÉES DE FRANCE
PRESIDENT
RÉUNION DES MUSÉES NATIONAUX

Henri Loyrette
DIRECTOR
MUSÉE D'ORSAY
PARIS

ACKNOWLEDGMENTS

The exhibition received support from the following individuals: William Acquavella, Jean-Pierre Angrémy, Alexander Apsis, Joseph Baillio, William Beadleston, Gorel Cavalli-Björkman, Bruno Blasselle, Philippe Brame, Christopher Brown, Marie-Andrée Corcuff, James Cuno, Jean-Pierre Cuzin, Jean Derens, Douglas W. Druick, Caroline Durand-Ruel Godfroy, Mark L. Evans, Walter Feilchenfeldt, Michael Findlay, Larry J. Feinberg, Colin Ford, François Gasnault, Louis Gautier, Léonard Gianadda, Olle Granath, Heide Grape-Albers, Anne d'Harnoncourt, Tokushichi Hasegawa, Arnaud d'Hauterives, David Jaffé, William R. Johnston, Paul Josefowitz, Eberhard W. Kornfeld, Marcel Landowski, Jacques Larché, John Leighton, Françoise Lemelle, Jean-Marc Léri, François Lorenceau, Neil MacGregor, Suzanne Folds McCullagh, Charles S. Moffett, Jean-Pierre Mohen, Miklós

Mojzer, Philippe de Montebello, Marie-Dominique Nobécourt, Christian Olivereau, Robert Parks, Jean Penent, Edmund P. Pillsbury, Joachim Pissarro, Robert Rainwater, Brian Regan, Brenda Richardson, Christopher Riopelle, Joseph Rishel, Malcolm Rogers, Laurent Salomé, Marie-Anne Sarda, François Scellier, Uwe M. Schneede, Susan Seidel, George T.M. Shackelford, Marianna Shreve Simpson, Christine E. Stauffer, Gerard Stora, Gary Tinterow, Françoise Viatte, Gary Vikan, Roberta Waddell, John Walsh, Alice Whelihan, Malcolm Wiener, James N. Wood, as well as those who prefer to remain anonymous.

AUTHOR'S ACKNOWLEDGMENTS

Following an invitation to lecture on Manet's *The Railway* at the National Gallery of Art, Washington, the enthusiasm of Philip Conisbee and D. Dodge Thompson, chief of exhibitions, led to the idea of turning the material of my lecture into an exhibition. The idea immediately received the whole-hearted backing and support of the Gallery's director, Earl A. Powell III, to whom I am immensely grateful for the invitation to carry the research forward and present the findings to a wide public. When the Musée d'Orsay and the Réunion des musées nationaux joined the project, Henri Loyrette, director of the Orsay, proposed that the scope of the exhibition be widened; he has been a constant source of encouragement, with the support of Irène Bizot and her staff at the Réunion. I am grateful to the staff of all three institutions for their help.

At the National Gallery, Florence E. Coman gave unstinting support throughout the cataloging process, marshaling complex material on both sides of the Atlantic, and compiling the checklist and bibliography. For their support, advice, and help with myriad organizational details I thank especially Naomi Remes, exhibition officer; Mark Leithauser, chief of design; Frances P. Smyth, editor-in-chief; Mary Yakush, senior editor; Hunter Hollins, assistant registrar; Melissa McCracken, foundation relations; and Kate Haw, assistant to Philip Conisbee.

At the Musée d'Orsay, I am grateful to Isabelle Cahn , who provided unfailingly generous support, as well as to Luce Abelès and Patrice Schmidt. At the Réunion, the exhibition and its catalogue owe much to the experience and enthusiasm of Anne Fréling, Anne de Margerie, and Marie-Dominique de Teneuille.

My initial research had two sources of inspiration: the experience of working with Françoise Cachin at the Musée d'Orsay on the great Manet retrospective exhibition in 1983; and, more recently, the prompting of Mr. Akiya Takahashi of the National Museum

of Western Art in Tokyo. His request for an essay on "Manet in 1874" for the exhibition catalogue *Paris en 1874. L'Année de l'Impressionnisme*, 1994, supported by Ruth Berson's generous offer of the available critical reviews, prompted the reflection and research that lie behind this presentation of Manet's painting *The Railway* in its context.

Two strands of investigation lie behind the project: one topographical, the other concentrating on the meaning of the pictures, the creativity of the artists, and their involvement with social and political as well as esthetic questions. In the first category, where much of the new material was found, I am grateful above all to Michel Fleury and his colleagues at the Commission du Vieux Paris and to Christiane Filloles at the Archives de Paris; they taught me a great deal about archival research and encouraged me to explore. Thanks are also due to all those who helped to provide information concerning Paris, its inhabitants, its urban environment, its railways, and above all the Gare Saint-Lazare: Madeleine Beaufort, Claude Billaud, Karen Bowie, Sophie de Cazenove, Jean Gennesseaux, Carmen Grente, Pierre Hoste, Muriel Laooque, Yvon Leblicq, Catherine l'Homme, Alexandre Loboff, Bernard Millet, Isabelle Parizet, Malcolm Park, Marie-Noëlle Polino, Laurence Sigal, Annie Térade, David van Zanten, Marie Veauvy.

For help with research into the works of art and their relationship to contemporary artistic practice and the wider cultural context, I am particularly indebted to Florence Bret, Nicole Castais, Jacques Chardeau, Marianne Delafond, Michael Diers, Roland Dorn, Inge Dupont, Jay M. Fisher, Judit Geskó, Gisela Hopp, Helmut R. Leppien, Bertrand Marchal, Adrian Mibus, Michèle Paret, Sophie Piétry, Paul Pfister, Jean-Claude Romand, Bertha Saunders, Barbara S. Shapiro, Julian and Ada Sofaer, Daniel Wildenstein, Martha Wolff.

The project has benefited enormously from the willingness of conservation departments and above all the Laboratoire de recherche des musées de France to examine paintings and discuss the resulting technical information. I am especially grateful to Anne Roquebert and Patrick Le Chanu at the Laboratoire de recherche in Paris; Karen French and Eric Gordon at the Walters Art Gallery, Baltimore; and Sarah Fisher, Ann Hoenigswald, and Kristi Dahm at the National Gallery of Art, Washington.

I also owe a very special debt of gratitude to the Bibliothèque nationale de France,

where the departmental staff were generous with help and advice as with their willingness to lend to the exhibition: Laurence Ratier in Imprimés, Catherine Hofmann and her colleagues in Cartes et Plans, and above all Laure Beaumont-Maillet and Gisèle Lambert, as well as Corinne Le Bitouzé and Jocelyn Bouquillard in Estampes et Photographies. I am also grateful to Françoise Bonnardel, Thierry Collin, Catherine Goerès, René Hardy, and Jean-Pierre Devin for their cooperation.

I would like to thank John House for his advice and encouragement, Lise and Jean-Marie Dunoyer and Claudie Ressort for their generous involvement in my activities in Paris, and Sally Salvesen for expert help and guidance in editing and designing this book. My friend Bill Scott has reflected on and discussed artistic questions as only an artist can. Finally, no words of thanks can adequately express my debt to David Degener, who has been involved in many aspects of this project and its publication. By freely sharing his experience of working in the Archives de Paris and on the terrain, he has contributed significantly to the presentation of places and people in Paris, while his extensive knowledge of the literary scene and his strong views about Mallarmé have helped to shape the discussion of Manet's art in the 1870s. I am very grateful to him both for large insights and for the exact detail that is essential to an understanding of the life and work of artists and littérateurs.

Juliet Wilson-Bareau

LENDERS TO THE EXHIBITION

ARCHIVES DE LA VILLE DE PARIS

THE ART INSTITUTE OF CHICAGO

THE BALTIMORE MUSEUM OF ART

BIBLIOTHÈQUE D'ART ET D'ARCHÉOLOGIE, FONDATION JACQUES DOUCET, PARIS

BIBLIOTHÈQUE HISTORIQUE DE LA VILLE DE PARIS

BIBLIOTHÈQUE NATIONALE DE FRANCE, PARIS

CONSEIL GÉNÉRAL DU VAL D'OISE, CERGY-PONTOISE

THE J. PAUL GETTY MUSEUM, LOS ANGELES

HAMBURGER KUNSTHALLE

HARVARD UNIVERSITY ART MUSEUMS, CAMBRIDGE

KIMBELL ART MUSEUM, FORT WORTH

THE METROPOLITAN MUSEUM OF ART, NEW YORK

MUSÉE CARNAVALET, PARIS

MUSÉE D'ORSAY, PARIS

MUSÉE DES BEAUX-ARTS, RENNES

MUSÉE DU LOUVRE, PARIS

MUSÉE DÉPARTEMENTAL STÉPHANE MALLARMÉ, VULAINES-SUR-SEINE

MUSÉE MARMOTTAN — CLAUDE MONET, PARIS

MUSEUM OF FINE ARTS, BOSTON

NATIONAL GALLERY OF ART, WASHINGTON

THE NATIONAL GALLERY, LONDON

NATIONAL MUSEUM & GALLERY, CARDIFF

NATIONALMUSEUM, STOCKHOLM

THE NEW YORK PUBLIC LIBRARY

NIEDERSÄCHSISCHES LANDESMUSEUM HANNOVER

PHILADELPHIA MUSEUM OF ART

THE PIERPONT MORGAN LIBRARY, NEW YORK

PRIVATE COLLECTIONS

JEAN-CLAUDE ROMAND

MR. AND MRS. JULIAN SOFAER

SZÉPMÜVÉSZETI MÚZEUM, BUDAPEST

THE WALTERS ART GALLERY, BALTIMORE

MALCOLM WIENER

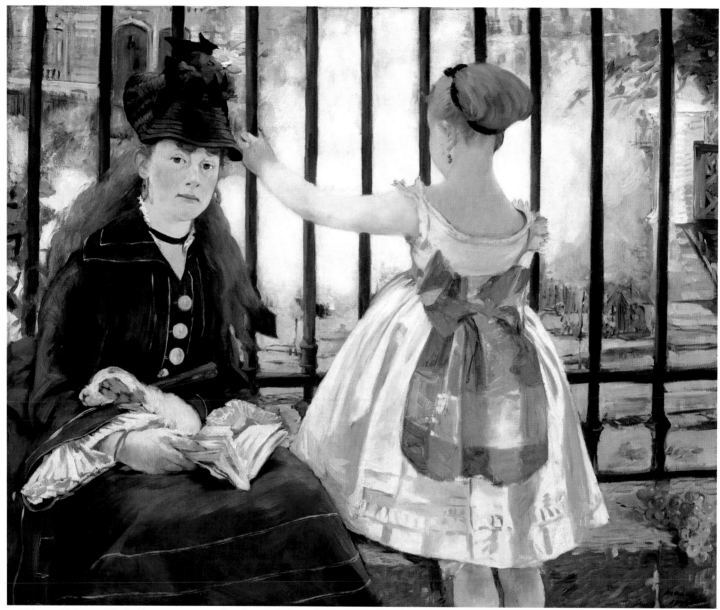

1 Edouard Manet, *The Railway,* 1872–1873, dated 1873, Salon of 1874, 93.3 x 111.5 cm, National Gallery of Art, Washington (Cat. 21).

INTRODUCTION

Edouard Manet's painting of *The Railway* (*Le Chemin de Fer*; fig. 1), his own title for a picture that has become more widely known as *The Gare Saint-Lazare*, occupies a uniquely significant position within his oeuvre. Painted in 1872, it was his first major work executed after the upheavals of the Franco-Prussian War and the Paris Commune, and it caused a sensation when it was exhibited two years later at the Salon of 1874. In it, Manet portrayed Victorine Meurent, the young woman who had been his principal model in the 1860s (fig. 11). She had posed naked for *Le Déjeuner sur l'herbe* and *Olympia* and many times in the artist's costume and genre pictures (figs. 12, 13). Victorine's appearance in *The Railway* was to be her last in Manet's oeuvre since he chose thereafter to work with models who were not professionals. Indeed, in this picture Victorine appears in ordinary dress as the attractive young woman that she undoubtedly was, to all intents and purposes without the involvement of any elaborate role-playing.

The subject of the picture, generally considered as intriguing today as it was baffling to viewers in Manet's time, has suddenly come into sharper focus, thanks to the identification of a topographical detail in the background. It had always been clear that the white stone pillar to the right, on the far side of the railway tracks, was part of the pont de l'Europe, the massive iron bridge that spans the railway lines just beyond the Gare Saint-Lazare, one of Paris's busiest railway stations. What had remained unrecognized was that the sketchy architectural details in the upper left corner of the picture are in fact a precise depiction of the front door and one of the windows of the studio into which Manet moved in July 1872 (figs. 1, 126).

This identification raises the problematic question of the viewpoint from which Manet painted his picture—something that had remained misidentified in contemporary accounts and thoroughly confused in that of Manet's most informed biographer, Adolphe Tabarant.[1] It also serves to demonstrate the importance of understanding the exact topography of a picture, however "impressionistic" it may appear to be. Research into the streets and buildings in the area of Paris known as the Europe district (figs. 3, 6), in which Manet and many other artists lived and worked in the 1870s, provides a sound, objective basis against which to measure the representational aspects of works of art and thereby gain an insight into the particular modes of an artist's style and manner of interpretation.

Among Claude Monet's many paintings of urban Paris, its boulevards and its monuments, the single most striking and coherent group is that of his canvases depicting the Gare Saint-Lazare. Monet set up his easel on the station platforms or on the tracks beside the pont de l'Europe, to observe the trains that ran beneath the great bridge, to and from distant places in Normandy and northwestern France; they also served such suburban stations along the river Seine as Argenteuil where Monet himself lived for several years, and other sites made famous by the Impressionists. Monet's twelve extant canvases of the Gare Saint-Lazare depict the station from many different angles and in a variety of styles (figs 95–112). Almost at the same time, Gustave Caillebotte painted his two masterworks, the monumental *Pont de l'Europe* and an equally striking topographical view which he titled *Paris Street, Rainy Day* (figs. 68 and 76). The works by Monet and Caillebotte were shown in the third Impressionist exhibition in 1877, in the series of shows that set out to challenge the role of the official annual Salon. Other artists moved to or took studios in the Europe district, and works by Jean Béraud and Norbert Goeneutte capture the pont de l'Europe and the station from different viewpoints and in various styles (figs. 85, 87–89). Topographical exploration of the Europe district has yielded much information about the artistic and literary community that lived there, and has revealed more about the ways in which its inhabitants responded to the fabric of the city in their work and the extent to which they were influenced by their environment.

Edouard Manet, the most Parisian of artists whose seminal picture of *The Railway* lies at the heart of our discussion, is a striking example of this sense of the importance of place, of the artist's relationship to his surroundings. His homes and studios

lay in and around the Europe district, sometimes on the periphery, in the 1860s, but mainly centred on the area between the place de l'Europe and the Gare Saint-Lazare to the south and west and the place Clichy to the north (figs. 3, 6). Manet walked these streets every day and knew every corner of his territory, its textures and colors, the distinctive styles of the newer, Haussmann-inspired urban developments and of the older areas toward Montmartre and beyond the outer boulevards. His work reflects not only the changing fabric of the city he knew and loved so well but also his responses to the events, the ebb and flow of political and social forces that shaped the city's history.

Manet's relationship with Paris and with its social figures—whether from the bourgeoisie, the demimonde, or the artistic and socially bohemian classes—is reflected in the development of his artistic style. This in its turn was responsible for the often violent repercussions of his continuing confrontation with the state-run annual exhibitions known as the Salon, each one governed by particular administrative structures and rules.[2] The works of artists who had not been awarded a medal, which conferred an automatic right of entry, were subject to scrutiny by the jury which usually included a majority of established, academic artists, opposed to innovation. Manet was not awarded a medal until 1881, two years before his death, and then only a second-class one, and he had to submit to the dictates of the Salon jury for almost the whole of his career.

From 1874, Monet, Caillebotte, and their like-minded colleagues, led by Degas, decided to exhibit outside the official Salon and formed a *Société anonyme*. Soon to be branded Impressionists, they mounted their first exhibition in premises recently vacated by the celebrated photographer Nadar.[3] The show established the principle of a major contemporary art exhibition independent of the annual Salon—and of its jury, awards, and exclusions—aimed at offering work that critics and public could judge freely without *a priori* guidance or selection.

Manet never exhibited with the group in these independent shows, seven of which were held in his lifetime and the eighth and last in 1886. Despite the criticism and abuse heaped on him almost every time he showed at the Salon, Manet was convinced that the battle for contemporary art had to be won on its walls. He clung to his right to show there and refused to admit defeat. He remained, in the words of his friend Stéphane Mallarmé, "persistent in his reiteration, unique in his persistency"[4] to present his art in a

socially acceptable, officially approved context. Since he never sought to placate the jury or the Salon public, what he chose to paint and to present to the jury is therefore of more than ordinary significance. His annual encounters with this organ of the State became a matter of extraordinary public interest at the time, and his Salon submissions and the critics' reaction to them remain a yardstick by which to gauge the radical style and content of his art.

A brief, preparatory look at Manet's situation in the 1860s and a passage through the traumatic period of the Franco-Prussian War and the Commune prepare the ground for a necessarily selective review of the art of Manet and his colleagues in the 1870s. This is built around Manet's picture *The Railway* of 1872–1873, and extends to a discussion of works executed in his studio on the rue de Saint-Pétersbourg between 1872 and 1878; it also looks at the artist's responses to the rejection of his work by several Salon juries during these years, and his relationship and artistic collaboration with Stéphane Mallarmé. Within this broad field, Monet's depictions of the Gare Saint-Lazare and Caillebotte's views of the pont de l'Europe and of the intersection just up the road from Manet's studio, in his *Paris Street, Rainy Day*, reveal their particular qualities and suggest a variety of ways of approaching their work. The diversity of styles in the work of Manet, Monet and other artists in the early years of the Third Republic is thrown into relief when their common interest in a particular theme is explored. Information about the development of the Europe district, the expansion of the Gare Saint-Lazare and the construction of the pont de l'Europe is here combined with knowledge of the location of artists' studios and the sites of their pictures. Investigation of this part of Paris reveals the very different responses by artists to the same motifs, and addresses fundamental questions concerning the art of painting in the 1870s, centered on one of its most dynamic and inventive exponents, Edouard Manet.

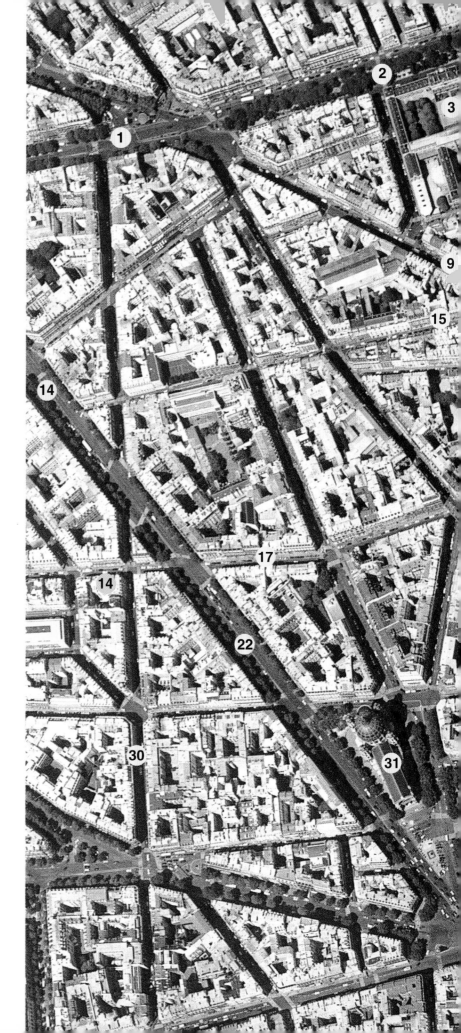

3 The Europe district, Paris, aerial photograph, 1996, Institut Géographique National, Paris. Paintings are indicated by white dots with their fig. number and an arrow showing the direction in which the artist faced.

STREETS AND LANDMARKS (yellow dots)

1	boulevard de Courcelles
2	boulevard des Batignolles
3	Collège Chaptal 1868
4	pont (former tunnels) des Batignolles
5	rue de Moscou 1869
6	rue Clapeyron 1869
7	rue de Turin 1869
8	to place Clichy
9	rue de Constantinople
10	rue de Berne / Mosnier (1870–1871)
11	rue de Saint-Pétersbourg
12	place de Dublin / carrefour de la rue de Moscou
13	rue de Hambourg
14	to parc Monceau and rue Guyot
15	rue de Naples
16	rue de Liège / Berlin
17	rue de Lisbonne
18	rue de Madrid
19	pont de l'Europe
20	place de l'Europe
21	rue de Londres
22	boulevard Malesherbes
23	rue du Rocher
24	rue de Vienne
25	rue de Rome
26	Gare Saint-Lazare, roof extension 1886
27	impasse Amsterdam
28	Gare Saint-Lazare 1853–1886
29	rue d'Amsterdam
30	rue de Miromesnil
31	Saint-Augustin
32	rue de la Pépinière
33	rue Saint-Lazare
34	boulevard Haussmann

ADDRESSES MENTIONED IN THE TEXT (blue dots)

1	to 89 (formerly 87) rue de Rome 1876, Mallarmé
2	to 49 rue de Saint-Pétersbourg, Manet family
3	29 rue de Moscou, Mallarmé, Méry Laurent 1872–1875
4	26 rue d'Edimbourg, Monet 1878–
5	62 rue de Rome, Clairin, Goeneutte
6	58 rue de Rome, Hirsch
7	7 rue Mosnier
8	2 rue Mosnier
9	Post Office 1936
10	4 rue de Saint-Pétersbourg, Manet's studio
11	Parcels depot 1886
12	17 rue Moncey, Monet 1877
13	52 rue de Rome, Méry Laurent 1875
14	77 rue de Miromesnil, Caillebotte
15	House in Zola's *La Bête humaine*

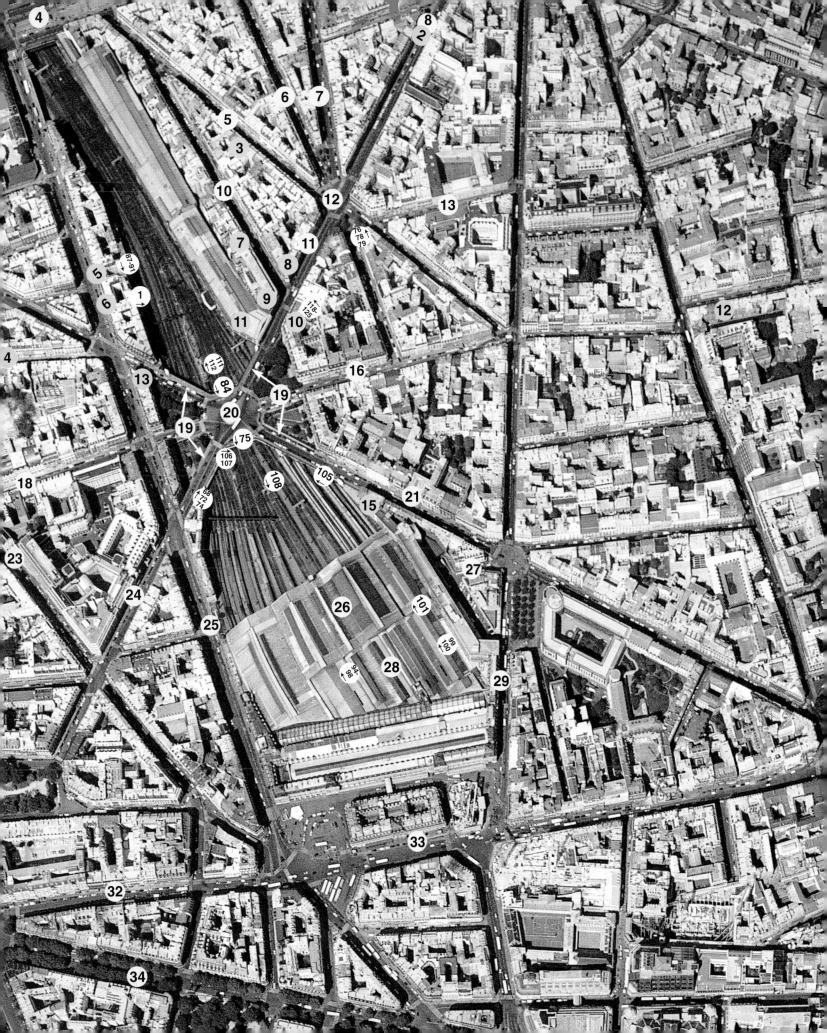

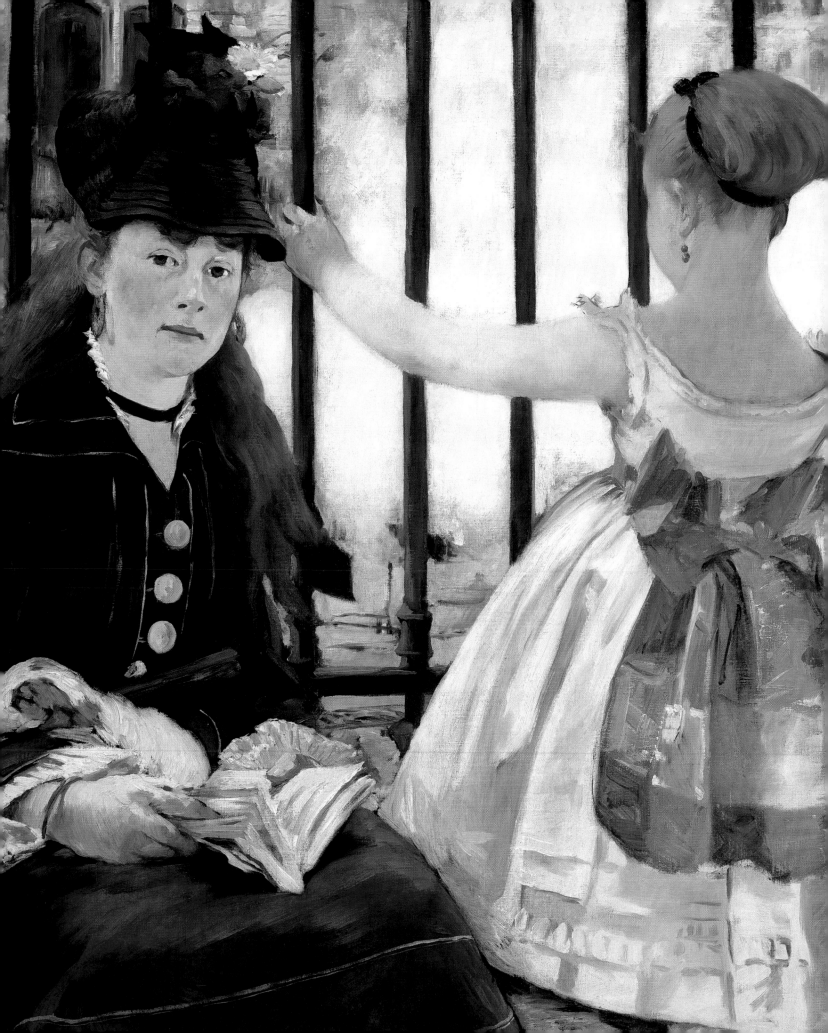

CHAPTER ONE

"The Railway" and Its Context

The Batignolles School: The 1860s

Manet's career as a Salon artist had begun in 1861 when the jury accepted his exuberant *Spanish Singer* (Metropolitan Museum of Art, New York) after having rejected his very first submission, *The Absinthe Drinker* (Ny Carlsberg Glyptotek, Copenhagen) in 1859. His first success at the Salon, where he was awarded an 'honorable mention' for *The Spanish Singer*, coincided with his move to a new studio at 81 rue Guyot which was to be the scene of his artistic activity throughout the 1860s. Long thought to have been destroyed, the building still exists today, virtually unchanged (fig. 7). Now numbered 8, instead of 81, following a change in the street numbering in the 1870s, it is located at the western rather than the eastern end of the street, as had always been assumed (figs. 5, 6). The building was constructed in 1859–1860, and Manet was recorded in 1861 as the first occupant of the studio.[5] Reached by crossing a courtyard and climbing two flights of stairs, Manet's studio looked eastward over what was then the bare, undeveloped Monceau plain, toward the urbanized Batignolles district. Although the studio was quite a distance both from the Batignolles and from Montmartre, where many of Manet's friends were working in the 1860s, it was located in a developing area near the old customs barrier on the boulevard de Courcelles and the district known as the

5 Lomière, map of Paris and its fortifications, 1860, Bibliothèque historique de la Ville de Paris; the detail shows the studio building on the rue Guyot, the unplanned area north of the place de l'Europe, and the outline of the future rue de Rome.

Ternes. The building itself was full of bustle and activity, including as it did a café, workshops and a laundry on the ground floor, some twenty-five lodging rooms and apartments inhabited mainly by tradesmen and artisans, and two artist's studios.[6]

At the Salon of 1870 Henri Fantin-Latour showed a large group portrait under the title *A Studio in the Batignolles* (fig. 8). It depicts Manet at his easel, in a non-specific

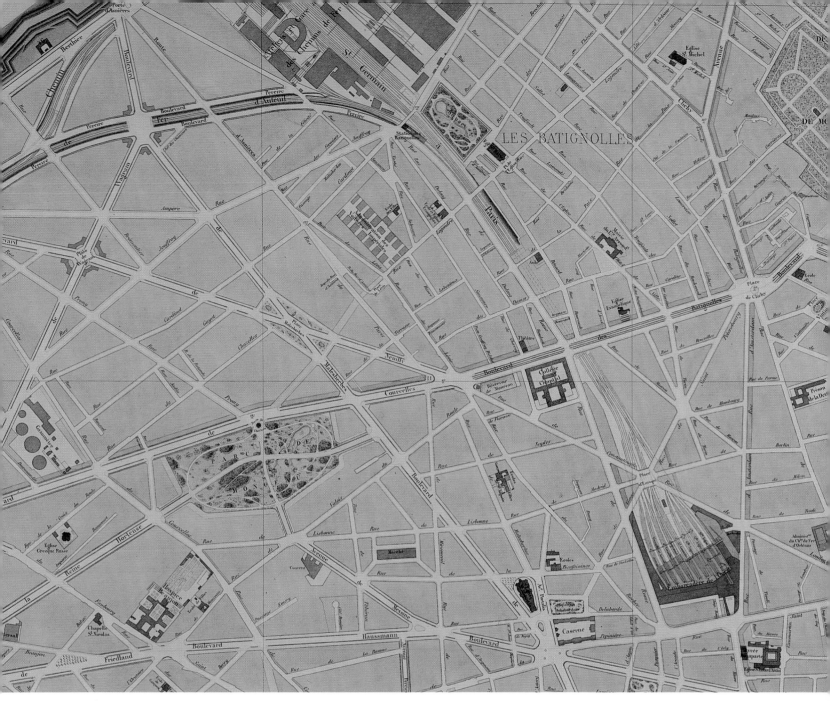

6 Map of Paris drawn up for baron Haussmann, 1866, watercolored presentation copy, Bibliothèque historique de la Ville de Paris (cat. 65); detail from plate 3 showing the Europe district, with the Batignolles to the north and rue Guyot to the north-west.

studio setting, painting a portrait of Zacharie Astruc, a lively young artist and critic who shared Manet's admiration for Spanish art. The huge canvas portrays Manet as the leading figure in the group of painters and critics who frequented the Café Guerbois in the Batignolles, most of whom also lived or had studios there. Among them, surrounding the journalist and critic Emile Zola who had become Manet's most

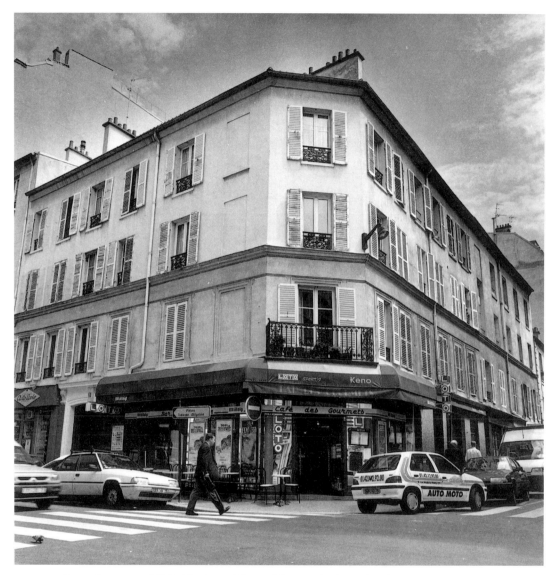

7 81 rue Guyot (now 8 rue Médéric), photo, Musée d'Orsay; the house in which Manet had his studio on an upper floor at the far end on the right, 1861–1872.

outspoken champion, are Auguste Renoir, Claude Monet and Frédéric Bazille. Some of Fantin's preparatory drawings and oil sketches, which included the additional figure of Degas, present a much livelier impression of the studio than the finished picture.[7] Nevertheless, the somewhat daunting solemnity of Fantin's painting includes a light

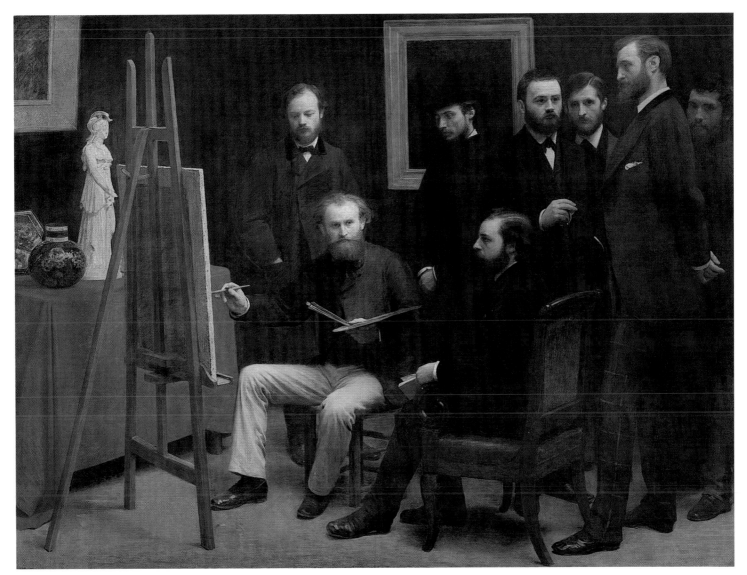

8 Henri Fantin-Latour, *A Studio in the Batignolles*, 1870, Salon of 1870, 204 × 273.5 cm, Musée d'Orsay, Paris (cat. 10); from left to right: Otto Scholderer, Manet seated, Auguste Renoir, Zacharie Astruc seated, Emile Zola, Edmond Maître, Frédéric Bazille, Claude Monet.

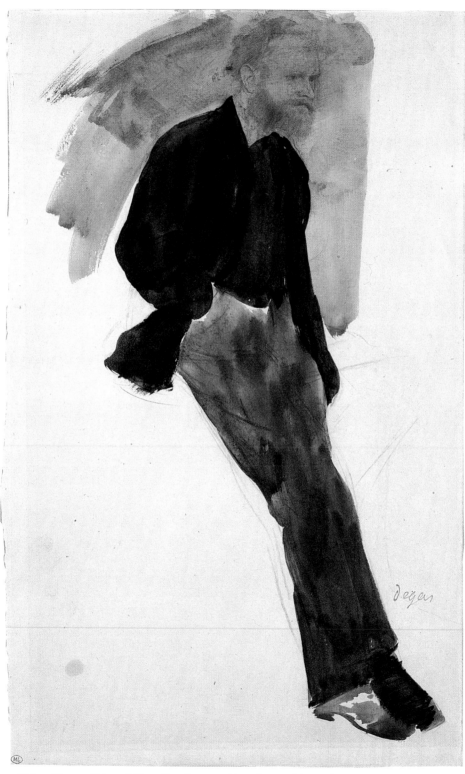

9 Edgar Degas, *Edouard Manet Standing*, c. 1866–1868, graphite and wash, Musée d'Orsay
–Louvre Arts graphiques, Paris (cat. 8).

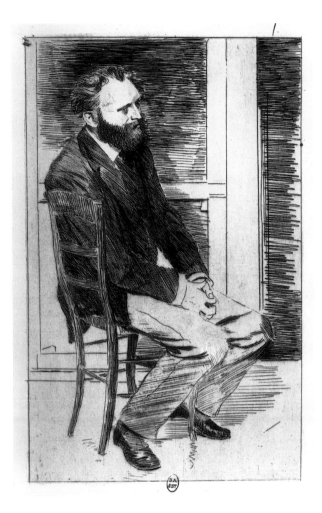

10 Edgar Degas, *Manet Seated, Turned to the Right*, c. 1866–1868, etching, first state, Bibliothèque nationale de France, Estampes, Paris (cat. 9).

touch: a cigarette stub on the floor beneath Manet's right foot suggests his smoking habit and recalls the stub in his *Spanish Singer*, the work in the Salon of 1861 that the younger generation of artists had so admired.[8] Edgar Degas, just two years younger than Manet, captured informal images of the artist at around the same time, in which the casual elegance for which Manet was so well known contrasts with body language that mingles determination, irony, and a sense of nervous anxiety (figs 9, 10).

From the early 1860s to the outbreak of war in 1870, Manet practiced his art in the rue Guyot studio. Regular Friday meetings with colleagues, critics, and writers at the Café Guerbois and endless discussions about art at his mother's weekly receptions, which were attended by Baudelaire and many other critics and connoisseurs, formed

the background against which Manet developed his ideas. His friend Antonin Proust, who had been a student with him in the atelier of Thomas Couture, recorded Manet's early appreciation of Gustave Courbet and his opinion that *The Burial at Ornans* (Musée d'Orsay, Paris), exhibited at the Salon in 1850–1851, was a major work: "really good . . . better than anything else," but that it still did not go far enough, because it was too dark.[9] From his *Spanish Singer* onwards, Manet took up Courbet's challenge by expressing a new and personal vision of the modern world, setting contemporary figures in natural poses and exploiting the luminous atmospheric effects that he admired in the landscapes of Corot, Daubigny and above all Jongkind. It was this initiative in Manet's art of the 1860s, to push beyond the bounds of Courbet's realism—hampered, as he saw it, by its traditional techniques—that led to the emergence of an avant-garde movement among such younger artists as Monet and Renoir.

Victorine: The Art of Painting

Victorine Meurent, Manet's favorite model (fig. 11), posed for most of his major paintings of the 1860s, including his monumental composition *Le Déjeuner sur l'herbe* (Musée d'Orsay, Paris), shown at the Salon des Refusés in 1863. Indeed, in the final stages of work on this painting Victorine may have replaced Manet's earlier model, his companion Suzanne Leenhoff, whom he married in 1863.[10] Born in 1844 near the Père Lachaise cemetery in Paris, Victorine Meurent was hired in 1862 to work in the studio of Thomas Couture, the academic artist celebrated for his enormous canvas *Romans of the Decadence* (Musée d'Orsay, Paris), with whom Manet had trained from 1850 to 1856.[11] It seems likely that Victorine also began modeling for Manet in 1862, since she appears in the full-length "fancy" picture *Mlle V . . . in the Costume of an Espada* (Metropolitan Museum of Art, New York) that Manet signed and dated that year. However, her first appearance in the artist's work was probably in *The Street Singer* (fig. 12). Antonin Proust would later recount the genesis of this work. Picking their way toward the studio along the route of the future boulevard Malesherbes, the two friends arrived at the rue Guyot where Manet saw "a woman coming out of a sleazy café, lifting her skirt and clutching a guitar."[12] When the woman laughed off the artist's request to come to his studio and pose, Manet recreated the scene that had caught his eye with Victorine's help: the young woman emerging from the saloon, holding ripe

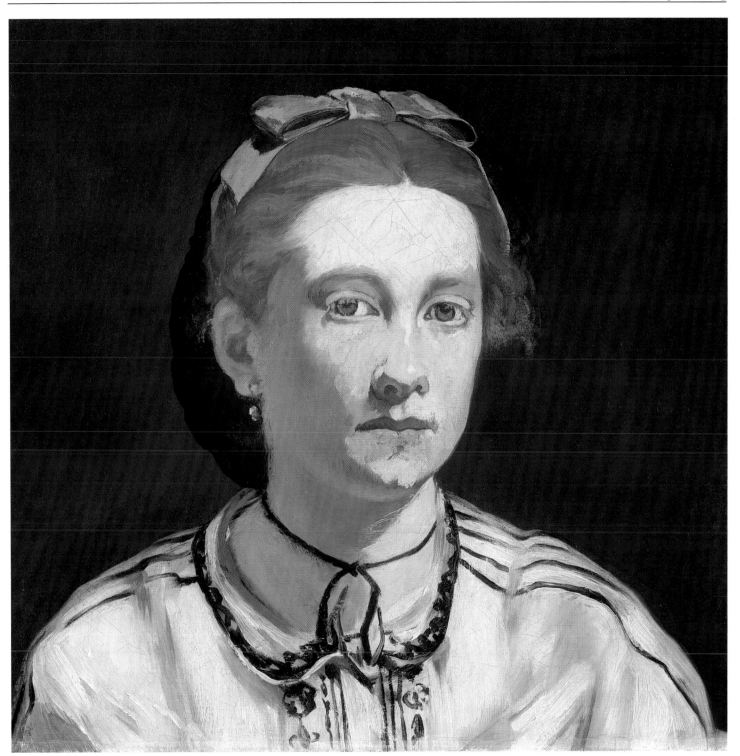

11 Edouard Manet, *Portrait of Victorine Meurent*, c. 1862, 43 × 43 cm, Museum of Fine Arts, Boston (cat. 13).

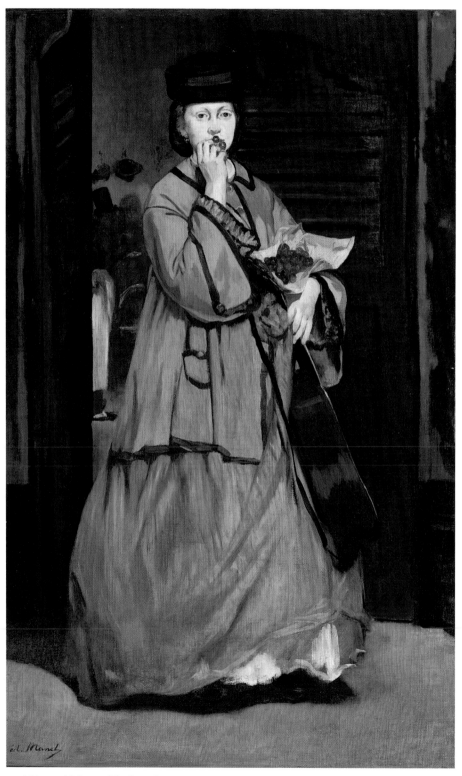

12 Edouard Manet, *The Street Singer*, c. 1862, 175.2 × 108.5 cm, Museum of Fine Arts, Boston (cat. 14).

red cherries to her mouth, a waiter and a top-hatted customer seen through the swing doors in the background.

This was the "modern Paris" that had begun to interest Manet as he moved away from compositions based directly on the Old Masters. The city was then in the grip of "Haussmannization"—a remarkable process directed by Georges Haussmann, prefect of the Seine Department and baron of the Empire, whom Napoleon III had charged with the redevelopment of Paris. In accordance with Haussmann's plans, houses were razed, whole streets were suppressed, hills were leveled, roads cut and paved, and row upon row of apartment buildings were erected, imposing patterns of modernity that are still very much in evidence in the lay-out of the city today (figs. 3, 6). Manet's early pictures reflect the predicament of the poor and dispossessed amid this upheaval in an oblique and dignified way. Following the darker, Courbet-influenced realism of *The Absinthe Drinker* in 1859, Manet's luminous *Old Musician* (National Gallery of Art, Washington) of 1862 depicts the vagrants and ragged children of Little Poland, an area to the south of his studio, not far from the Gare Saint-Lazare. The shacks and tenements of Little Poland were demolished to make way for the boulevard Malesherbes and new construction in the Europe district (figs. 6, 77) in a process recorded in prints by Martial Potémont of 1860 and 1861.[13]

Victorine as *Street Singer* belongs to the urban underworld that Baudelaire had made acceptable and fashionable, the world that lay open to the *flâneur*, the detached and sympathetic observer of city life. Antonin Proust, who maintained that Baudelaire was much influenced by Manet, said of his friend: "Manet's eye played such an important role that Paris had no other *flâneur* to match him and no *flâneur* for whom that activity was more useful."[14] The artist's independent nature and liberal sympathies opened his eyes to the visual splendors of his surroundings, however unprepossessing they seemed to others. Manet set out to recreate on canvas, in the calm of his studio, the "shock of the new"—his own poetic vision of the contemporary world untainted by current artistic conventions.

Years later, his friend Stéphane Mallarmé recorded Manet's reflections on his early period:

Wearied by the technicalities of the school in which, under Couture, he studied, Manet, when he recognized the inanity of all he was taught, determined either not to paint at all or to paint entirely from without himself.

And of Manet's distinctive method of painting he commented:

> Each time he begins a picture, says he, he plunges headlong into it, and feels like a
> man who knows that his surest plan to learn to swim safely, is, dangerous as it may
> seem, to throw himself into the water. One of his habitual aphorisms then is that no
> one should paint a landscape and a figure by the same process . . . Each work should
> be a new creation of the mind. The hand, it is true, will conserve some of its acquired
> secrets of manipulation, but the eye should forget all else it has seen, and learn anew
> from the lesson before it.[15]

Manet's uncompromising stance and the consequent variety and unconventionality of
his art divided critics into two camps: those who could see only his shocking subject
matter and its shockingly "inartistic" treatment and those who, although they under-
stood the importance of his new approach and appreciated the tonal and coloristic
effects that he achieved, were disturbed by Manet's "impressionistic," apparently
"unfinished" brushwork, given the high level of finish then expected of exhibition
pictures.

As the decade advanced and the city continued to expand and change, the radical
modernity inspired by Courbet and the realist school acquired a new civility. In *Olympia*
(Musée d'Orsay, Paris), shown at the Salon of 1865, a traditional nude inspired by
Titian's *Venus of Urbino* is transposed, in the figure of Victorine, into the outrageously
cool, contemporary image of a young prostitute.[16] The outcry that greeted the picture
so affected Manet that he decided to make for Spain—to "go to Maître Velasquez for
advice," as he put it in a letter to his hispanophile friend Zacharie Astruc, who gave him
detailed information about the country and its art treasures.[17] On his return, Manet
portrayed Victorine as a *Young Lady in 1866* (fig. 13), dressed in a sumptuous but simple
satin peignoir and holding a bunch of violets, a parrot on a perch her sole companion.
Here for the first time his model appears not to act out a role but to represent herself.
The lesson of Velázquez is evident in the stately but unaffected presentation of the
figure in pink against a plain but exquisitely modulated grey ground. If the painting
contains allegorical references—an allegory of the five senses seems the most plausi-
ble—they are understated. From another perspective, the monocle, the flowers, and the
parrot are grounds for an erotic reading.[18] But even if the "subject" of the picture
remains elusive, Manet's bold technique is inescapable. Viewers at the 1868 Salon saw

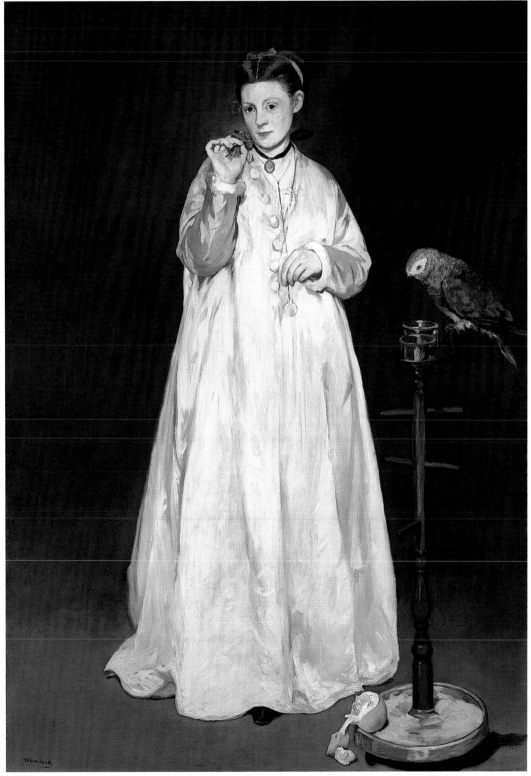

13 Edouard Manet, *Young Lady in 1866*, 1866, Salon of 1868, 185.1 × 128.6 cm, Metropolitan Museum of Art, New York (cat. 15).

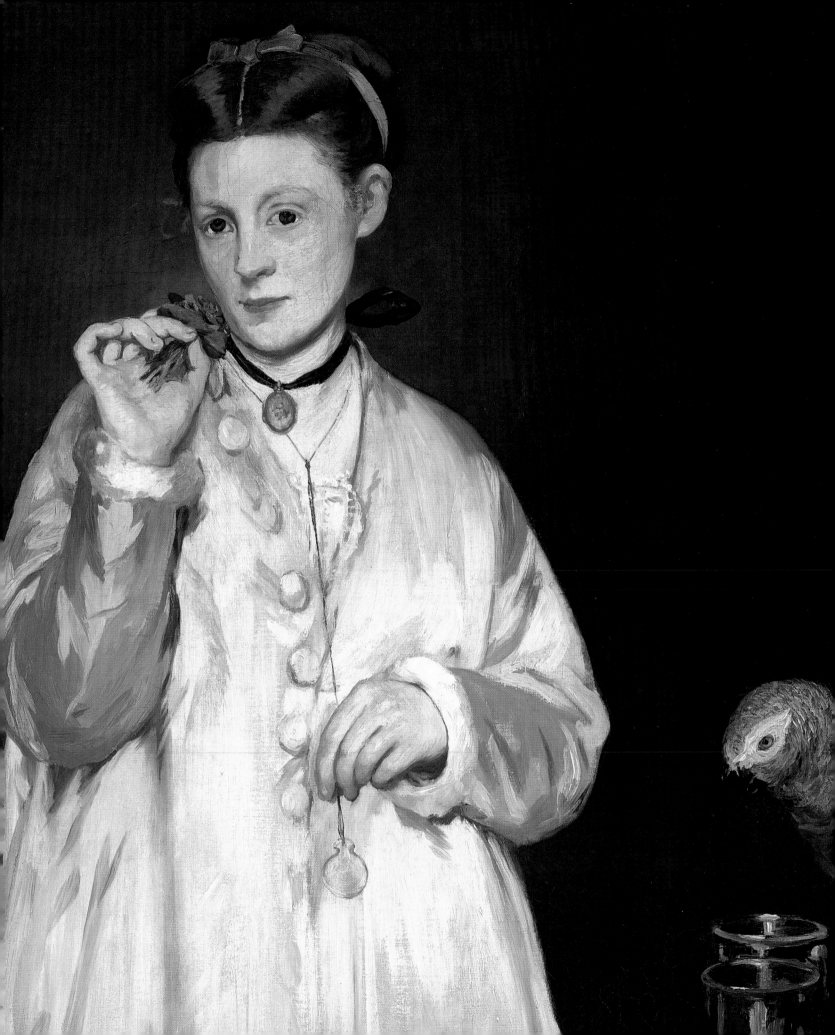

only a careless lack of finish in Manet's broad and confident brushstrokes and only ugliness and brutality in the absence of chiaroscuro in Victorine's features. The frontal presentation must have made this disturbingly alive yet denatured "creature" challenging and difficult to approach.

Exhibited at the Salon of 1868 together with Manet's portrait of the journalist and critic Emile Zola, the *Young Lady in 1866*, one of Manet's most splendid figure studies of the decade, lacks any specifically anecdotal points of reference that one could assimilate to the future novelist's themes. In that respect, the picture anticipates the suggestive, poetic sphere of Mallarmé, who grasped the essential qualities both of Manet's art and of his figures, in which "there was nothing vague, general, conventional, or hackneyed."[19] Zola championed Manet in the 1860s, and his longest and most closely argued defence of the artist was published at the time of Manet's one-man exhibition in 1867.[20] But just as Baudelaire, for different reasons, failed to recognize Manet as the quintessentially modern artist that he was and instead preferred the more anecdotal art of Constantin Guys, so Zola, for all his early enthusiasm for the *Le Déjeuner sur l'herbe* and *Olympia*, was unable either to follow Manet's later development or to understand his aims. Years later, an observer at one of Mallarmé's famous Tuesday gatherings recorded the poet's view of the resulting situation:

> Mallarmé refers to what is fine and praiseworthy in Zola's work . . . The pain he caused Manet when, after praising him and seeming at first to have understood him, he spent the rest of his life saying that Manet was "incomplete" as an artist. Zola blamed Manet for producing nothing but sketches, fragments, studies. But does that matter when each new piece is more powerful than the one before it? when Manet goes on discovering, innovating, and revealing things unknown before him? and when every inspiration results in the creation of a new painting? Zola was never able to see a work of art in any terms other than its number of printings.[21]

Manet was too sophisticated, too allusive for Zola, a point brought out by the juxtaposition of the relatively early *Young Lady in 1866* with a figure painting of almost a decade later, the dashing *Parisienne* (fig. 15) of 1874–1875. The two paintings demonstrate the persistency of Manet's aims and the increasingly daring artistry of his means. The later picture shows a similar single life-size figure, presented neither as a portrait nor, because it lacks accessories, as a genre scene, but simply as an individual and as a social

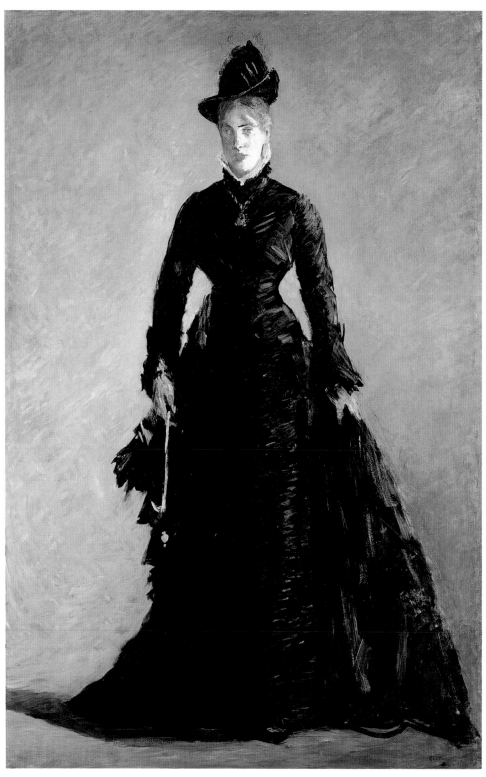

15 Edouard Manet, *La Parisienne: Study of Ellen Andrée*, 1874–1875, 190 × 123 cm, National-museum, Stockholm (cat. 29).

"type," a young woman of a particular time. The flavor of the moment is conveyed as much by the manner of painting as it is by the dress and is characterized by vibrant, broken, "impressionistic" brushwork. Yet *The Parisienne* remains closer to the tradition of Velázquez and to Manet's own earlier figure paintings than it does to the work of his Impressionist colleagues. Manet insists on the chic allure, the energy, and the "presence" of his model, strikingly silhouetted against an atmospheric ground that replicates, but in an entirely different mode, the effect of the earlier painting of the 1860s. The freshness and impact of such pictures never came easily to Manet, and his struggle to achieve the most telling contour is suggested in *The Parisienne* by the *pentimenti*, the covered brushstrokes that have been revealed by the passage of time and that are as pronounced as those in a portrait by the seventeenth-century Spanish master he so deeply admired.

Here, the figure is not an obscure artist's model like Victorine but Ellen Andrée, a "personality," a well known beauty of the day who posed for major paintings by Degas, Renoir, Stevens, and Gervex, and who later took up a successful acting career. After Victorine's final appearance in the contemporary, open air setting of *The Railway*, in 1872, Manet thereafter chose his models from an ever-changing cast of artists and writers, singers and actresses, demimondaines and bourgeois men and women, each of whom played a role in the social life of his time. *The Parisienne* typifies the direction that Manet's art was to take under the Third Republic, after the cataclysmic events that shattered his way of life and made *The Railway* both an epitaph and a new departure.

War and Peace

The invasion of France and collapse of the Second Empire in 1870 was heralded by disastrous events in Mexico three years earlier. In 1867, Archduke Maximilian of Austria, who had been placed on the throne of Mexico by Napoleon III, initially with the support of French troops, was captured, condemned, and executed with the approval of the rebel Republican government (fig. 16). The catastrophe, which occurred during the great *Exposition Universelle* in Paris, resounded throughout Europe, bringing shame to France and arousing dismay and anger in the republican camp. Deeply affected by the outcome of the ill-fated Mexican adventure, Manet worked on three monumental canvases, the last one intended for the Salon, and he made a lithograph as a further public protest. Both projects fell victim to state censorship.[22] The

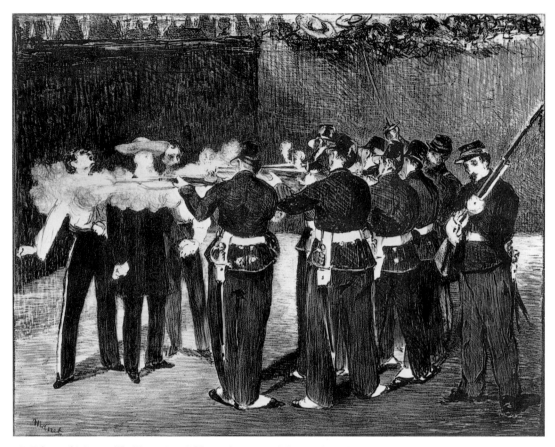

16 Edouard Manet, *The Execution of Maximilian*, 1868, lithograph, published 1884, Bibliothèque nationale de France, Estampes, Paris.

Mexican fiasco fatally weakened French imperial power. France's declaration of war in July 1870 in the face of Bismarck's expansionist policies in Europe resulted in the Prussian invasion of France in September that led to the siege of Paris. Manet sent his family to the country and endured the bitter winter in the city, which suffered from constant bombardment and terrible deprivation and famine.

Paris, ringed by fortifications and protected at strategic points by more distant forts around its perimeter (figs. 17, 18), was defended by its inhabitants. Manet, his brothers Eugène and Gustave, his colleague Edgar Degas, and the art collector Ernest Hoschedé (fig. 19) all served in the National Guard. Félix Bracquemond's suite of etchings of the

17 Paul Fauré, *Paris Fortified*, 1871, lithograph, Bibliothèque nationale de France, Cartes et Plans, Paris (cat. 67); detail of the perspective view of Paris and its surroundings seen from the south.

18 Lomière, map of Paris and its fortifications, 1860, Bibliothèque historique de la Ville de Paris; the detail shows the southern fortifications, including bastions 77–87, and the fortresses of Montrouge and Bicêtre.

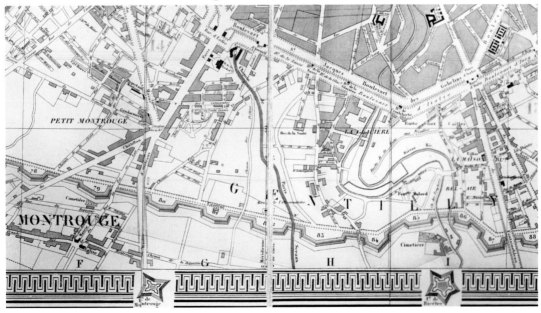

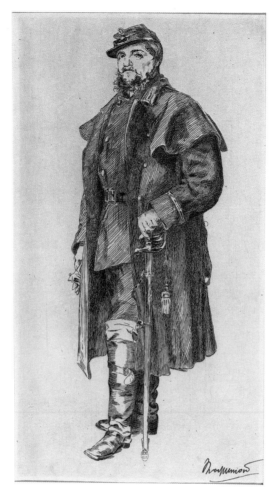

19 Félix Bracquemond, *Hoschedé*, 1871,
etching, Bibliothèque nationale de France,
Estampes, Paris; Ernest Hoschedé, art
patron and friend of Manet and Monet, was
a lieutenant in the National Guard.

Siege of Paris in 1870 records particular dates during his guard duty on the numbered bastions of the southern fortifications and includes unique views of two symbolic "ice sculptures" created during that terrible winter: *The Republic* by Hippolyte Moulin and *The Resistance* by Alexandre Falguière (figs. 20, 21).[23] The war claimed many victims. In 1870 they included such young artistic talents as Frédéric Bazille who appears in Fantin-Latour's group portrait (fig. 8) and Degas's friend, the sculptor Joseph Cuvelier; in January 1871, Henri Regnault, Mallarmé's close friend, was killed at Buzenval, just days before the end of the war.

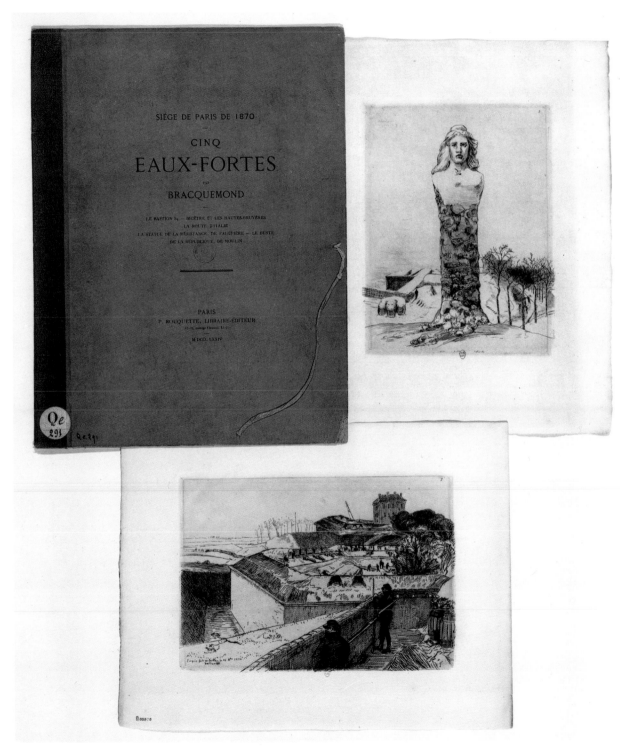

20 Félix Bracquemond, *The Siege of Paris in 1870, Five Etchings*, 1874, portfolio of etchings, Bibliothèque nationale de France Estampes, Paris (cat. 2); portfolio and two etchings: "The Bust of the Republic, by Moulin," and "Bastion 84," inscribed "Sketch made on duty 14 October 1870, bastion 84,"

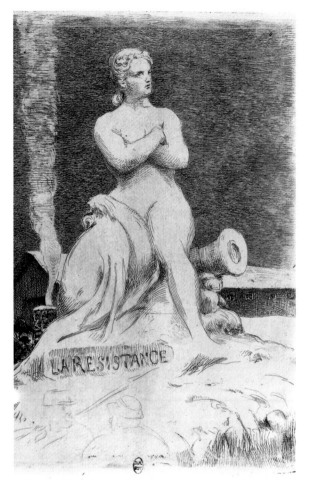

21 Félix Bracquemond, "Statue of The
Resistance, by Falguière," etching from
The Siege of Paris in 1870, 1874 (see fig. 20).

In November 1870, Manet told Eva Gonzalès, then in Dieppe, that he was a volun-
teer gunner in the artillery with Degas and added, "My paintbox and portable easel are
stuffed into my military kitbag . . . and I'm going to take advantage of the facilities avail-
able."[24] An evocative oil sketch dated 20 December 1870 shows a desolate, almost
monochrome urban snowscape near the southern fortifications with the church of
Saint Pierre at Petit-Montrouge (fig. 22); still under construction, its nave was used as a
hospital during the war. Besides the hardships and dangers of his own tasks, Manet's
many letters to his family and friends, which left the besieged city by balloon, record the
privations and miseries that everyone in Paris endured during the siege (fig. 23).[25]

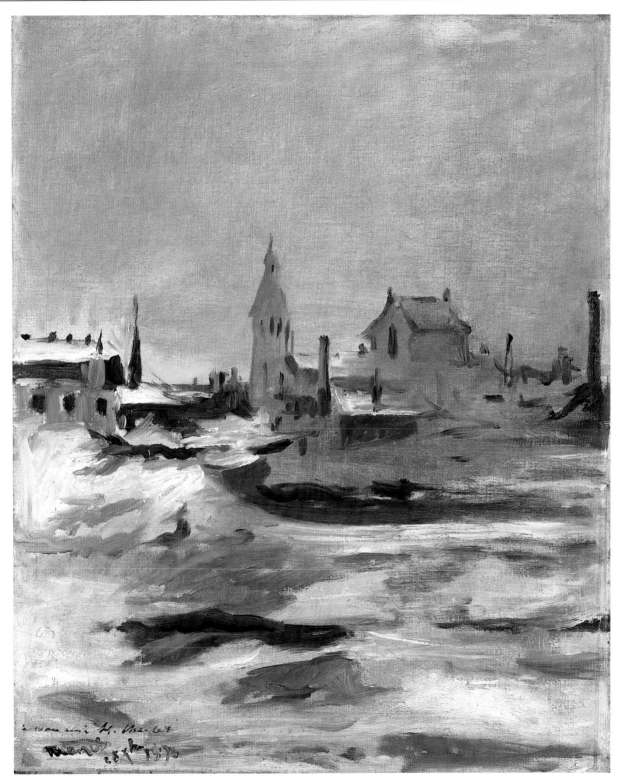

22 Edouard Manet, *Effect of Snow at Petit-Montrouge*, dated 28 October 1870, inscribed "to my friend H. Charlet," 61.6 × 50.4 cm, National Museum & Gallery of Wales, Cardiff (cat. 16); view of the church of Saint-Pierre de Montrouge.

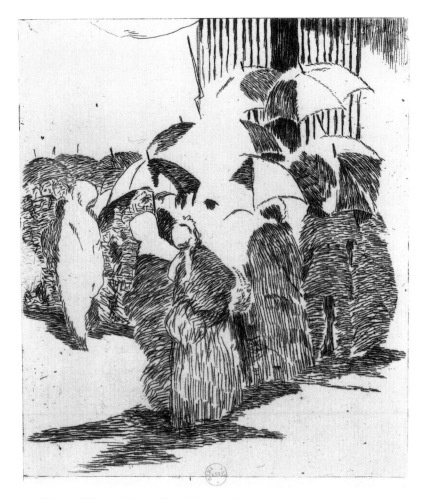

23 Edouard Manet, *Line in Front of the Butcher's Shop*, c. 1871–1872, etching,
Bibliothèque nationale de France, Estampes, Paris (cat. 17).

France capitulated at the end of January 1871, and Manet joined his family in the southwest; he returned to Paris only when the civil war unleashed by the Paris Commune was virtually over. The new republican government based at Versailles, which had accepted the humiliating terms of peace imposed by the Prussians, had repressed all opposition with great brutality. Manet saw something of the slaughter in the streets that had brought the Commune to an end, and it affected him as deeply as the execution of Maximilian. Two of his most celebrated prints record these events. *The Barricade* (fig. 24) exploits the same emotions and compositional structure as his

24　Edouard Manet, *The Barricade*, c. 1871–1873, lithograph,
Bibliothèque nationale de France, Estampes, Paris (cat. 18).

Execution of Maximilian, while *Civil War* (fig. 25) brings military and civilian victims together in a simple image of great power and pathos.

The violent events of the Commune that followed the war slowed the return to normal life and made it impossible to hold a Salon exhibition in 1871. Not until the following year was there an opportunity for artists to express their response to the war and its aftermath in a public exhibition. One of those who did so was Pierre Puvis de Chavannes. An older member of the Paris art scene, Puvis practiced a pure, classicizing form of art, untainted by the academic school, and he was admired and respected for

25 Edouard Manet, *Civil War*, dated 1871, published 1874, lithograph, Bibliothèque nationale de France, Estampes, Paris (cat. 19).

his sincerity by the younger generation of artists. During the siege of 1870, handsome lithographs were published of his two large compositions that symbolized the spirit of resistance in Paris (figs. 26, 27). At the Salon of 1872, Puvis showed an impressive allegorical composition entitled *Hope* (fig. 28). A young girl, in a simple, classic pose, sits on

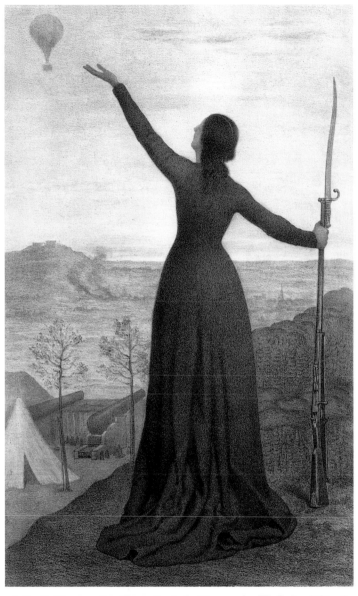

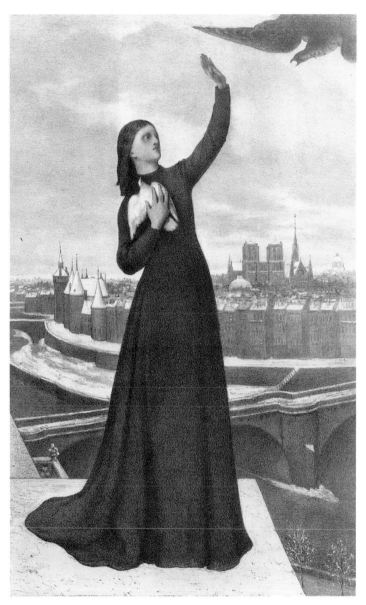

26 Emile Vernier after Pierre Puvis de Chavannes, *The Besieged City of Paris Entrusts Its Appeal to France to the Air: The Balloon*, 1870, lithograph, Bibliothèque nationale de France, Estampes, Paris (cat. 62).

27 Emile Vernier after Pierre Puvis de Chavannes, *Having Eluded the Encircling Enemy, the Long-Awaited Message Raises the Spirits of the Proud City: The Pigeon*, 1870, lithograph, Bibliothèque nationale de France, Estampes, Paris (cat. 63).

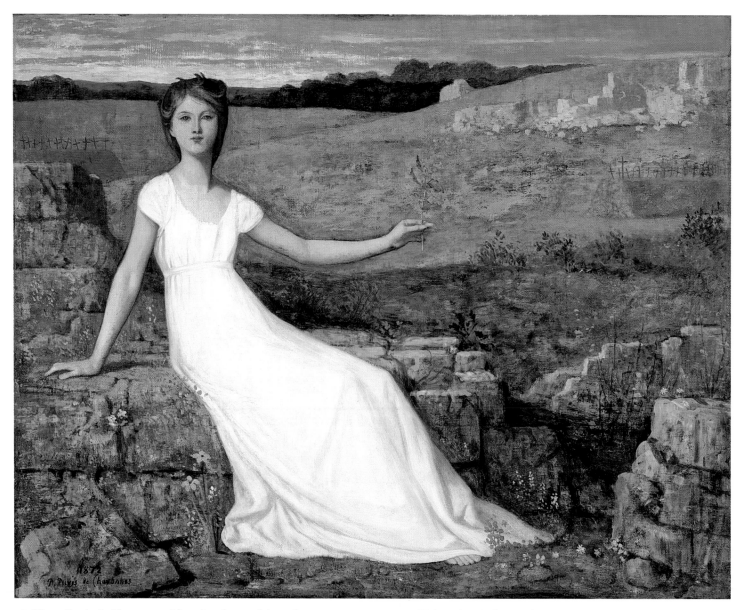

28 Pierre Puvis de Chavannes, *Hope*, dated 1872, Salon of 1872, 102.5 × 129.5 cm, Walters Art Gallery, Baltimore (cat. 60).

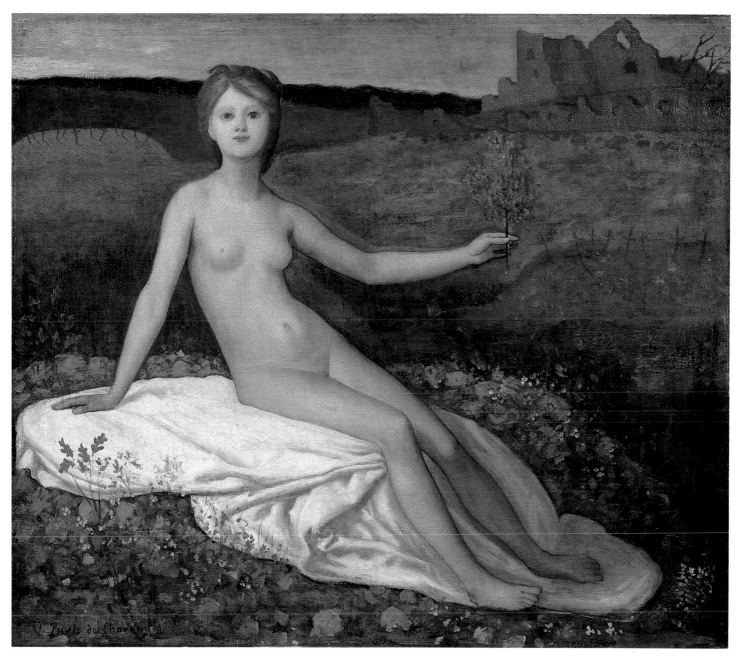

29 Pierre Puvis de Chavannes, finished sketch for *Hope*, 1871–1872, 70.7 × 82 cm, Musée d'Orsay, Paris (cat. 59).

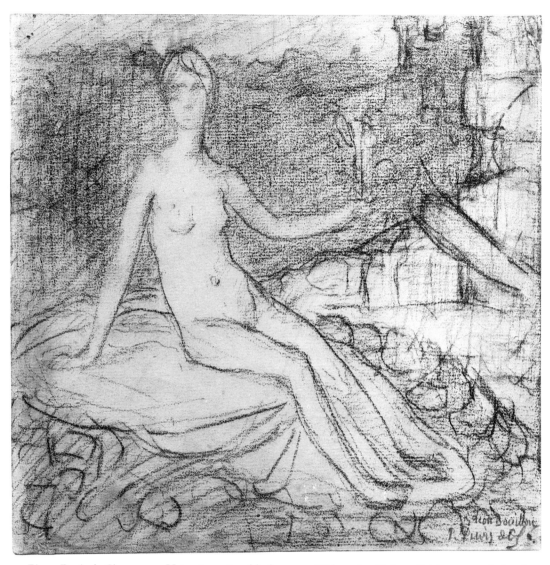

30 Pierre Puvis de Chavannes, *Hope*, 1871–1872, black crayon, Walters Art Gallery, Baltimore; study for the oil sketch (fig. 29), signed and inscribed to Léon Bouillon.

a rocky outcrop, a sprig of oak in her outstretched hand; burial mounds surmounted by crosses appear in the devastated landscape behind her. Drawings and a large oil sketch (figs. 29, 30) show that *Hope* was first conceived as a nude figure holding an olive branch and that she was garbed in white only for the final composition.[26] Puvis's composition met with general hostility, and critics and caricaturists mocked the work for the stiffness and frailty of the symbolic female (fig. 31, 32). "M. Puvis de Chavanne's HOPE: much

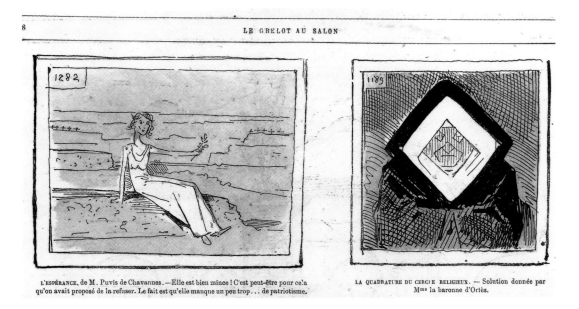

L'ESPÉRANCE, de M. Puvis de Chavannes. — Elle est bien mince ! C'est peut-être pour ce'a qu'on avait proposé de la refuser. Le fait est qu'elle manque un peu trop... de patriotisme.

LA QUADRATURE DU CERCLE RELIGIEUX. — Solution donnée par Mᵐᵉ la baronne d'Ortès.

31 Bertall, "Le Grelot at the Salon, by Bertall,' 1872, Bibliothèque nationale de France, Estampes, Paris; the detail includes "M. Puvis de Chavannes's Hope: much too slim. That's perhaps why they wanted to turn her down. Fact is, she does seem a bit lacking in... patriotism."

32 Stop, "The Salon of 1872, by Stop," *Le Journal amusant*, 18 May 1872, Bibliothèque nationale de France, Estampes, Paris; the detail includes "Hope, by M. Puvis de Chavannes. Alas, this Hope is a bit lean, a bit pale, a trifle anemic. She needs iron, a fortifying tonic... "

LE SALON DE 1872, — par Stop (suite).

L'ESPÉRANCE, par M. Puvis de Chavannes.
— Un peu maigre, hélas! cette Espérance! Un peu pâle, un peu sèche, un peu anémique! Nous lui conseillons du fer et du vin de quinquina. — Berthelier, qui passait par là, s'est écrié (cet âge est sans pitié) : C'est la poupée à vis de Chavannes.

— Dans sa joie d'avoir été reçu au Salon, Pygmalion se livre, avec sa statue, aux polkas les plus folâtres. *Dantan sculpsit.*

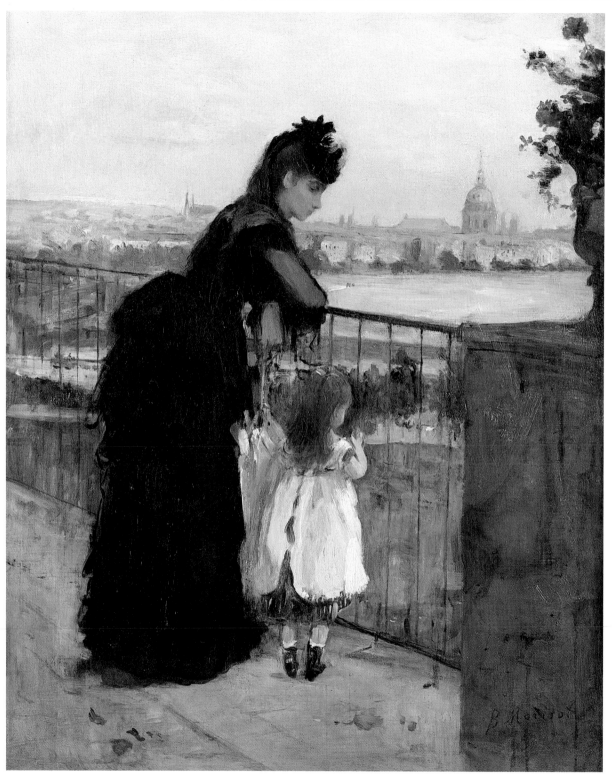

33 Berthe Morisot, *Woman and Child on a Balcony*, c. 1871–1872, 60 × 50 cm, private collection (cat. 56).

too slim," commented *Le Grelot*.[27] However, Puvis's figure, which he perhaps conceived before the end of the war, and which can be compared with the symbolic ice sculptures recorded by Bracquemond (figs. 20, 21), seems to have inspired or at least found an echo in works by several of his younger admirers.

Manet and Berthe Morisot, both city dwellers who had remained in the capital during the war, began in 1872 to explore the new, postwar world that in Morisot's case was symbolized by her sisters' young daughters: *Woman and Child on a Balcony* (fig. 33) is a tender evocation of Yves Gobillard with her daughter Paule. Although Morisot's painting is quite differently conceived, it shares with Manet's *The Railway* (fig. 1), also painted in 1872, the motif of a child in white gazing at an urban prospect through railings. Both artists would have seen Puvis's composition at the Salon and been sensitive to its significance as a sincerely expressed allegory of grief for violence and destruction of the recent past and hope for the new era. But Morisot and Manet were committed to the expression of their feelings through entirely contemporary subject matter. Manet's child at the railings is almost a mirror image of Puvis's figure of Hope, yet whatever meanings may lurk within his composition—and it is one that has always demanded interpretation—the modernity of its artistic vocabulary is unequivocally clear.

Manet's "Railway" in Perspective

Manet's painting of *The Railway* (fig. 1) emerged as a result of events that radically changed his way of life in the 1870s. With the outbreak of hostilities, he had closed his rue Guyot studio in September 1870 and deposited some of his most important pictures with Théodore Duret, the collector-cum-critic friend who would become the Impressionists' historian.[28] The rue Guyot rental remained in Manet's name, however,[29] and it was probably there that in January 1872 he received a visit from Paul Durand-Ruel, the established art dealer who was beginning to buy avant garde works in addition to those of the realist and Barbizon schools. In a single deal, Manet sold no fewer than twenty-four pictures to Durand-Ruel, earlier canvases as well as recent ones (fig. 34).[30] Having been unable to find a market for his paintings in the previous decade, the artist had been largely dependent on money inherited from his father and on loans from his mother. Now, this windfall from the sale of so many pictures enabled him to take a splendid studio not far from his home.[31] At about this time his former model, Victorine

34 Manet's address book open at the letter F with a note "sold to Fèvre" at upper right and the January 1872 sale to Durand-Ruel detailed over the double page, reproduction (magazine clipping, source unknown), Musée d'Orsay, Documentation, Paris.

Meurent, returned from what is said to have been a romantic escapade to the United States of America and posed for Manet once again, for the first major canvas painted after he moved his studio to 4 rue de Saint-Pétersbourg.

The picture that Manet titled *The Railway* shows two people in close-up. A young woman sits looking at the viewer, a book in her hands, a puppy on her lap. A child stands to her left (our right); she turns her back on us and gazes into the distance. Freely and boldly painted, with a predominance of largely unmodulated tones of white and blue, the figures are placed in front of a grid of black iron railings that spans the entire canvas and evidently continues beyond the upper edge of the picture. Through the railings we glimpse railway tracks and a cloud of smoke and steam (but no train), a pillar of

35 Detail of fig. 1

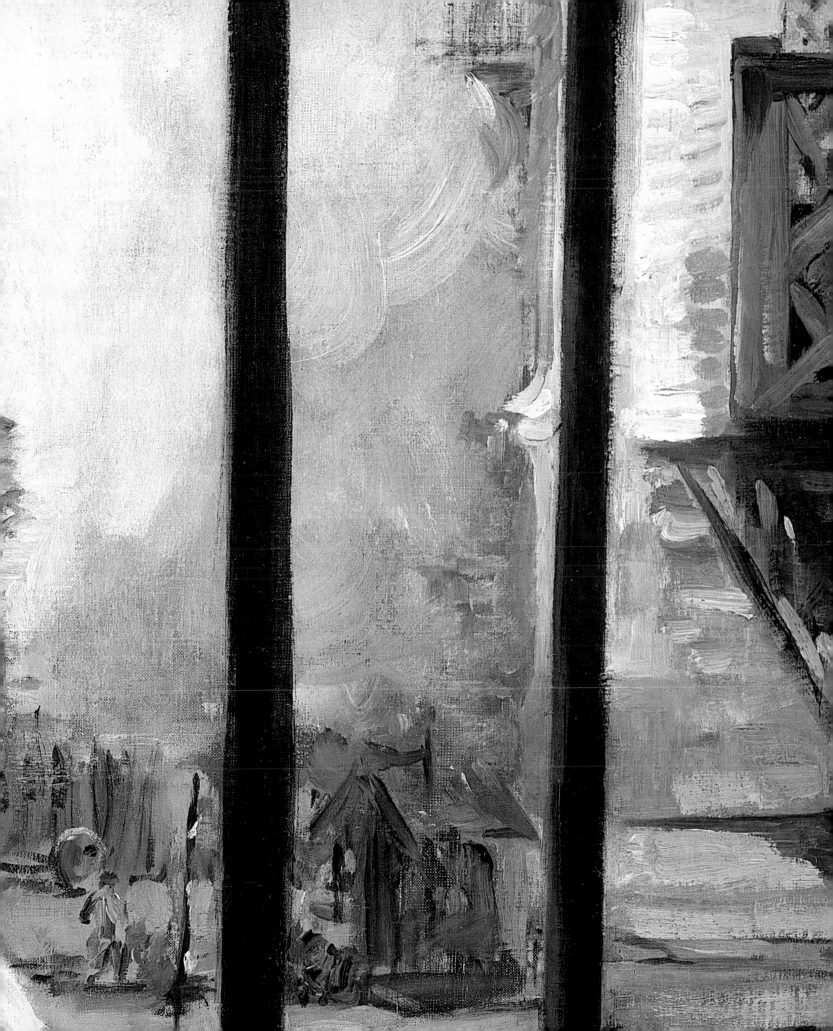

36 Alphonse Hirsch, *First Stirrings*, Salon of 1876, Goupil photograph, Bibliothèque nationale de France, Estampes, Paris

the pont de l'Europe signaling that the scene is located near the Gare Saint-Lazare (fig. 64), and, in the distance, some sketchy house façades. At the physical center of the picture are the child's bare arm and the cloud of white smoke.

The Railway is always said to have been painted in the garden of an artist friend, Alphonse Hirsch, a purveyor of agreable Salon pictures and portraits, who formed part of the circle that included Giuseppe de Nittis and Edgar Degas (figs. 36–38).[32] Hirsch had a studio, as did many artists, in one of the newly built properties on the rue de Rome. Documents confirm that he leased a spacious fourth-floor studio in the building

37 Edgar Degas, *Alphonse Hirsch*, 1875, drypoint and aquatint, National Gallery of Art, Washington.

38 Giuseppe de Nittis, *Alphonse Hirsch*, 1875, drypoint, Bibliothèque nationale de France, Estampes, Paris.

39 *Paris—Pont de l'Europe*, c. 1900–1905, postcard (enlarged), Musée Carnavalet, Paris; view of the rear façades of the rue de Rome houses with Hirsch's two tall studio windows at the top of number 58, near the center.

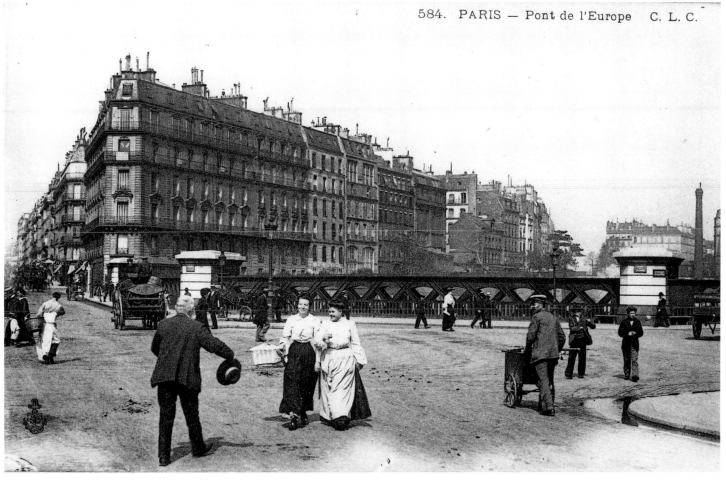

584. PARIS — Pont de l'Europe C. L. C.

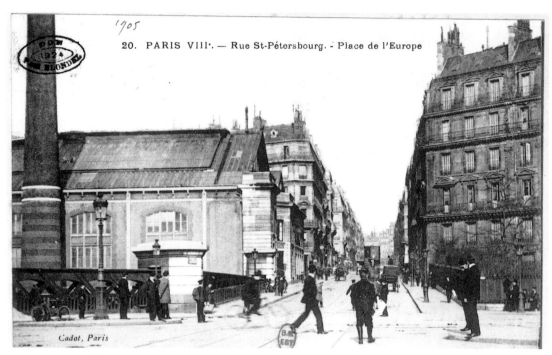

40 *Paris—Rue St-Pétersbourg—Place de l'Europe*, 1905; postcard, view up the rue de Saint-Pétersbourg: the Place de l'Europe façade of number 2 on the right; to the left are the parcels depot of 1886 (with the chimney built 1892), and a glimpse of the corner house at 2 rue Mosnier (now rue de Berne).

41 The Pont de l'Europe from Hirsch's studio, photograph, Musée d'Orsay, Paris; today only the outer stone pillars are still intact and the original superstructure is gone.

at the rear of 58 rue de Rome in July 1872 (fig. 39). He had, however, no apparent claim on the ground floor *atelier* or the narrow strip of garden, whose tall iron railings, which border the tracks between the pont de l'Europe and the boulevard des Batignolles, are still in place today.[33] From the rear of number 58 one can still see the stone pillar that appears at the right in Manet's picture. It supports the massive iron bridge at the point where one of its six "arms" joins the rue de Saint-Pétersbourg, which runs from the place de l'Europe up to the place Clichy (figs. 40, 41, 64). At that date, there were no buildings immediately opposite the studio on the rue de Saint-Pétersbourg and Manet had an uninterrupted view over the railway cutting. This meant that he could see the little gardens behind the railings, and the rear elevations of the houses fronting on the rue de Rome (fig. 39), while the view from Hirsch's side of the tracks looked directly onto the façade of Manet's new studio.

In the painting, a cloud of smoke and steam from a passing train obscures the distant façades on the place de l'Europe and the wide angle formed by their junction with the rue de Saint-Pétersbourg. To the left, where the smoke has not yet enveloped the scene, two doors and a window are visible behind a wooden fence. A walk along the street today and a photograph from Manet's time (fig. 42) confirm that they are in fact the tall carriage entrance doors of 2 and 4 rue de Saint-Pétersbourg, while the window with its stone balustrade is one of four in the upper ground floor room that served as Manet's studio from 1872 to 1878. The identification of this apparently insignificant architectural detail in the background of Manet's picture suggests new levels of meaning in *The Railway*, the first important work painted after the artist's move to the studio where he was to spend six of the happiest and most fruitful years of his life.[34]

The transfer of Manet's studio, after so many years at rue Guyot, to this new address in July 1872 must have been a major undertaking, and Manet's next concern would have been to prepare his pictures for the Salon of 1873. *The Railway* was one of the first works to be painted and was seen in his studio by the critic Philippe Burty before the year was out. Burty described it thus:

> a double portrait, not quite finished, that was sketched out in full sunlight. A young woman, dressed in the blue twill that was all the fashion until this autumn, sits beside her little daughter. The latter, dressed in white, stands looking through the railings of

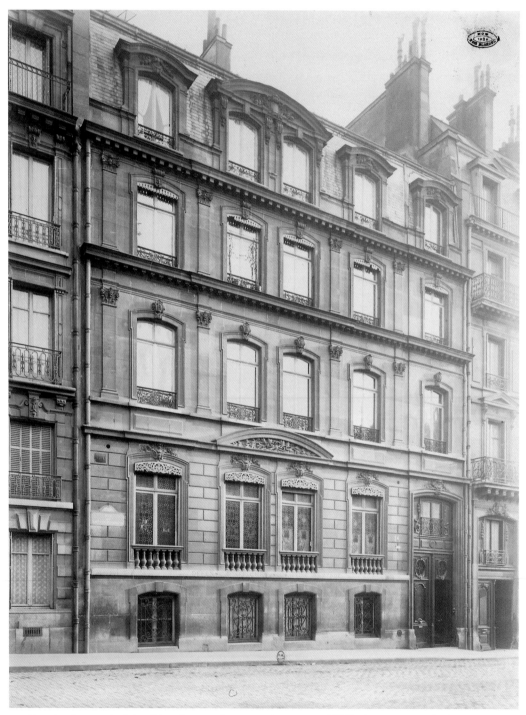

42 Façade of 4 rue de Saint-Pétersbourg, albumen print, c. 1870, Bibliothèque nationale de France,
Estampes, Paris (cat. 68); the house was built in 1864 and Manet's studio lay behind the four leaded windows
with stone balustrades.

the place des Batignolles at the fleecy white smoke of a passing train and the houses on the other side of the tracks. Movement, sunshine, pure air, the reflected light, all create an impression of nature, but nature captured with a sensitive eye and expressed with refinement.[35]

In spite of the clue provided by the pillar of the pont de l'Europe, Burty curiously misidentifies Manet's viewpoint and locates the site of the picture north of the boulevard des Batignolles, near the workshops and freight yards of the Chemin de Fer de l'Ouest, a mistake which seems to underline Manet's characteristic reluctance to provide factual information about his works.

As soon as *The Railway* was completed—and Manet signed and dated the canvas in 1873—it was acquired by the celebrated baritone Jean-Baptiste Faure (fig. 159), a connoisseur and major collector who was closely associated with Durand-Ruel.[36] However, it was not *The Railway* but the picture called *Le bon bock* and a large, earlier study of Berthe Morisot that Manet sent to the Salon of 1873. He waited until 1874 before submitting *The Railway,* together with two other canvases and a watercolour, to the Salon jury. The regulations that year entitled artists to submit three oil paintings. Of Manet's three canvases, only *The Railway* was accepted. Even the artist's least enthusiastic supporters considered that the jury had gone too far, and this was argued extensively in the press, most notably by Stéphane Mallarmé, the young poet and critic whom Manet had probably encountered a year earlier.[37]

Manet's participation in the Salon had already become a cause célèbre when the exhibition opened its doors on 1 May 1874, and the single picture that had been accepted achieved immediate notoriety and provoked protest and ridicule. To the public of Manet's day, *The Railway* seemed outrageous and incomprehensible. It raised all the questions—about meaning and significance, the readability of works, acceptable "artistic" practice and technique—that have always been asked of avant-garde art. Every newspaper carried references to M. Manet and his latest work, and caricaturists had a field day depicting the work. It was above all the ostensible subject and the possible relationship of the figures that provoked comment and confusion: Was Manet depicting a mother and daughter, as Burty had already suggested? or should they be seen as a young woman and her little sister? or an English governess and her pupil? The caricaturists showed them as madwomen or prisoners, given the iron bars spanning the

entire picture space. One caricaturist put the bars in front, caging the figures and cutting them off from the viewer (fig. 43). Another described them as "Two madwomen gripped by incurable *monomanetmania*" (fig. 44). A third commented on their expressions of despair, occasioned, he imagined, by "the departure of M. Faure for England," to which he added, "It's not much fun for M. Manet either"—a reference to the fact that Faure was Manet's most important private patron and the owner not only of *The Railway* but also of *Masked Ball at the Opera*, one of the pictures that had been rejected by the Salon jury (fig. 45, 140).

One of the first cartoons to appear, drawn by Cham for the comic journal *Le Charivari*, called the picture *The Lady with a Seal*. The caption commented, "The poor things, seeing themselves painted like this, have tried to escape! In anticipation, he has put in a railing that cuts off all possibility of retreat." The picture had become so notorious that out of the hundreds of comic drawings by Cham, this image was selected for the cover and title page of an album of his collected Salon caricatures (fig. 46). In a later cartoon, he imagined yet another scenario, which the caption sums up: "Imprisoned for having failed to show due respect for the public" (fig. 47). The small creature on the

43 Anon., caricature of paintings in the Salon of 1874, including Manet's *Railway* (see fig. 1), *La Vie parisienne*, 9 May 1874, Bibliothèque nationale de France, Estampes, Paris.

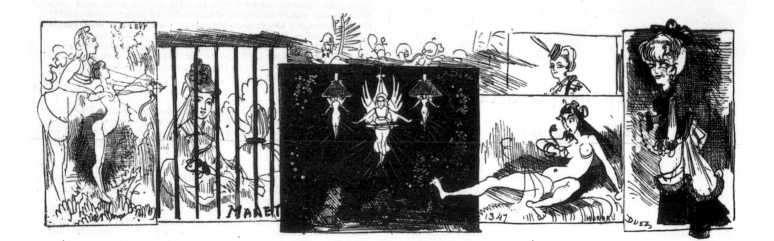

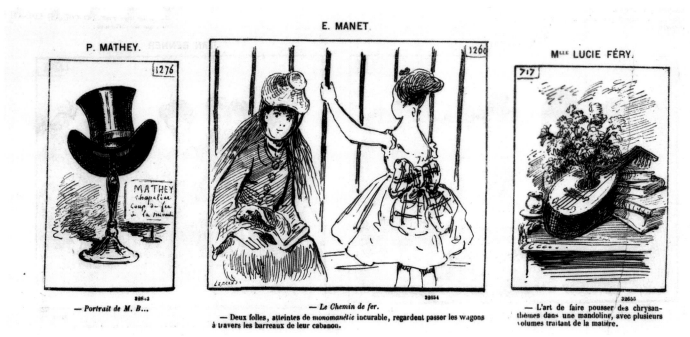

44 Stop, "The Salon of 1874 by Stop," *Le Journal amusant*, 13 June 1874, Bibliothèque nationale de France, Estampes, Paris (cat. 79); the detail includes "The Railway. Two madwomen, gripped by incurable *monomanetmania*, watch the rail cars through the bars of their cell,"

45 Bertall, "Bertall's Tour of the Salon of 1874," *L'Illustration*, 23 May 1874, Bibliothèque nationale de France, Estampes, Paris (cat. 77); the strip includes "Today's Special," by de Nittis (see fig. 48) and "The Railway, by M. Manet. Or, the departure of M. Faure for England, which accounts for the pained expressions of the figures.—It's not much fun for M. Manet either,"

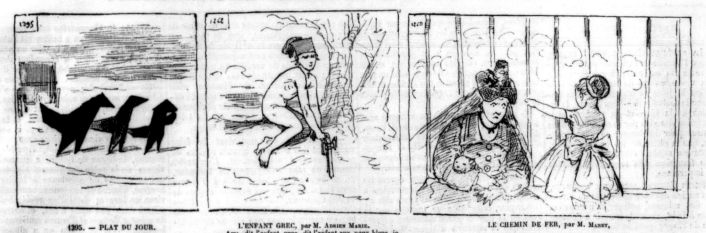

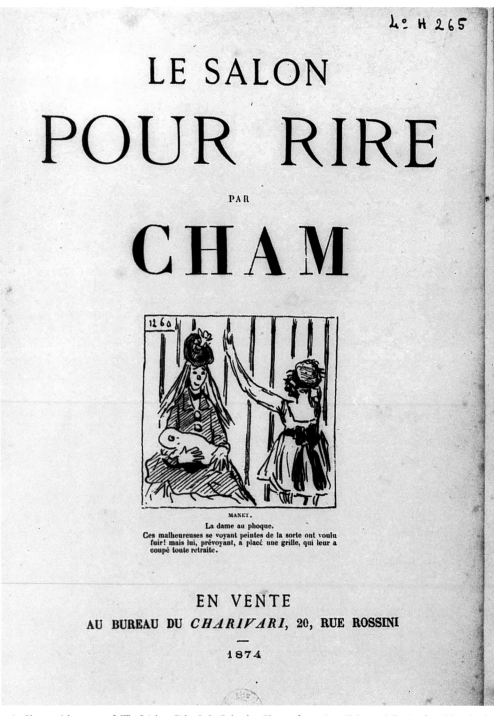

46 Cham, title page of *The Lighter Side of the Salon*, by Cham, featuring "Manet. The Lady with a Seal. The poor things, seeing themselves painted like this, have tried to escape! In anticipation, he has put in a railing that cuts off all possibility of retreat," album of caricatures, May 1874, Bibliothèque d'Art et d'Archéologie, Fondation Jacques Doucet, Paris (cat. 76).

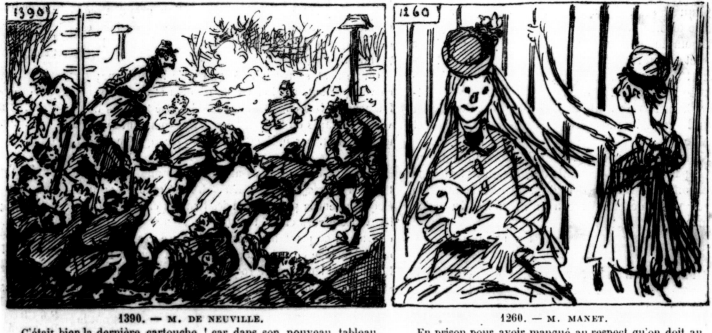

1390. — M. DE NEUVILLE.

C'était bien la dernière cartouche ! car dans son nouveau tableau de cette année pas un ne tire un coup de fusil.

1260. — M. MANET.

En prison pour avoir manqué au respect qu'on doit au public. (C'est-justice.)

47 Cham, *Cham's Comical Critique*, from *Le Monde illustré*, 6 June 1874, Bibliothèque nationale de France, Estampes, Paris (cat. 78); the detail includes "M. Manet. Imprisoned for having failed to show due respect for the public. It's only fair."

young woman's lap was variously interpreted—as a seal or a rabbit—but most commentators agreed that it was poorly painted.

The figures and what they were meant to be doing also posed a major problem for the Salon public. What was the little girl looking at so intently that she turned her back on viewers of the picture? In any normal genre scene, she would be showing off her pretty face and dress, and the artist would have placed her in some charming or amusing relationship with other people or animals. A picture of this kind by Giuseppe de Nittis was catalogued under the catchy title *Goodness, It's Cold!!!* (fig. 48), and hung in Room 20, next to the one in which Manet's *Railway* and another painting by de Nittis were displayed.[38] A comic commentary referred to both works: "Here's a curious picture: a woman and a little girl in a cage; a real cage with bars. . ."—"No, it looks like a cage, but they're behind some garden railings; it's the famous Manet."—"At first sight, they look

48 Giuseppe de Nittis, "*Goodness, It's Cold! !!*", Salon of 1874, Goupil photograph, Bibliothèque nationale de France, Estampes, Paris.

49 Anonymous caricature of paintings in the Salon of 1874, including de Nittis (see fig. 48) *La Vie parisienne*, 9 May 1874, Bibliothèque nationale de France, Estampes, Paris.

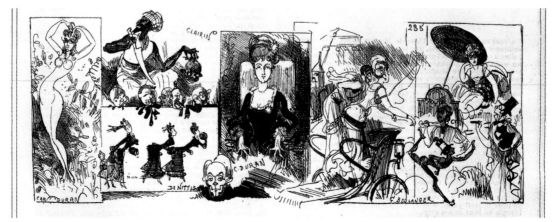

just as if they're in prison." And of the de Nittis: "So sweet, those shivering women out for a walk, in that freezing weather. . ."—"And one can just hear the one who holds the child's hand saying: 'Hurry up and you won't feel the cold'" (figs. 43, 49)—a telling demonstration of the public's demand for legibility.[39]

Even the alleged subject of Manet's picture—the railway—is glimpsed only through the infamous railings, and its traffic is merely denoted by the cloud of white smoke and steam that drifts up from an invisible train. Indeed, the smoke obscures completely a large part of the interesting or picturesque background that Salon viewers expected to see. Critics reviled Manet's trivial "modern" subject matter, incoherent composition, and the inadequacy of his drawing and application of paint to canvas. At the previous Salon, *Le bon bock*, which belonged to a recognizable Dutch tradition of figure painting, had won him general support (fig. 156).[40] Now, the incorrigible Mr. Manet was up to his old tricks with the kind of violent illumination and bold, flat colors that had shocked the public when he showed *The Balcony* at the Salon of 1869 (Musée d'Orsay, Paris).

Of course, some critics supported Manet and saw the qualities in *The Railway*. Zola, significantly, had almost nothing to say about this picture, probably because it lacked a clear subject and social context and because it resisted the rather simplistic formal analysis on which he often relied. He nevertheless praised its "charming" color scheme and reiterated his admiration for Manet as "one of the few original artists our school can boast."[41] Perhaps the most appreciative and perceptive view of the picture was expressed by Ernest Chesneau, who pointed to Manet and Alfred Stevens as the only artists who were "bold enough, strong enough, sure enough of themselves and their theme to dare to give Parisian life the place it deserves to occupy." He added that "M. Manet, whose summary methods may appear brutal at times . . . seems concerned above all to express modern life exactly as it is and to free his art from technical conventions."[42] Enlarging on the text published some eighteen months earlier, Philippe Burty noted with approval aspects of the picture's realism and explained the flattening effect of reflected light on flesh, although he criticized the lack of finish in the hands (a frequent complaint). Burty emphasized that Manet had achieved his realistic effects without concession to picturesque artificiality in the poses and arrangement, and he underlined Manet's determination "to paint truly in the open air and not simply in a glazed environment."[43]

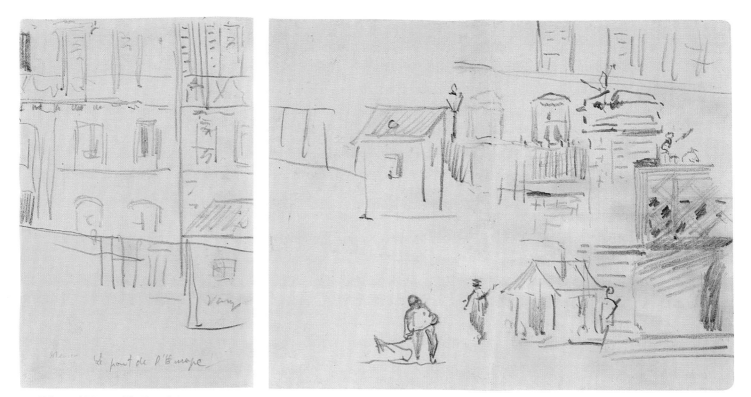

50 Edouard Manet, *The Pont de l'Europe and Rue de Saint-Pétersbourg*, 1872, graphite on pages from a sketchbook, Jean-Claude Romand collection (cat. 20): sketches for *The Railway* (fig. 1).

The question of exactly how and where the picture was painted is important. Aspects of the painting's construction throw doubt on statements by contemporary critics that it was painted in the open air. On two pages from a small notebook (fig. 50), Manet made a vivid, sketchy graphite drawing showing the pillar of the pont de l'Europe with an indication of the façades behind it, and a railway hut with two signalmen down on the tracks below. On the verso of the lefthand page the façades continue as far as the entrance door of 2 rue de Saint-Pétersbourg, the door and balcony consoles above it as clearly identifiable as they are in the painting and the contemporary photograph (figs. 1, 42). Manet's drawing omits the railings, but it was clearly made on the spot, probably at ground level in the little back garden at 58 rue de Rome. However, a change in the relationships between the signalmen's hut and the stone pillar from drawing to painting suggests that the painting may correspond with a higher viewpoint, possibly with the view from Hirsch's fourth-floor studio.

Technical examination of the painting shows that Manet shifted the railings in the course of work (their spacing varies considerably, particularly on the left), just as he had done with the bars in *The Balcony* of 1868. The black velvet band around Victorine's neck was originally slightly higher, a blouse covered up her neck, and less of her loose hair fell over the shoulder nearest the child. The child's hair was quite different, tied up with a ribbon in a ponytail, while her much plumper quarter-profile overlapped the railing with which it is now almost aligned. At the same time, the skirt of her dress was extended on the left to obscure even more of the railway tracks and form the harmonious bell-shaped "negative space" that both separates her from and links her with Victorine. The x-radiograph of the canvas also reveals an important shift in the architectural elements in the upper left corner, where the studio window and the doors were lowered and made to feature more prominently in the background.[44]

All these adjustments suggest that the scene as we see it now is largely a studio invention, even if the first rough sketch, the *ébauche*, was made out of doors. The garden is so narrow—only four meters (thirteen feet) separate the building from the low stone wall—that Manet could hardly have set up his easel and had sufficient space to view both his canvas and the motif unless he painted within the *atelier* which lies "behind" the viewer. Moreover, although the details of the wall and the iron railings are faithfully rendered, Victorine could not have settled herself comfortably, with a puppy and a book on her lap, on the five-inch surface that lies between the front edge of the wall and the railings. Furthermore, given the height of the houses along the railway cutting and their northeasterly exposition, only morning sunlight from the general direction of the bridge could have reached the figures. The shadow cast by Victorine's earring on her neck can only have come from a light source to the left, an impossibility in the garden setting but clearly feasible if she were sitting beside a window in Hirsch's or Manet's studio. Burty's statement that the picture was still unfinished when he saw it in Manet's studio, probably in October 1872, and the fact that Manet sent it not to the Salon of 1873 but to that of 1874 strongly suggest that he worked on it over a period of time.

The canvas has an effect of great luminosity and spontaneity. That was indeed part of the problem for Salon viewers. In many areas, the paint was applied in broad strokes, and the artist made no attempt to blend and shade the passages from light to dark or from one tone to another. The paint is sometimes used very thinly; the white ground of the commercially prepared canvas shows through in many places. Elsewhere, the paint

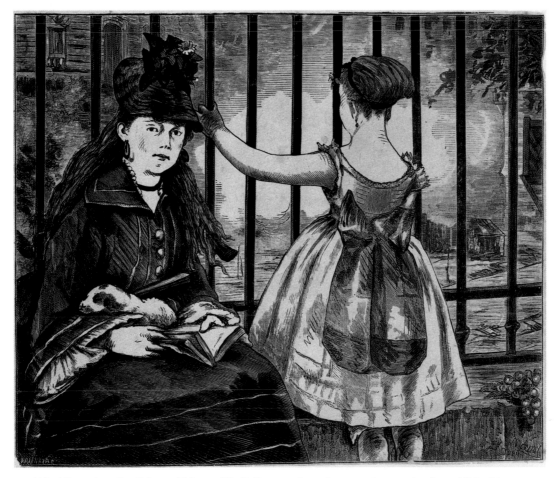

52 Alfred Prunaire after Edouard Manet, *The Railway*, c. 1873–1874, wood engraving (unpublished in Manet's lifetime), Bibliothèque nationale de France, Estampes, Paris (cat. 57).

has been laid on with a loaded brush to form areas of relatively high impasto. There is evidence that paint layers were applied "wet-in-wet," with much emphasis on texture and the quality of actual brushstrokes and with great variation in the use of very rich or very lean, almost dry paint. Typically, this variety and the effect of "careless freedom" conceal Manet's efforts to create an absolutely rigorous composition, to which the many subtle changes bear witness. Manet was a master at covering his tracks, apparently because he did not want to reveal the enormous effort that went into his pictures. "Don't make it feel like a punishment, no, not punishment!" he told one young artist.[45]

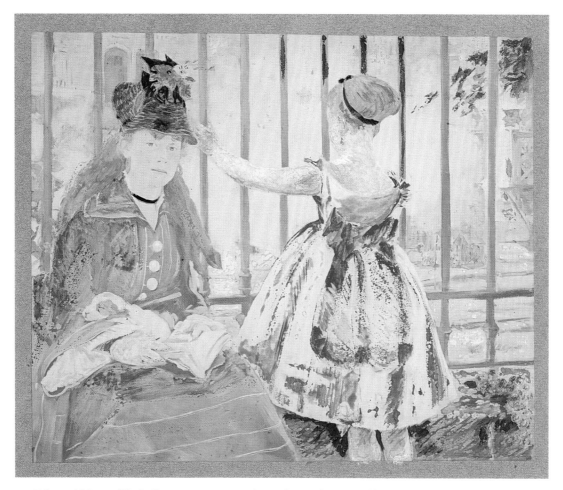

53 Edouard Manet, *The Railway*, c. 1873, watercolor and gouache on an albumen print by Godet, courtesy of Durand-Ruel & Co., Paris (cat. 22).

One of the most radical and shocking aspects of the picture for contemporary viewers must have been Manet's foregrounding of the figures. The close-up grid of the railings, a device adopted from Japanese prints, Victorine's level gaze, and the fact that both figures are cut off at the legs by the picture frame, force the viewer to see them as part of his or her space. Manet's insistent yet enigmatic presentation of the figures, and the particularities of their poses and attire have tempted later critics and art historians to consider deeper levels of meaning within the picture. They have been reluctant to accept a straightforward interpretation which simply suggests that the little girl has turned to watch a passing train, and has dumped her puppy on Victorine's lap or interrupted the reading of a book whose place is marked by her governess's finger. Aware of the deeper, usually hidden significance of many of Manet's paintings, and also of the fact that the artist absorbed so much from the Old Masters in his early years, this apparently simple scene has been and continues to be the subject of analysis and interpretation.[46]

A purely formal analysis of the picture might have led to attention being paid to the background motif long ago. The direction of the child's gaze and the line of her raised arm link up with the curving brim of Victorine's straw bonnet and lead the viewer's eye inexorably to the distant door to Manet's studio. Even the strangely "blank" center of the picture, the mass of billowing smoke or steam, should serve to attract attention to this peripheral element. However, the insistent repetition of the railings and the impact of Victorine's alert gaze draw the spectator's attention forward and distract it from the distant view. In this sense, the composition is a masterpiece of playful perversity. In general terms, the picture can now be seen as a celebration by Manet of his new studio and a reflection on his painterly practice which had been, and would continue to be, studio based, even in the case of ostensibly *plein air* pictures.

In terms of the topography of the picture, one might say that Manet deserved to be misunderstood. A wood engraving by his friend Alfred Prunaire shows clearly that the latter did not understand the work and that he woefully misinterpreted the details of the architectural background (fig. 52). Prunaire probably worked from a photograph of the completed painting made by Manet's habitual studio photographer Godet.[47] One of Godet's photographic prints was embellished by the artist with gouache and watercolor (fig. 53). It bears the stamp that was applied to the works in Manet's studio after his death, and when the picture itself was sold to Faure, Manet must have made this unique souvenir of it for himself.

54 View from the rue de Rome garden, photo, Musée d'Orsay, Paris; the 1886 parcels
depot and 1936 postal building blocking the view of 2 and 4 rue de Saint-Pétersbourg.

Less than fifteen years after the picture was completed, a large one-story parcels
depot was constructed over the railway tracks, alongside the part of the rue Mosnier
that lay directly beside the steep drop to the bottom of the cutting; it filled the space
between the pont de l'Europe and the first house that Monsier had built beside the
railway, to which the city authorities assigned the number 7. The parcels depot is clearly
seen in engravings of 1886 and in postcard views of the early 1900s (figs. 40, 65). It
effectively blocked the view from the rear of the properties on the rue de Rome to the
houses on the rue de Saint-Pétersbourg, and it may have accounted in part for the fact

that they were never positively identified in Manet's painting, although Hirsch's address was well known. Recognition of the site was further compromised when part of the parcels depot was replaced by a very large postal sorting office built in 1938–1951 to plans by Léon Azéma (fig. 54). The continuing development of the area around the pont de l'Europe and the Gare Saint-Lazare succceeded in obscuring the view of Manet's studio as effectively as the smoke and steam had blurred his contemporaries' view of the artistic significance of his painting of *The Railway*.

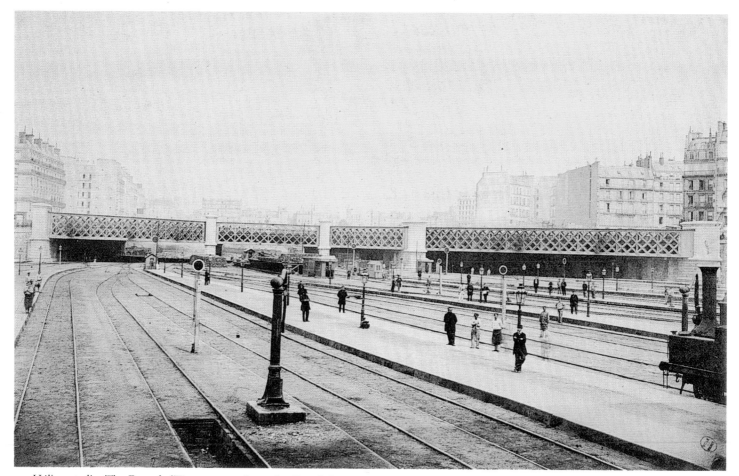

55 Hélios studio, The Pont de l'Europe seen from the Gare Saint-Lazare, albumen print, c. 1868, Bibliothèque historique de la Ville de Paris, Paris (cat. 74).

Artists in The Europe District: Caillebotte and Monet at The Gare Saint-Lazare

A New Site: The Europe District

The area in which Manet both lived and worked from the early 1870s until the end of his life was known as the *quartier de l'Europe*, the Europe district. Its development dates to the early nineteenth century. The city of Paris had grown over the centuries as a series of concentric rings around its original nucleus on the Ile de la Cité, as one can see from tourist maps showing the city and its monuments in 1864 and in 1867, the year of the *Exposition Universelle* (figs. 56, 57). The massive fortifications that were to play so vital a role in the defense of Paris in 1870 were erected in the 1840s (figs. 17, 18). They enclosed the whole city at a distance of one to three kilometers beyond the old limits, and the earlier *barrières* (customs gates) on what were then known as the outer boulevards—at Courcelles, Monceau, Clichy and so on—were replaced by new *portes* (city gates) that still bear that designation on today's outer boulevards. As we have seen, Manet's studio on rue Guyot lay just north of the Courcelles barrier on the suburban *plaine de Monceau* near the Batignolles district (figs. 5–7). The Europe district lies to the south of the Courcelles and Batignolles boulevards. At the beginning of the nineteenth century, the whole area was little more than open countryside divided into small holdings; nursery gardens predominated, but there were a few private residences, a

56 Hilaire Guesnu, *Souvenir of the New Paris*, 1864, colored lithograph published by A. Logerot, Bibliothèque nationale de France, Cartes et Plans, Paris (cat. 64).

57 Hilaire Guesnu, *Getting Around Paris Without a Carriage: New Pedestrian Guide*, 1867, lithograph published by Michel, Bibliothèque historique de la Ville de Paris, Paris (cat. 66).

slaughterhouse, and a market. Little Poland lay in the western sector, the famous Tivoli Gardens in the east.

By 1824 two speculators, Jonas Hagerman, a banker, and Sylvain Mignon, an entrepreneur, had acquired almost the whole area. Plans for a tracery of roads named after the capitals of Europe were approved. One development centered on the Roule slaughterhouse to the west. The other, bounded on the east by the rue de Clichy and on the south by the rue Saint-Lazare, had the star-shaped place de l'Europe at its heart (fig. 58).[48] The first railroad in Paris had been opened in 1835, with its embarkation point beside the place de l'Europe, where the Gare Saint-Lazare would later be developed.[49] The train station gave the area fresh impetus, but real development did not begin until the 1860s, when Little Poland was razed, streets were built or completed, and apartment houses were constructed. The new properties all conformed to the standards regarding height and proportions that were baron Haussmann's most

58 Alexis Donnet, topographical map of Paris, 1837, Bibliothèque nationale de France, Cartes et Plans, Paris; detail showing the undeveloped Europe district, the projected boulevard Malesherbes, and the railway with the boarding point at the place de l'Europe and a planned station on the rue Tronchet.

important contribution to the development of Paris and that are still such a pronounced feature of the Europe district.[50]

The Gare Saint-Lazare and The Pont de l'Europe

The railway enabled Parisians of all classes to travel for work or pleasure, to move into the city and out to the suburbs. Illustrated tourist maps portray the city's many stations in great detail and identify the trains connecting them with suburban or main line destinations (figs. 56, 57). The first line to be opened ran northwest from the place de l'Europe in Paris to Saint-Germain-en-Laye on the left bank of the Seine. A lithograph of 1837 (fig. 59) shows, to the left, the original station on the place de l'Europe and, to

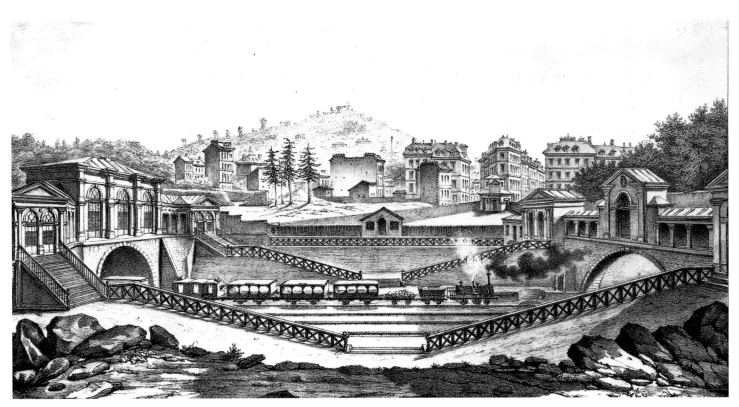

59 Victor Hubert, *Paris–Saint-Germain Railway, Side View. Place de l'Europe, Paris.,* dated 1837, lithograph, published by Lemercier 1838, Bibliothèque nationale de France, Estampes, Paris (cat. 70).

the right, a second station on the rue de Stockholm, which ran over the railway lines; the rue de Londres and rue de Tivoli (later renamed rue d'Athènes) run off into the distance on the right, while a few private dwellings lie beyond the place de l'Europe on ground that rises toward Montmartre and its crown of windmills.

The development of the Gare Saint-Lazare is clarified in a multipart map that graphically demonstrates the changes made to the site between 1837 and 1886 (fig. 60). By 1853, the engineer Eugène Flachat had considerably enlarged the station. He added an enormous roof to span two additional sets of tracks, and he created a second tunnel for them beneath the circular place de l'Europe (fig. 61).[51] However, the most dramatic change occurred when the place de l'Europe and its tunnels were replaced by the massive pont de l'Europe and the railway cutting was decisively widened.

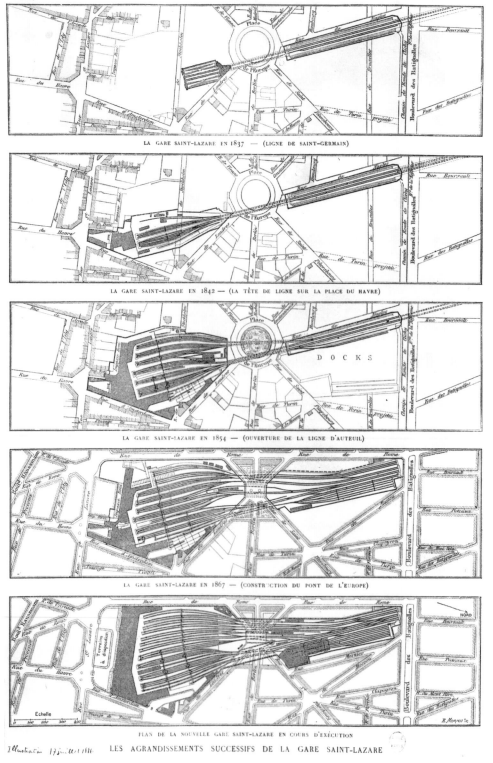

LA GARE SAINT-LAZARE EN 1837 — (LIGNE DE SAINT-GERMAIN)

LA GARE SAINT-LAZARE EN 1842 — (LA TÊTE DE LIGNE SUR LA PLACE DU HAVRE)

LA GARE SAINT-LAZARE EN 1854 — (OUVERTURE DE LA LIGNE D'AUTEUIL)

LA GARE SAINT-LAZARE EN 1867 — (CONSTRUCTION DU PONT DE L'EUROPE)

PLAN DE LA NOUVELLE GARE SAINT-LAZARE EN COURS D'EXÉCUTION

LES AGRANDISSEMENTS SUCCESSIFS DE LA GARE SAINT-LAZARE

60 E. Morieu, *Growth of the Gare Saint-Lazare over Time*, from *L'Illustration*, 17 July 1886, Musée Carnavalet, Paris; the plans show the station in 1837, 1842, 1854, 1867, and 1886 with new work under way, including the construction of the parcels depot on the rue de Saint-Pétersbourg.

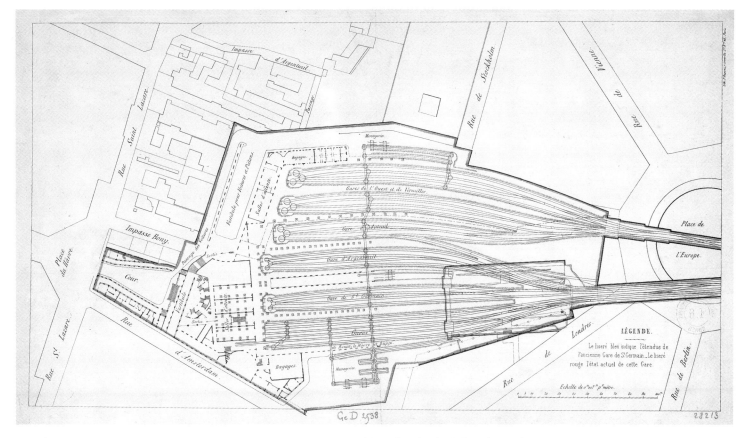

61 After Eugène Flachat, untitled plan of the Gare Saint-Lazare, as published in the *Journal des chemins de fer*, 23 July 1853, Bibliothèque nationale de France, Cartes et Plans, Paris; the plan shows the original parcels depot (*Messageries*), and the railway lines or *Gares* that extend from the area near the rue de Londres: Gare de Rouen, le Havre, Dieppe; Gare de Saint-Germain; Gare d'Argenteuil; and finally Flachat's enlargement of the Gare d'Auteuil and addition of the Gare de l'Ouest et de Versailles.

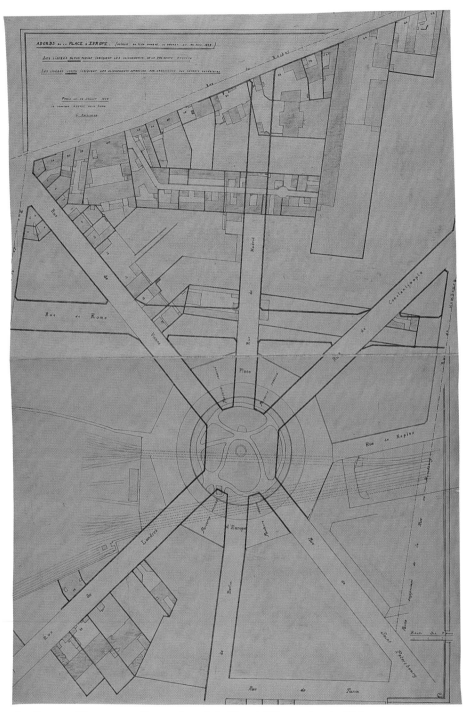

62 Georges Haussmann, *Surroundings of the Place de l'Europe*, dated 16 July 1858,
Bibliothèque historique de la Ville de Paris (cat. 72); map attached to the decree of 30 June
1859, which Haussmann signed and dated as prefect of the Seine; the new bridge is outlined
over the existing place de l'Europe, and the expropriations required for the work are indicated.

EMBELLISSEMENTS DE PARIS. — Ouverture de la rue de Rome, à l'angle de la rue Saint-Lazare et de la rue du Rocher. — État actuel des démolitions.

63 *Paris Beautified: The Rue de Rome Under Construction, Viewed from the Intersections of the Rue Saint-Lazare and the Rue du Rocher*, 1865, wood engraving, signed A. D., Bibliothèque nationale de France, Estampes, Paris.

In 1858, Haussmann signed the plans that show the great star-shaped iron bridge in outline over the existing circular structure, and the rue de Rome that was to be built immediately alongside the widened railway cutting (fig. 62). Extensive roadworks were authorized by an official decree of 1859,[52] and work on the bridge was completed in 1868, when prints and photographs commemorated the event (figs. 63–66). Building work continued, and the elevations of the properties fronting the new bridge and the place de l'Europe were not completed until 1872.[53] Further development that occurred in 1886–1889, when the architect Juste Lisch expanded the station, is seen in an engraving that shows, as an inset, the new parcels depot on the corner of the rue de Saint-Pétersbourg (fig. 67). In the space of less than thirty years the Europe district had

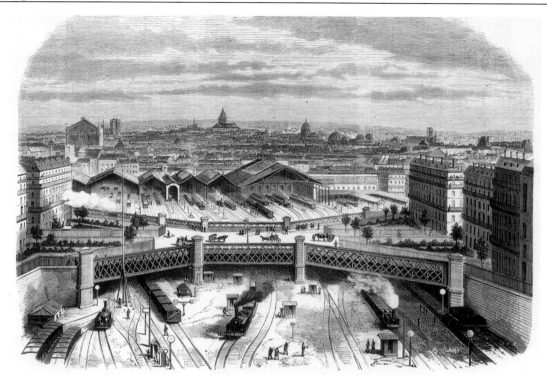

64 Auguste Lamy, *Paris. Bridge erected on the site of the Place de l'Europe, over the Western Region Railway*, wood engraving, from *L'Illustration*, 11 April 1868, Musée Carnavalet, Paris (cat. 73).

65 Georges Perrichon, *New Paris. The Place de l'Europe over the Western Region Railway*, wood engraving drawn by Bertrand, from *L'Univers illustré*, 9 October 1868, Musée Carnavalet, Paris.

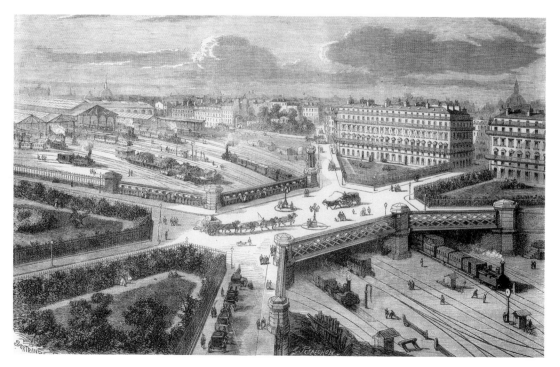

66 Hélios Studio, The Pont de l'Europe seen from the Gare Saint-Lazare, albumen print, c. 1868, Musée Carnavalet, Paris; the buildings on the Place de l'Europe were not constructed until 1869, and the advertisement for the Belle Jardinière on the end wall of 4 rue de Saint-Pétersbourg is clearly visible.

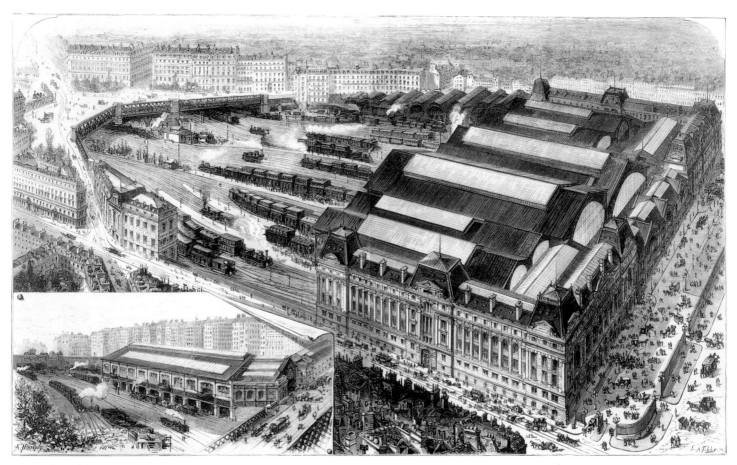

67 Emile and/or Auguste Tilly, *Bird's-eye View of the New Gare Saint-Lazare Now Under Construction*, wood engraving, drawn by Adolphe Normand, from *L'Illustration*, 17 July 1886, Musée Carnavalet, Paris (cat. 75); the inset shows the parcels depot on the corner of the rues de Saint-Pétersbourg and Mosnier.

been transformed. From a hilly, almost countrified area away from the centre of Paris, it had developed into an urban environment with a closely knit pattern of old and new streets (fig. 77). Haussmann's plans had ensured that these were lined with densely populated apartment buildings that lay around the busiest railway station in the capital.

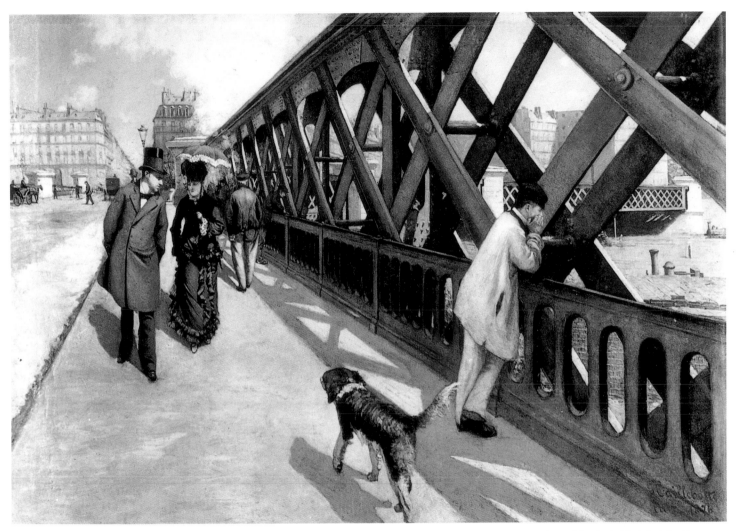

68 Gustave Caillebotte, *The Pont de l'Europe*, dated 1877, third Impressionist exhibition 1877 (2), 124.7 × 180.6 cm, Musée du Petit Palais, Geneva.

On The Bridge and In The Street

In 1866, long before Edouard Manet and Alphonse Hirsch took studios near the place de l'Europe, the wealthy Caillebotte family purchased a building plot at the intersection of the rues de Miromesnil and de Lisbonne in the eastern sector of the Europe district, some distance from the railway station and the bridge.[54] Gustave Caillebotte, then a

69 Caillebotte's viewpoint on the present-day rue de Vienne beside the altered bridge, photograph, Musée d'Orsay, Paris.

young law student, became an artist after the Franco-Prussian War and in 1874, the year of his father's death, a spacious studio was added to the family home. As a very wealthy young man, Caillebotte was instrumental in helping his Impressionist friends and colleagues, particularly Monet. Famous for his bequest of Impressionist paintings to the State, his own paintings have recently become much more widely known.[55] Impressive and exceptionally interesting in their own right, Caillebotte's finished works are executed in a distinctively realistic style that often contrasts with the freedom and apparent spontaneity of his preparatory sketches. He exhibited at the second Impressionist

70 *Paris VIIIe. Rue de Vienne. – Rue de Rome*, postcard, 1905, Bibliothèque nationale, Paris; view up the rue de Vienne and the rue de Saint-Pétersbourg across the Place de l'Europe with the bridge on the right.

71 *Paris. – Pont de l'Europe (Gare Saint-Lazare)*, postcard, c. 1905, Musée Carnavalet, Paris; view overlooking the site of Caillebotte's picture.

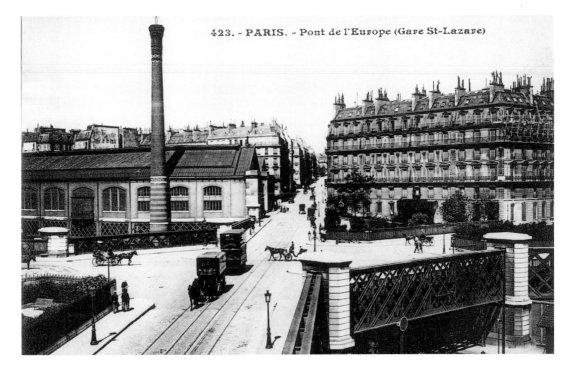

exhibition in 1876 and was responsible for much of the organisation of the third exhibition in 1877, at which he showed two monumental views of the Europe district. The earlier, titled *The Pont de l'Europe* (fig. 68) depicted the structure that had so transformed the area, while the second was a panoramic street scene, set less than a hundred and fifty meters up the rue de Saint-Pétersbourg, which he called *Paris Street, Rainy Day* (fig. 76).

A ten-minute walk from Caillebotte's home and studio along the rue de Lisbonne and rue de Madrid takes one directly to the pont de l'Europe. However, Caillebotte chose to paint the bridge not from its central axis but from the much more striking view afforded by the rue de Vienne. That view highlights the massive iron superstructure of the bridge and leads the eye across the place de l'Europe and up the rue de Saint-Pétersbourg. The huge girders of the original bridge have since been replaced with much lighter railings, and the great stone pillars, with the exception of the outer ones, have been removed to the level of the supporting substructure (fig. 69). But its original appearance can be seen in many contemporary prints, photographs, and paintings and in postcards from the early 1900s (figs. 70, 71). The bridge was a major focus of activity, since so many streets crossed there and the heavy railway traffic made it a meeting place for all classes of society. The constantly changing scene within the station and on the tracks attracted the spectators who are visible in contemporary photographs (fig. 66) and who figure in all paintings of the site.[56]

A small and vibrant sketch (fig. 72) suggests that Caillebotte was enthralled by the light and space of the site and that he captured on canvas a first response to the scene, an "impression" that would develop into a major painting. On further examination, however, it becomes clear that the sketch is already the result of considerable reflection and adjustment to the realities of his chosen view. A series of traced drawings (fig. 73), probably based on a photograph, reveal the way in which Caillebotte twisted the perspective view so that the roofs and façades of the distant houses lie horizontally on the picture plane and contrast to maximum effect with the diagonal lines that thrust into depth along the street and the structure of the bridge.[57] The façades of the houses on the rue Mosnier to the left, on the place de l'Europe itself, and on the rue de Londres to the right (where the longest arm of the bridge, punctuated by white stone pillars, splays out toward the Gare Saint-Lazare) are balanced against the steep perspective pull and thrust of the foreground rue de Vienne and distant rue de Saint-Pétersbourg.

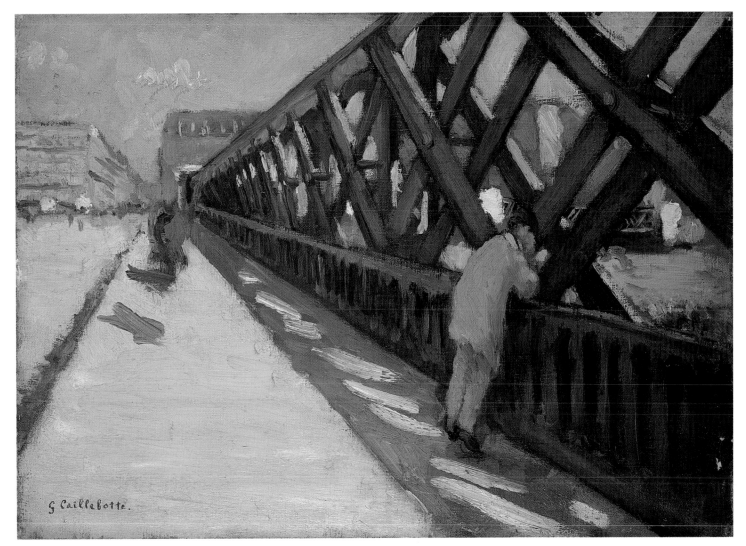

72 Gustave Caillebotte, preliminary sketch for *The Pont de l'Europe* (fig. 68), 1876–1877, 32 × 45 cm, Musée des Beaux-Arts, Rennes (cat. 3).

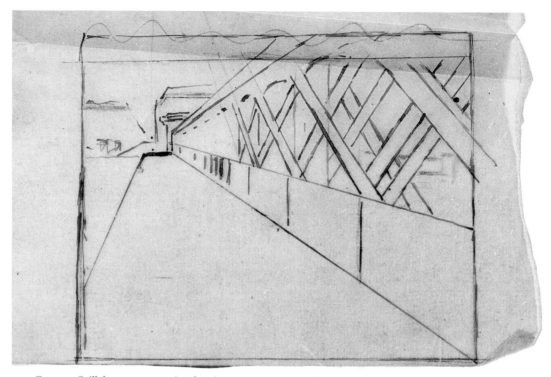

73 Gustave Caillebotte, perspective drawing on tracing paper for *The Pont de l'Europe* (fig. 68), private collection.

Impressed by the strong abstract patterns formed by bridge, streets, and buildings, Caillebotte was able to combine a convincingly "realist" vision of the scene with a complex and subtle construction in which the various elements are manipulated to create the desired artistic and emotional effects. The drawings—studies in perspective and linear construction—are devoid of human or animal life. The sketch itself, painted with richly loaded wet-in-wet brushstrokes, already shows evidence of much rethinking. It includes only one fully defined figure, that of the worker who looks down at the tracks. Another, probably that of a single woman advancing along the sidewalk, is partly glimpsed in a repainted area on the sidewalk, partly revealed in the x-radiograph of the sketch.[58] That Caillebotte already had a clear idea of the figures that were to find their place in the final composition is suggested by the two disembodied shadows that lie on the sidewalk like so much litter, waiting to be "attached" to the figures that would later cast them. All the figures were worked out in a separate series of drawings and oil studies for insertion into the composition.

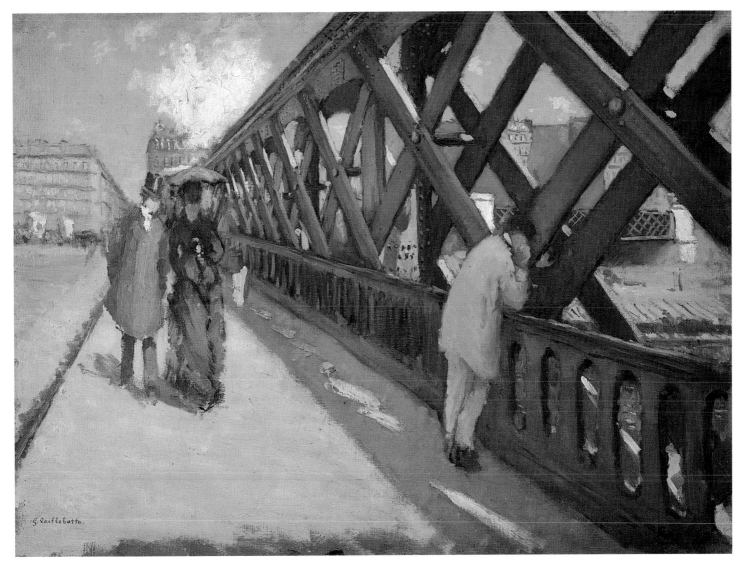

74 Gustave Caillebotte, final sketch for *The Pont de l'Europe* (fig. 68), 1876–1877, 54 × 73 cm, private collection (cat. 4).

A final working sketch shows the almost fully defined composition (fig. 74)—almost, because the relationship of the man and woman on the sidewalk still differs from their presentation in the large painting (fig. 68). In the precise but lively and freely brushed working sketch, the figures appear to be walking together as a couple. In the final painting, the woman is distanced and set back from the male figure, in a way that corresponds with the positions of the sidewalk shadows noted in the earlier sketch. The impeccably dressed bourgeois *flâneur*—recognized by a contemporary critic as a portrait of the artist[59]—overtakes and half turns back toward the lady with a parasol who thus appears less a companion and more probably a soliciting prostitute. The man, his ear and sharp-angled jaw serving as the vanishing point for the road, sidewalk, and houses on the rue de Saint-Pétersbourg, is the focus of energy. His attitude and gaze connect the *dramatis personae* in the scene and set up a dynamic contrast with the blue-bloused, cloth-capped worker leaning on the bridge, whose pose relates to that of the other worker seen from behind. The latter is represented in the working sketch by just two quick strokes of light and dark blue that indicate his trousers.

Swiftly painted, with a heavily impasted cloud of smoke rising over the bridge and brilliant sunshine throwing the bolts on the girders into sharp relief, the working sketch incorporates solutions to problems in other studies, such as the stretching out of the bays in the guard rail at lower right, in order to provide a glimpse of the station yard.[60] It must have immediately preceded the huge exhibition canvas. Here, in a process akin to the one adopted by Fantin for his large Salon pictures (fig. 8), Caillebotte eliminated the lighter touches, and toned down his coloring; he also sharpened the elements of social satire and alienation. It is little short of a miracle that, despite his almost obsessive attention to exact topographical detail and his equally strong interest in the construction of his painting, Caillebotte was able to retain in the large-scale work much of the excitement and sensitivity that are a feature of the sketches.

The Pont de l'Europe depicts a sunny, early afternoon scene with touches of bright color and dark shadows and a spatially dynamic composition. Another, very different portrayal by Caillebotte of the same site focuses on a section of the massive iron bridge (fig. 75). All three figures shown—two bystanders and a pedestrian striding briskly past—are abruptly cropped by the frame. The composition is structured by the trellis. Through it we see a delicate (and fictional) vertical tracery of train tracks that leads the eye back toward the station. The roof of Charles Garnier's new Opera house can be

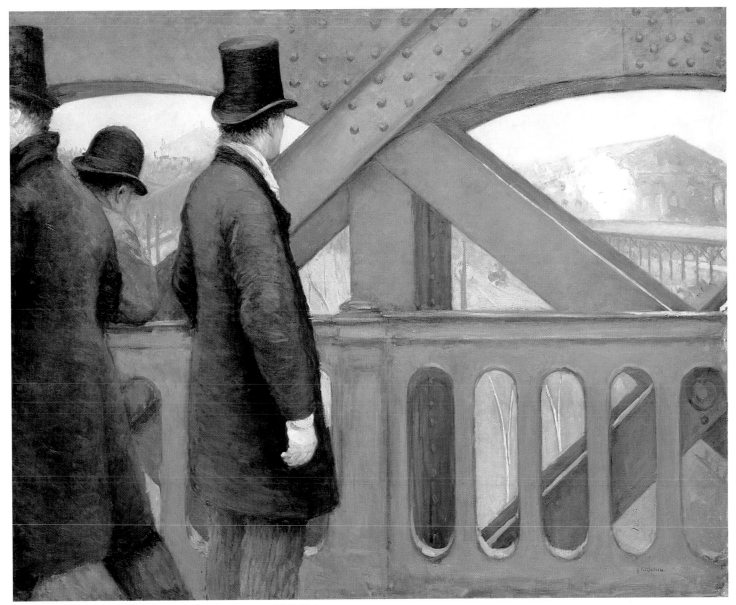

75 Gustave Caillebotte, *On The Pont de l'Europe*, c. 1876–1880, 105 × 131 cm, Kimbell Art Museum, Fort Worth, Texas (cat. 5).

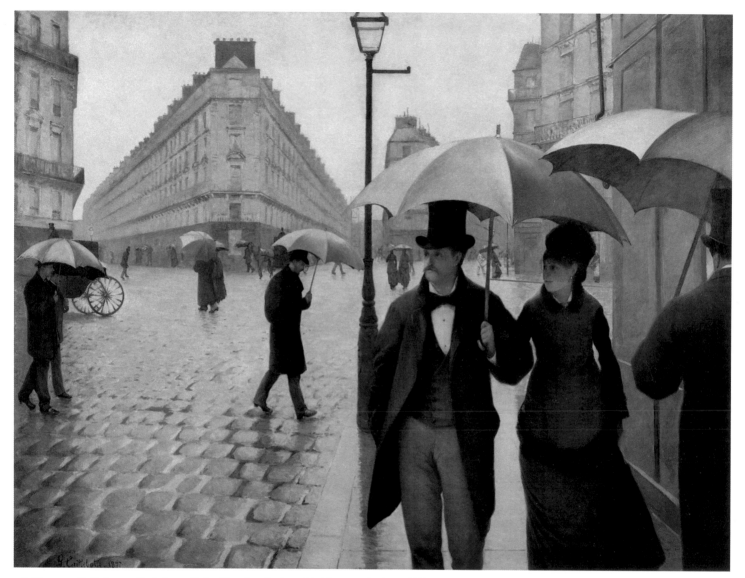

76 Gustave Caillebotte, *Paris Street, Rainy Day*, dated 1877, third Impressionist exhibition 1877 (1), 212 × 276 cm, Art Institute of Chicago.

77 *Paris in 1871*, plate XII detail, *Travaux de Paris 1789–1889*, Bibliothèque historique de la Ville de Paris, Paris (cat. 69); the map shows roads built between 1854 and 1871 (yellow and red); the year is the date of completion.

glimpsed on the left, while Flachat's huge station roof looms in the background on the right. The melding of men and metal in this almost monochrome blue-grey picture conveys a sense of the male world of trade and industrial progress. Its relationship with Manet's *Railway* has been remarked,[61] but the relationship underlines the differences between the two artists. Manet's commitment to direct confrontation with the spectator and his emphasis on the individuality of his sitters, even while he withholds information about them, contrasts with Caillebotte's treatment, which makes the figures anonymous representatives of the various social classes who people these urban spaces.[62]

The Pont de l'Europe suggests a warm and sunny day. In *Paris Street, Rainy Day*, the picture generally regarded as Caillebotte's masterpiece (fig. 72), the figures are warmly dressed for winter. After capturing his view of the pont and place de l'Europe from the rue de Vienne (figs. 68, 71), Caillebotte had only to take a short walk past Manet's studio and up the rue de Saint-Pétersbourg, the street seen in deep perspective in his picture, to reach the huge intersection then known as the carrefour de Moscou. As a result of

78 Gustave Caillebotte, study for *Paris Street, Rainy Day* (fig. 76), 1876–1877, graphite on tracing paper, private collection, New York (cat. 6).

extensions to the rues de Moscou and de Turin and the opening of the rue Clapeyron, no fewer than eight streets converged there at a point that until 1869 had been only very partially developed (fig. 77).[63] Still farther up the rue de Saint-Pétersbourg, between the rue de Florence and the place Clichy, was the Manet family's apartment at number 49 (now 41).[64] Toward the end of 1876 or early in 1877, as Manet walked to and from his studio, he would have encountered Caillebotte making prepararations for a major new work on the corner of the rue de Turin.

As in the case of *The Pont de l'Europe*, the new composition was based on a perspective study that may have been sketched initially in front of the motif or made from a photograph (fig. 78). In either case, the drawing was then worked on to define the almost abstract quality of the setting. Caillebotte also made a large oil sketch of the whole composition (fig. 79) as well as several painted studies, including a close-up detail of an area of cobblestones, and many drawings for the figures.[65] Compared with the final painting, the oil sketch is much more impressionistic, its loose, open contours

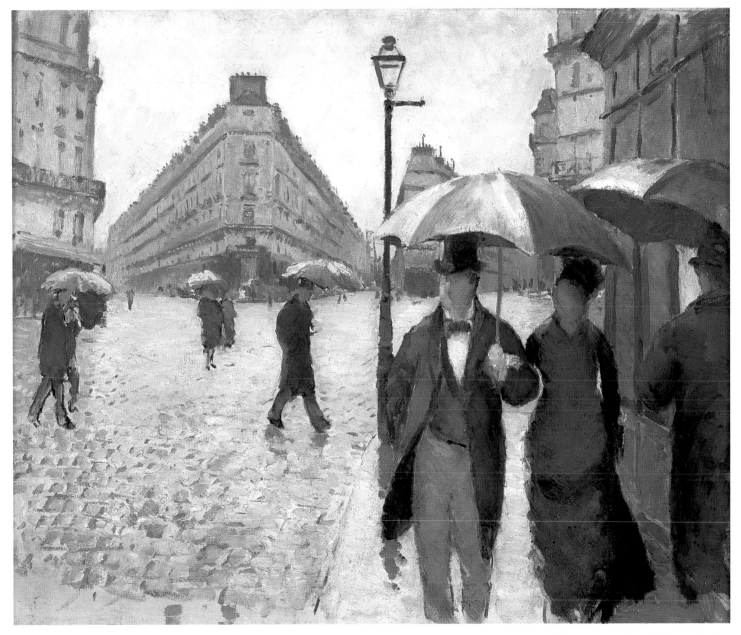

79 Gustave Caillebotte, final working sketch for *Paris Street, Rainy Day* (fig. 76), 1876–1877, 54 × 65 cm, Musée Marmottan – Claude Monet, Paris (cat. 7).

80 *Paris—The Moscou–Rue de Turin Intersection*, 1908, postcard, Bibliothèque nationale de France, Estampes; the café that Caillebotte took as his viewpoint on the rue de Turin.

achieved with diagonal brushstrokes, its atmosphere more luminous and its colours richer and more vibrant.

The very large canvas (fig. 76) was painted in Caillebotte's studio, and when *The Pont de l'Europe* and *Paris Street, Rainy Day* were shown at the Impressionist exhibition in 1877 alongside Monet's paintings of the Gare Saint-Lazare and Renoir's *Ball at the Moulin de la Galette* (Musée d'Orsay, Paris), it was obvious to the critics that Caillebotte was not a true "Impressionist" and that his canvases were as carefully prepared and finished as any academic painting. The structured composition that evolved from his perspective drawing for *Paris Street* and from the working sketch was based on a set of proportions that included use of the golden section. It enabled Caillebotte to achieve a harmonious balance between depth and surface in the two halves of his picture, between the illusion of spatial recession and the perfection of the surface rhythms that produce its magical effect.[66]

On the sidewalk at 16 rue de Turin beside the corner café that still forms an angle

81 *All Paris—Intersection of the Rues de Moscou, Clapeyron and de Turin*, postcard, c. 1905, on the left the block
that appears in perspective in Caillebotte's picture.

with the rue de Moscou, one can stand on the spot where the view of the crossroads
with its diverging streets and vanishing perspectives exactly corresponds with
Caillebotte's painting. Postcards of the early 1900s show that the buildings have
changed little since then (figs. 80–82), and the whole site has remained remarkably true
to its Second Empire character. *Paris Street, Rainy Day*, with its many figures crisscross-
ing the vast intersection, suggests the comings and goings not only of ordinary, anony-
mous passersby in the great metropolis but also of the individual inhabitants of a
quartier that included such artists as Manet and Monet, who was working a couple of
corners away on the rue Moncey and who had his home, after 1878, on the rue
d'Edimbourg just off the rue de Rome. There were also writers and poets like Mallarmé,
who in the early 1870s lived on the rue de Moscou; architects, many of whom designed
and built the houses in which they lived; and lawyers like Manet's brother Gustave.

Although Caillebotte to some extent stresses the anonymity of the isolated figures

27. PARIS VIIIe arr. — Rue de Turin. - Rue Clapeyron.

82 *Paris VIIIe—Rue de Turin—Rue Clapeyron*, c. 1905, postcard, Bibliothèque nationale de France, Estampes, Paris; view of the buildings that appear in the right half of Caillebotte's picture.

sheltering from the rain under their umbrellas, the particularity with which he depicts many elements of the scene, including the buildings and even the paving stones, creates a strong sense of authenticity, of "place."[67] As for the old-fashioned street-lamp that some critics found so objectionable at the very center of the composition, it would be replaced and the aspect of the junction itself altered just a year after the picture was completed: With the safety of pedestrians in mind, two traffic islands were added, each furnished with a five-branched candelabrum of the latest design, similar to those already installed on the place de l'Europe.[68] The fabric of the city, its pleasures and problems, the infinite variety of its human and material resources had become an integral part of the search by artists for contemporary themes that could address their own desire for innovation or for picturesque subjects that would please the public.

An artist constantly in search of the picturesque was Jean Béraud, a highly successful

83 Detail, fig. 79

84 Jean Béraud, *The Place and Pont de l'Europe*, signed, c. 1876–1878, 48.3 × 73.7 cm, private collection (cat. 1).

85 Norbert Goeneutte, *The Boulevard de Clichy on a Snowy Day*, etching, 1876, after the painting in the Salon of 1876 (National Gallery, London), Bibliothèque nationale de France, Estampes, Paris.

painter of Parisian scenes. He was one of a younger generation of artists, many of whom were friends of Manet, who were sometimes accused of achieving success by marketing a modified, more palatable adaptation of his style. In an undated picture (fig. 84),[69] Béraud takes the pont de l'Europe as his theme and offers a decorative, amusingly anecdotal version of Caillebotte's views. Béraud shows the bridge from across the wide expanse of the place de l'Europe, which he peoples with an array of carefully selected "types" that could have been culled from the pages of a fashion magazine. The slightly unsure relationships of scale and placement suggest that Béraud picked them out of his sketchbooks and "collaged" them onto his canvas: the young delivery boy, the well-dressed, presumably married couple, the provocatively unveiled woman at whom the

86 *Paris. – Place and Pont de l'Europe*, c. 1905–1908, postcard, Musée Carnavalet, Paris; the view along the rue de Londres shows the tall building that lacks a façade in the paintings by Béraud and Monet (figs. 84, 106, 107) and that appears complete in those by Goeneutte (figs. 87–89).

"husband" appears to glance, the pretty young woman leading a child, and in the distance the red-trousered soldier. The buildings beyond, in the panorama that seems to have become obligatory, appear to be lit by the late afternoon sun, but the action in the fore- and middle ground takes place in a strange half light, and the elegant yet insubstantial figures cast almost no shadows. Caillebotte, whose manipulations of visual space are based on close and precise observation, had taken the slope of the rue de Vienne into account when he rendered the horizontal trellis of the bridge (figs. 68, 74). Béraud, more interested in the overall decorative effect than in the detail of his scene, allows the trellis to slant like the street. He was evidently unaware of this relatively insignificant error which throws into relief the rigorously truthful perception that guided the work of such colleagues as Manet, Monet and Caillebotte, when they applied themselves to a motif.

Béraud's picture is more or less contemporary with those by Caillebotte but it is also related to several views of the pont de l'Europe by Norbert Goeneutte. Most of these

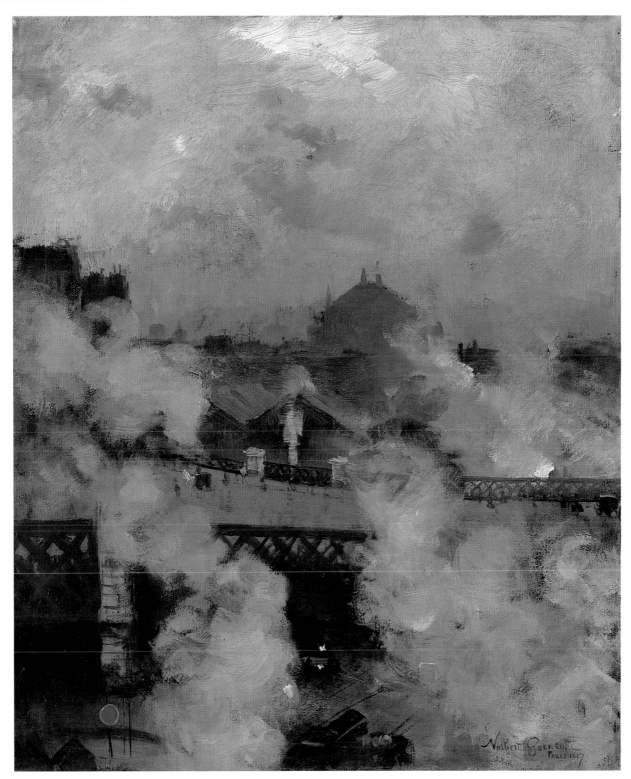

87 Norbert Goeneutte, *The Pont de l'Europe at Night*, dated 1887, 46 × 37.5 cm, Mr and Mrs Julian Sofaer (cat. 11).

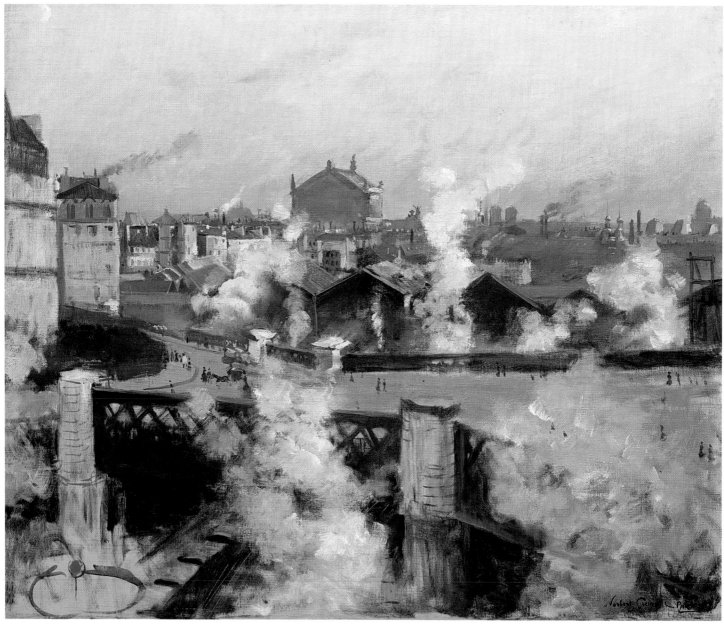

88 Norbert Goeneutte, *The Pont de l'Europe and Gare Saint-Lazare*, dated 1888(?), 45.7 × 55.5 cm, probably Salon of 1888 as *Nightfall*, Baltimore
Museum of Art, George A. Lucas Collection (cat. 12).

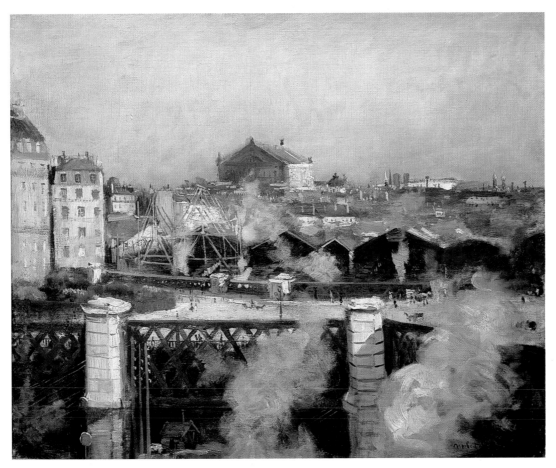

89 Norbert Goeneutte, *The Pont de l'Europe and the Gare Saint-Lazare with Scaffolding*, 1888, 38 × 46 cm, formerly Whitford Gallery, London.

were painted a decade later, from a studio window at 62 rue de Rome (figs. 87–89). In 1874, Béraud and Goeneutte both had studios off the boulevard de Clichy, near the place Pigalle. They both sent views of this old, as yet unmodernized boulevard, as seen from near the place Clichy, to the Salon of 1876 (fig. 85).[70] Caillebotte's monumental *Pont de l'Europe* (fig. 68), painted the same year, can be seen almost as a reponse to their picturesque interpretations.

In February 1887, Goeneutte took a studio in a building that had been specifically designed for artists. The property at 62 rue de Rome, just two doors away from Alphonse Hirsch's studio, was built and owned by a contractor who worked for the city of Paris

90 Scaffolding on the roofing extension of the Gare Saint-Lazare, photograph dated July 1888, *La Vie du Rail* (Falaise Collection), Paris.

and had constructed the great masonry pillars of the pont de l'Europe.[71] Georges Clairin, son of the builder, became one of the most fashionable artists and decorators of his day, and his father provided him with studio spaces in the building at the rear of the property, overlooking the railway tracks. When Norbert Goeneutte moved into a studio on the third floor, he commanded a superb view of the pont de l'Europe, the Gare Saint-Lazare, and the panorama south toward Paris (fig. 87). Oil paintings and etchings reveal his fascination with this motif, which he depicted at different times of day. He had already shown a pastel of *The Pont de l'Europe* at the 1884 Salon. During his first year at 62 rue de Rome Goeneutte painted the view from his window and also made an etching that recalls views of the bridge by Béraud and Caillebotte.[72] A small poetic canvas (fig. 87), and a larger, freely brushed painting of a similar scene (fig. 88), both signed and dated 1887, may be related to pictures that he exhibited at the Salon: *Dusk in Paris* in 1887 and *Nightfall* in 1888.[73] A much more precisely rendered view and a small etching show wooden scaffolding that was erected for alterations to the station roofs in 1888–1889 figs. 89, 90).[74] When Louis Anquetin moved into the studio below Goeneutte's in 1889,

91 Louis Anquetin, *The Pont de l'Europe*, dated 1889, pastel, private collection.

his dated pastel depicts a similar view in the radically simplified style that the young Nabi artists had just adopted (fig. 91).[75]

The move of a group of young artists from the older areas of Clichy, Montmartre, and Pigalle to new studios in the Europe district illustrates the close connections between their lives and their living and working spaces and draws attention to the extent to which an artist's physical habitat can be reflected in his or her work. Goeneutte's studies of the pont de l'Europe were painted in the years after Manet's death in 1883. Well within Manet's lifetime, Claude Monet became interested in the same motifs and painted not just one or two but a dozen pictures of the Gare Saint-Lazare and the pont de l'Europe.

Monet at The Gare Saint-Lazare

Of all the artists of the Batignolles school who had looked to Manet as their leader in the 1860s (fig. 8), Claude Monet was the one whose painting style was the closest to that of Manet. Indeed, when Monet's work first appeared at the Salon in 1865, the year of *Olympia*, the public mistook his signature for that of the older and by then notorious artist, to Manet's considerable annoyance. To some extent, Monet followed in Manet's footsteps, with seascapes and single figures, but he was committed above all to land-scape painting in a way that Manet, the inveterate urban *flâneur* and man-about-town, could never be.

Like many others in artistic and literary circles, including the dealer Paul Durand-Ruel, Monet had escaped to London on the outbreak of war in 1870. On his return to France in fall 1871, Monet stayed with his family at a hotel opposite the Gare Saint-Lazare and rented a studio on the nearby rue de l'Isly.[76] At the end of 1871, he moved with Camille and their son Jean, then four, to Argenteuil, just outside Paris, where they lived until 1877. From his new home, Monet traveled the short distance to and from Paris by train. One of the first pictures painted after his move, in 1872, was a view of the *Gare d'Argenteuil* (fig. 93), in which the locomotives—those in the distance dark, only their lamps glowing; one in the foreground blue-grey and brass-trimmed—confront each other across a wide space bounded by twin hills beneath a luminous wind-blown sky, racing clouds, and plumes of smoke and steam.[77]

Monet continued to live and paint in Argenteuil,[78] but he regularly came to Paris to visit friends and colleagues, meet dealers and patrons, and generally attend to his affairs as a practising artist. In spring 1874, two important events preoccupied artists, critics, and public: the Salon at which Manet's *Railway* was shown, and the first Impressionist exhibition that immediately preceded it, at which Monet exhibited his famous *Impression, Sunrise*, a harbor scene at Le Havre (Musée Marmottan, Paris), and a view of the *Boulevard des Capucines* (Pushkin State Museum, Moscow).[79] During the summer, both Manet and Renoir visited Monet in Argenteuil and painted with him in his garden and on the banks of the Seine, an experience reflected in Manet's large canvas *Argenteuil* (Musée des Beaux-Arts, Tournai), exhibited at the Salon of 1875.

By 1877, Monet was detaching himself from Argenteuil. He had already begun to paint views of Paris again, albeit "landscape" views of the Tuileries gardens and of the

93 Claude Monet, *The Gare d'Argenteuil*, 1872, 47.5 × 71 cm, Conseil général du Val d'Oise, Musée de Luzarches (cat. 42).

Parc Monceau on the edge of the Europe district. He then decided to tackle a radically modern, urban theme, and sought official permission to paint inside the Gare Saint-Lazare.[80] Early in 1877, Monet attended a dinner party at Caillebotte's home on the rue de Miromesnil; Degas, Sisley, Renoir, and Manet were also present. They discussed what was to be the third Impressionist exhibition, which would be held in April and would include Caillebotte's two very large paintings, *The Pont de l'Europe* and *Paris Street, Rainy Day,* as well as at least seven of Monet's twelve canvases painted in and around the Gare Saint-Lazare.[81]

Monet no longer had a Paris studio at this date, and for a painting campaign in the railway station he needed a *pied à terre* for himself and a place to store his canvases and work on them when the weather conditions were unsuitable. Since as usual he was short of funds, Caillebotte paid the rent for him on a small ground floor apartment not far from the station. On 17 January, Monet informed Georges Charpentier, the publisher who was soon to become a major collector of the Impressionists' work, that he had "more or less moved in at 17 rue Moncey" and invited him to visit.[82] In spite of the problems hinted at in Monet's earlier letter, permission to paint in the station was granted, and by early March Monet was already selling his pictures to collectors.

When the third Impressionist exhibition opened in April, seven of the thirty catalogued works that Monet exhibited were views of the station; three of these were lent by their owners, Ernest Hoschedé and Georges de Bellio.[83] Many critics regarded Caillebotte's monumental urban views (figs. 68, 76) as the two most important pieces in the show, especially *Paris Street, Rainy Day,* "la *masterpiece* de l'exposition," according to a writer who, like many of his contemporaries, was anxious to show off his English.[84] While critics familiar with the Europe district appreciated the careful depiction of the urban landscape in *Rainy Day,* they complained about its arbitrary perspective, dull tints, and lack of vigor, and above all about the absence of rain. However, Monet's paintings of the Gare Saint-Lazare had a powerful impact on visitors to the Impressionist exhibition of 1877. It was one of Monet's Gare Saint-Lazare interiors that apparently greeted visitors to the exhibition (fig. 94), and the comments of critics—even those who hated them—were remarkably positive. Many of them cited Monet's ability to convey the sounds as well as the sights of his subject, and Emile Zola praised his "terrific views of train stations. You can hear the trains rumbling in, see the smoke billow up under the huge roofs." In Zola's view, "That is where painting is today . . . Our artists have to find

the poetry in train stations, the way their fathers found the poetry in forests and rivers."[85] Monet's imagery in these remarkable pictures parallels and may very possibly have inspired the writings of such realist novelists as Maupassant and Zola. In *La Bête humaine*, published over a decade later in 1889–1890, Zola celebrated in words the sights recorded by Monet's paintings, a sequence of uncompromisingly modern, urban views that challenged assumptions about the role of landscape painting.

Zola's *La Bête humaine* is a novel that takes the railway as its central theme and is set at the end of the Second Empire, soon after construction of the pont de l'Europe. It opens with a description of the Gare Saint-Lazare as seen from a window high up in the tall building that Monet depicts in several works (figs. 105–107), precisely at the time of year when those pictures were painted. The novelist's description is almost a paraphrase of Monet's views of the station and the railway cutting:

> It was the last house on the right along the impasse d'Amsterdam, a tall building used by the Compagnie de l'Ouest ... The fifth-floor window ... looked over the station, a wide trench cutting through the Europe district like a sudden broadening out of the view, an effect made the more striking that afternoon by a grey mid-February sky, a misty, warm greyness through which the sun was filtering. Opposite, in this vapoury sunshine, the buildings in the rue de Rome seemed hazy, as though fading into air. To the left yawned the huge roofs spanning the station with their sooty glass; the eye could see under the enormous main-line span, which was separated from the smaller ones, those of the Argenteuil, Versailles and Circle lines, by the buildings of the foot-warmer depot and the mails. To the right the Europe bridge straddled the cutting wih its star of girders, and the lines could be seen emerging beyond and going on as far as the Batignolles tunnel. And right below, filling the huge space, the three double lines from under the bridge fanned out into innumerable branches of steel and disappeared under the station roofs. In front of the bridge spans, scrubby little gardens were visible beside the three pointsmen's huts. Amid the confusion of carriages and engines crowding the lines, one big red signal shone through the thin daylight.[86]

Monet's twelve paintings of the Gare Saint-Lazare and its immediate vicinity are extraordinarily varied, both in their technique and in the views he chose to paint.[87] Several of them were executed on previously used canvases; some appear to be single-session sketches, painted entirely on the motif, others seem to hover on the boaderline between

94 Claude Monet, *Interior View of the Gare Saint-Lazare: the Auteuil line*, dated 1877, third Impressionist exhibition 1877 (102?), 75 × 104 cm, Musée d'Orsay, Paris (cat. 45).

95 Claude Monet, *Within the Gare Saint-Lazare: View of the Normandy Line*, (see figs. 99, 100) graphite on sketchbook pages (carnet 2, 14), 1877, Musée Marmottan – Claude Monet, Paris (cat. 44).

96 Claude Monet, *Within the Gare Saint-Lazare: View of the Auteuil Line*, graphite on sketchbook pages (carnet 2, 15), 1877, Musée Marmottan – Claude Monet, Paris (cat. 44).

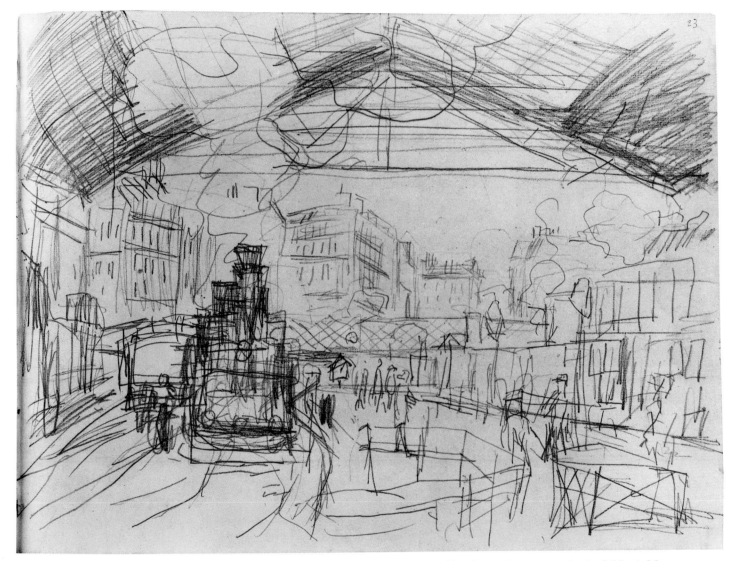

97 Claude Monet, *Within the Gare Saint-Lazare: View of the Auteuil Line*, graphite on sketchbook page (carnet 1, 23v), 1877?, Musée Marmottan –
Claude Monet, Paris (cat. 43).

initial sketch and a work-in-progress, while one or two are very fully worked and were
undoubtedly completed in Monet's studio-cum-apartment on the rue Moncey. There
are no objective criteria for establishing a chronology within the series,[88] and the pic-
tures are probably best approached as a sequence of views of the station and its sur-
roundings, some more fully worked up than others. Possibly at an early stage in his

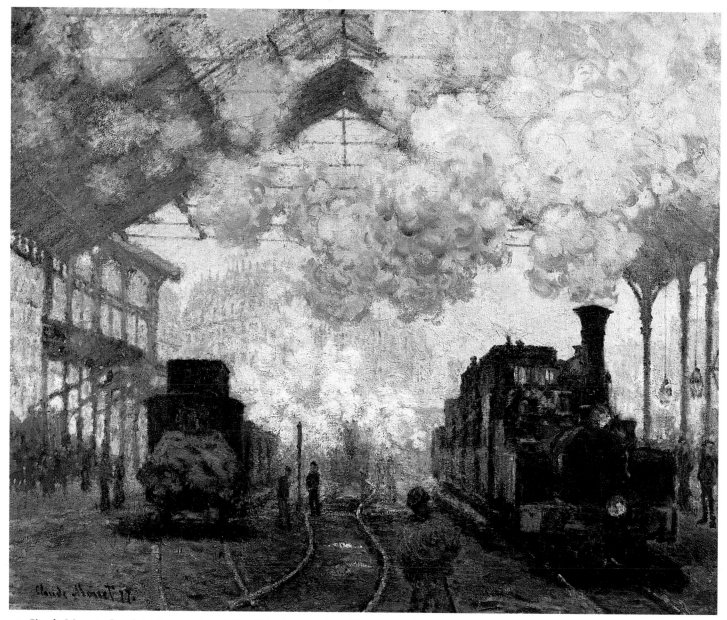

98 Claude Monet, *Gare Saint-Lazare: Arrival of a Train*, dated [18]77, third Impressionist exhibition 1877 (100), 82 × 101 cm, Fogg Art Museum, Harvard University Art Museums, Cambridge, Massachusetts (cat. 46).

project or in the course of developing ideas for it, Monet made a number of bold pencil studies in two large sketchbooks (figs. 95–97). They show his search for interesting views and sometimes indicate the framing of a composition. However, while a few drawings are very close to particular paintings, they probably all served the same purpose, that is, as general preparatory material for the canvases and as rapid notations of possible motifs.[89]

The Gare Saint-Lazare had been enlarged in 1851–1853 to designs by Eugène Flachat (fig. 61). Flachat added the so-called Auteuil station, a set of covered tracks for the trains serving that destination. Beyond it, toward the future rue de Rome, tracks for the lines to Versailles and the west were laid, and Flachat covered them with a single forty-meter span roof. All these structures, as well as the earlier roofs over the tracks beside the rue de Londres, still exist, supported on the original cast-iron columns, within the present-day Gare Saint-Lazare. The station was further enlarged and modified when the pont de l'Europe replaced the place de l'Europe with its two tunnels in 1867–1868 (fig. 60). It was this version of the station that is reflected in Monet's paintings executed in the early months of 1877.[90]

The Auteuil platform was Monet's viewpoint for a preparatory drawing in one of his sketchbooks and for the two most highly finished pictures in the series (figs. 94, 96, 98). Both pictures appear to show the same stationary train alongside Flachat's extension on the left. A locomotive, which has probably just been detached from the train and switched to another set of tracks by means of a turntable out of sight in the foreground, heads off in the middle distance toward the pont de l'Europe. Beyond the bridge to the left, the buildings on the rue de Rome are balanced in the more open view (fig. 94) by the backs of the houses on the rue Mosnier to the right, including the end house with its reddish-brown advertisement for the Belle Jardinière department store (figs. 66, 119, 122). The corresponding element in the other painting (fig. 98) is the exceptionally detailed rendering of a huge locomotive that fills the air with clouds of bluish smoke, its *facture* echoed in an unusually detailed drawing made on a page of a different album (fig. 97).

Monet painted two versions of a view of the oldest tracks, which were used by the Normandy lines (figs. 99, 100). One set ended at a massive buffer placed in front of a building halfway down the roofed platform area. The other ran the full length of the platform and ended at the station concourse. The paintings, one fully signed and dated,

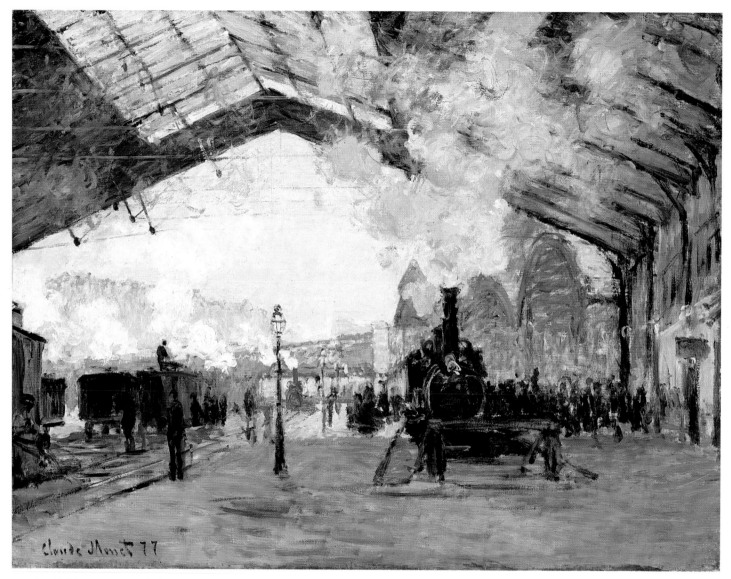

99 Claude Monet, *Arrival of the Normandy Train, Gare Saint-Lazare*, dated [18]77, third Impressionist exhibition 1877 (97), 59.6 × 80.2 cm, Art Institute of Chicago (cat. 47).

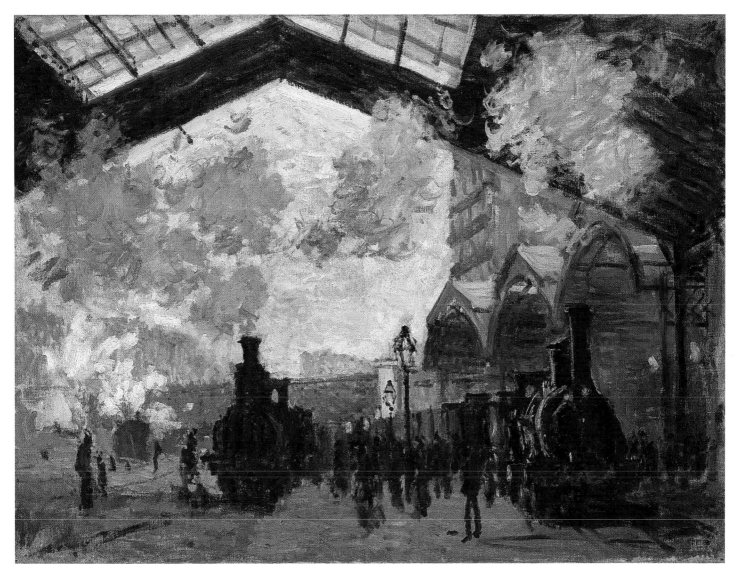

100 Claude Monet, *Gare Saint-Lazare: View of the Normandy Line*, 1877, third Impressionist exhibition 1877?, 54.3 × 73.6 cm, National Gallery, London (cat. 48).

101 View of the Western Region Goods Sheds, c. 1858–1864, photograph, *La Vie du Rail*, Paris.

the other more of a sketch—an *esquisse* that may have been signed later—offer striking impressions of the bustle and activity in the station. Closely related to the most vivid of the sketchbook drawings (fig. 95), they are painted in a much freer, less finished style than those already described. Both paintings show the arched bays of the parcels depot beyond the station roof, which can be seen in a contemporary photograph (fig. 101).

102　Claude Monet, *Gare Saint-Lazare: The Western Region Goods Sheds*, 1877, third Impressionist exhibition 1877?, 60 × 80 cm, private collection, (cat. 49).

103 Claude Monet, *Le Pont de l'Europe (Gare Saint-Lazare)*, dated [18]77, third Impressionist exhibition 1877 (98, *Le Pont de Rome*), 64 × 80 cm, Musée Marmottan – Claude Monet, Paris (cat. 50).

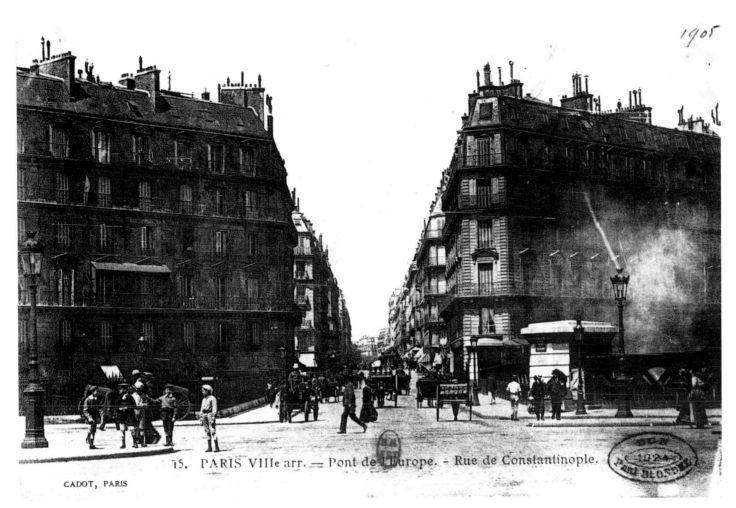

1905

15. PARIS VIIIe arr. — Pont de l'Europe. - Rue de Constantinople.

CADOT, PARIS

104 *Paris VIIIe. – Pont de l'Europe. – Rue de Constantinople*, 1905, postcard, Bibliothèque nationale de France, Estampes, Paris.

Monet took these curiously shaped structures as the main motif in a dramatic, swiftly brushed sketch (fig. 102) that he signed and dated.[91] Moving beyond the parcels depot, Monet painted his most striking view of the bridge (fig. 103). Its title in the 1877 exhibition catalogue, *The Pont de Rome (Gare Saint-Lazare)*, identifies the buildings depicted as those that front onto the rue de Rome, behind their visible elevations on the place de l'Europe and beyond the gap that marks the rue de Constantinople (fig. 104). Although

105 Claude Monet, *Beside the Pont de l'Europe: View Toward the Normandy Line*, 1877, graphite on sketchbook page (carnet 2, 11), Musée Marmottan – Claude Monet, Paris (cat. 44).

the buildings seem precisely defined, the canvas is freely and very thinly painted. Clouds of smoke and steam brushed over areas of bare, primed canvas animate the foreground, and an engine with gleaming steel and brass fittings acts as a *repoussoir*, a foil to the distant view, and anchors the scene on the left.

From the end of the bridge closest the rue de Rome, Monet captured the view as he looked back across the tracks toward the tall building on the impasse Amsterdam, the one from which Zola would later describe the station (figs. 105–107). From a dramatic vantage point beneath the bridge, Monet swiftly brushed over a previously used canvas to produce a subtly colored view (fig. 106). The other, similar view (fig. 107), dominated by the disks of two signals, is the least resolved though one of the most remarkable of the series, linked by its astonishing technique with twentieth-century

106 Claude Monet, *Gare Saint-Lazare: The Normandy Line Viewed from a Vantage Point Under the Pont de l'Europe*, 1877, 64 × 81 cm, third Impressionist exhibition 1877, private collection, courtesy Galerie Brame et Lorenceau, Paris (cat. 51).

107 Claude Monet, *Gare Saint-Lazare: View Toward the Normandy Line, with Track Signals*, 1877, third Impressionist Exhibition 1877, 65.5 × 81.5 cm, Niedersächsisches Landesmuseum, Hannover (cat. 52).

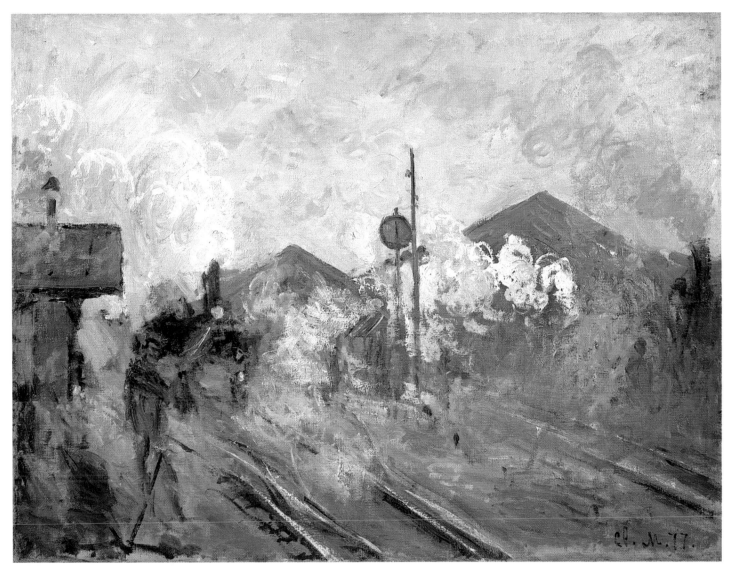

108 Claude Monet, *Gare Saint-Lazare: Tracks and a Signal in Front of the Station Roofs*, dated [18]77, third Impressionist exhibition 1877?, 60 × 80 cm, private collection, Japan (cat. 53).

109 Claude Monet, *View from Beneath the Pont de l'Europe Toward the Batignolles Tunnels*, 1877, graphite on
sketchbook page (carnet 2, 13), Musée Marmottan – Claude Monet, Paris (cat. 44).

art. In an only slightly less freely handled canvas, sold to Hoschedé in March 1877 (fig.
110), agitated clouds of smoke and steam from several locomotives billow and swirl
around the baleful red "eye" of a signal and are set against the stable forms of the
station roofs.[92]

From almost the same vantage point on the tracks, Monet captured in his sketch-
book a view from beneath the bridge, looking away from the station toward the build-
ings on the boulevard des Batignolles (fig. 109). Moving in the same direction beyond
the bridge, he also drew (fig. 110) and painted the part of the railway cutting beside the
rue de Rome that appears in Manet's *Railway*. One of the two paintings that resulted
(fig. 111), a brilliantly evocative sketch, suggests a scene swiftly brushed on a raw day
early in the year. The other (fig. 112), closely linked with the sketchbook drawing, is

110 Claude Monet, *Outside the Gare Saint-Lazare: View of the Batignolles Tunnels*, 1877, graphite on sketchbook page (Carnet 2, 12), Musée Marmottan – Claude Monet, Paris (cat. 44).

flooded with warm sunshine; patches of vivid green and pink on the embankment to the right, which may represent colorful advertisements (fig. 113), would otherwise suggest foliage more suited to a summer scene.[93]

Reviewing an exhibition of Monet's work in 1889, Hugues Le Roux recorded his memories of Monet painting in the Gare Saint-Lazare. As the only known eyewitness account, it is curious that Le Roux situates Monet's painting campaign in the Gare Saint-Lazare in midsummer. The documentary evidence proves that Monet painted his exhibition canvases between January and March, when he sold four pictures to collectors, or April, when the show opened. Le Roux described his encounter with the painter in these terms:

I remember having noticed a man in the Gare Saint-Lazare perched with his easel on a pile of crates. It was a warm summer Sunday. Parisians were leaving town in droves.

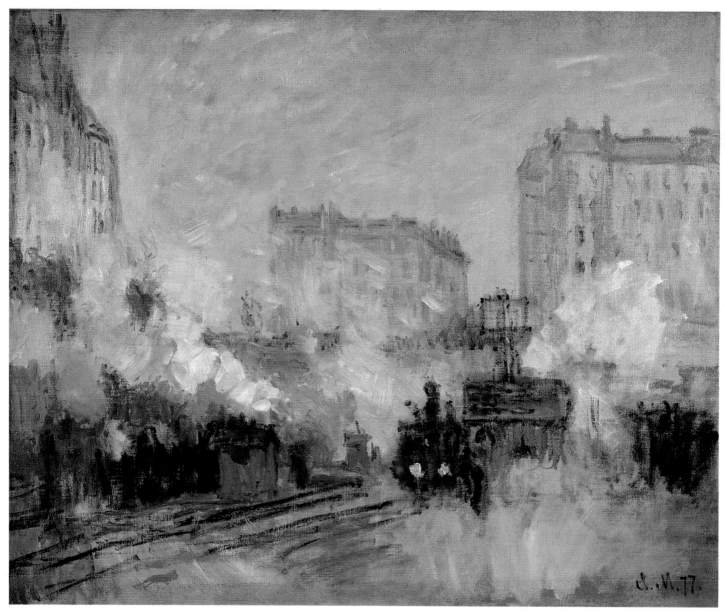

111 Claude Monet, *Outside the Gare Saint-Lazare: View Toward the Batignolles Tunnels*, dated [18]77, third Impressionist exhibition 1877?, 60 × 72 cm, private collection, (cat. 54).

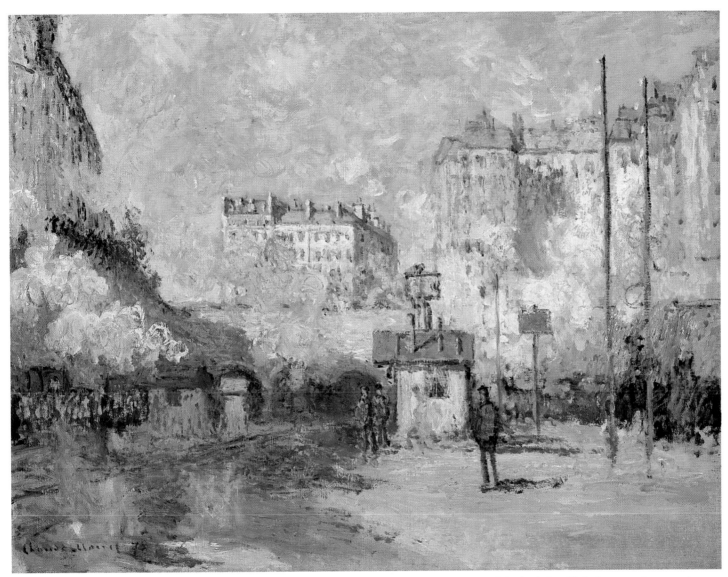

112 Claude Monet, *Outside the Gare Saint-Lazare: View of the Batignolles Tunnels in Sunshine*, 1877, signed (and misdated?) [18]78, 50 × 80 cm, private collection (cat. 55).

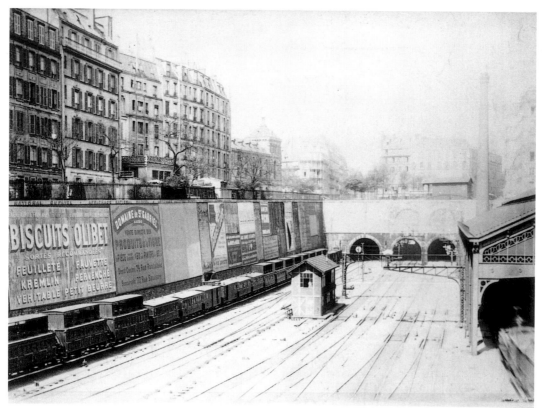

113 The cutting near the Batignolles tunnels, showing advertising hoardings beside the tracks, 1878, photograph, *La Vie du Rail*, Paris.

I moved closer because I wanted to know who couldn't wait till he got to the first stop before hauling out his paints and putting up his umbrella. It was Claude Monet. He was doggedly painting the departing locomotives. He wanted to show how they looked as they moved through the hot air that shimmered around them. Though the station workers were in his way, he sat there patiently, like a hunter, brush at the ready, waiting for the moment when he could put paint to canvas. That's the way he always works: clouds aren't any more obliging sitters than locomotives.[94]

Monet's paintings of the Gare Saint-Lazare were his first major commitment to the exploration of a single, consistent theme, an idea to which he was increasingly drawn. In 1872, he had painted several versions of Camille alone or with other figures beneath

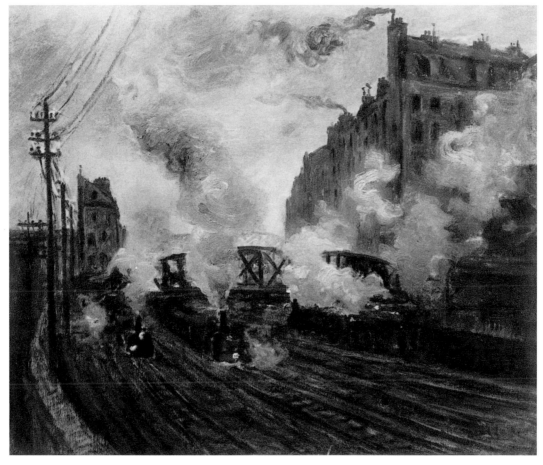

114 Claude Monet, *The Batignolles Cutting and Bridge at Rue Legendre*, c. 1877, location unknown (from a reproduction).

the lilac trees at Argenteuil, and groups of landscapes on similar motifs. His concentrated experience of picture making at the Gare Saint-Lazare in 1877 preceded the series of views of Vétheuil and Lavacourt painted two or three years later and clearly prefigured the later, famous "series" of grainstacks, poplars, and waterlilies. Monet's near dozen different views of the station and the tracks leading to and from it are painted in a wide variety of styles. Many canvases, including some of those he signed and dated, take the form of swiftly brushed studies, where the handling of the medium is a major element in the effect of the image.

115 Money order for 1000 francs from Edouard Manet to Claude Monet dated from Manet's home at 49 rue de Saint-Pétersbourg 5 January 1878, Pierpont Morgan Library, Tabarant collection, New York (cat. 89).

These characteristics underline the differences between Monet and Caillebotte, who set out to monumentalize and fix forever on a very large canvas (fig. 68) what had begun as a fleeting impression and perhaps as an "instantaneous" photographic image. They also mark the differences between Monet, the artist committed to setting down his "impressions" of a given scene in response to its particularities of motif, atmosphere, and light, and Manet, the artificer of complex Salon pictures. Manet's single allusion to the Gare Saint-Lazare in *The Railway* is oblique: a glimpse of railway tracks and of the pont de l'Europe, no train, no view of the station. His interests lie elsewhere. Moreover, in Monet's evocation of fleeting changes in light and atmosphere, of the static power and dynamic movement of great machines, the human figures remain undifferentiated, barely characterized.[95] Manet's view, a very different one, is illuminated by remarks he made in 1881, when requesting permission from the railway company to paint a loco-motive with its driver and mechanic. He told his young friend Georges Jeanniot: "One day, on my way back from Versailles, I climbed into the locomotive beside the driver and the fireman. Those two men were a magnificent sight, so calm and collected, so staunch! It's an appalling job, and they and men like them are the real heroes of our

time."[96] For Manet, man is always at the center. For Monet, it is the spectacle, the visual experience itself.

However different their aims may have become over the years, Manet remained a friend and supporter of Monet. He owned some of his canvases and Antonin Proust recalled how Manet always promoted the younger artist's work, showing it to the Sunday visitors to his studio and expressing his admiration above all for Monet as a painter of water.[97] Manet followed the struggles of his younger colleagues, and he gave them practical and moral support. In Monet's case, Manet helped him many times financially, although his own situation was often strained. When Monet was in dire straits at the start of 1878, he received a money order for a thousand francs from the older artist (fig. 115), and he continued to count on Manet for help. In later years, long after Manet's death, Monet was able to repay his debt to the artist by ensuring that *Olympia* was acquired for the French nation.[98]

CHAPTER THREE

Manet and The Rue de Saint-Pétersbourg

The Rue Mosnier

The house at 4 rue de Saint-Pétersbourg was built in 1864 as a single, free-standing property (fig. 42).[99] The apartments were described at the time as high ceilinged and richly decorated, and this was certainly true of the upper ground floor where a room designated as a *Salle d'armes*—a fencing hall—spanned almost the width of the building. Manet took a nine-year lease on this unusual space in July 1872 and installed his studio. The view from the studio's four large windows was both striking and extensive. A journalist in 1873 described it, not quite accurately, as giving on to the place de l'Europe. Nevertheless his description accords with what is known of the site and with the view that Manet depicted in a drawing (figs. 117, 118):

> The train passes close by, sending up plumes of white smoke that swirl and eddy in the air. The ground constantly shakes under one's feet like the deck of a ship in full sail. In the distance, the view extends along the rue de Rome with its pretty ground floor gardens and majestic houses. Then, below the boulevard des Batignolles, one spies a dark and shadowy hole: the tunnel, into which trains disappear with a shrill whistle as if into a gaping mouth.[100]

The drawing shows the view from Manet's studio of a new street, then known after

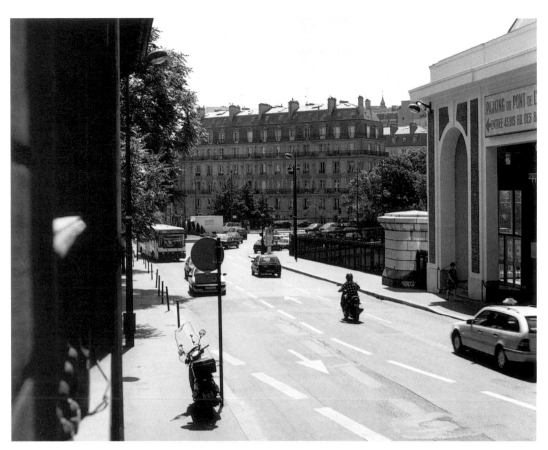

117 View from Manet's studio windows toward the Place de l'Europe, photograph, Musée d'Orsay, Paris.

its developer as rue Mosnier, today as rue de Berne. Lying at right angles to his windows, the street runs alongside the railway cutting from the rue de Saint-Pétersbourg to the rue de Moscou, near the point where the latter joins the boulevard des Batignolles (fig. 3). It was part of a major development project by the entrepreneur Jean-Baptiste Armand Mosnier. Mosnier had seized an opportunity offered by the extension of the railway and the construction of the pont de l'Europe that had freed land previously reserved for a vast goods depot between the railway cutting and the place Clichy.[101] Three streets that fan out from the rue de Saint-Pétersbourg—rue de Turin, rue Clapeyron, and rue de Moscou—were either extended or cut, and properties were built on them by 1869 (fig. 77). These form the dramatic perspective seen in

118 Edouard Manet, *Rue Mosnier with a Gaslamp*, 1878, graphite with brush and lithographic ink tusche, Art Institute of Chicago (cat. 38).

Caillebotte's painting *Paris Street, Rainy Day* (fig. 76). In 1870 houses on the rue Mosnier were built back to back with those on the rue de Moscou to form a characteristic *îlot* (fig. 3). Those on the other side of the rue Mosnier were so close to the railway cutting and the ground fell away so steeply toward the tracks that construction could begin only where the terrain widened out, roughly one third of the way down the street from the rue de Saint-Pétersbourg. The first building was numbered 7, and work on the odd-numbered side was completed in 1871.[102]

Two of Manet's paintings and a drawing of the street (fig. 118) made from his studio

windows clarify the relationship between the rue Mosnier houses and the railway embankment. In the foreground, the embankment drops down behind a rough wooden fence, while the houses are supported by an angled retaining wall like the one on the opposite side of the cutting. The drawing indicates the distant wall crowned by the garden railings. Manet has even sketched the white stone ribs that are still clearly visible in the wall today. A locomotive with smoke rising from its funnel is glimpsed in the foreground and suggests the engine that we do not see in *The Railway* (fig. 1). In addition, two of his three paintings of the street show part of the blank end wall of 7 rue Mosnier (figs. 119, 122). Most of the wall was covered by a reddish brown painted advertisement for the Belle Jardinière (a large department store in the center of town) that is also glimpsed on the far right of one of Monet's views of the Gare Saint-Lazare (fig. 94). A photograph taken before the construction of 2 rue de Saint-Pétersbourg shows that an identical advertisement had earlier occupied the blank end wall of number 4 (fig. 66).[103] The first property on the corner of the rue Mosnier and rue de Saint-Pétersbourg, 2 rue Mosnier, is a grand, double-fronted building designed by the architect Joseph Olive, which is visible in Caillebotte's *Pont de l'Europe* (fig. 68). The farther of its two monumental carriage entrance doors is also clearly identifiable in one of Manet's paintings of the street (fig. 122).

The new properties on the rue Mosnier were advantageously located near the busy place de l'Europe where solicitation was a not uncommon activity. Zola's novel *Nana* refers to the street by name,[104] and one of its brothels figures in the plans of J.-K. Huysmans's strange hero, des Esseintes, to turn a blue-collar youth into a murderer.[105] The gallant encounters depicted or hinted at in street scenes by Caillebotte and Béraud (figs. 68, 84) would have found their *dénouement* in apartments like the ones described by Zola and Huysmans.

Surveying the street from his upper ground floor windows (fig. 120), Manet must have been fascinated by the constantly changing scene, a transposition into Parisian terms of *ukiyo-e*, the transient, floating world of the Japanese print. He made three paintings, an oil sketch, and several evocative drawings of the rue Mosnier during his years in the rue de Saint-Pétersbourg studio. Most if not all these works can be dated to the end of Manet's stay there, in the summer of 1878, the year of another *Exposition Universelle* and the much-criticized *Fête de la Paix*, which under a more truly Republican government would be transformed into France's *Fête nationale*, now known as Bastille

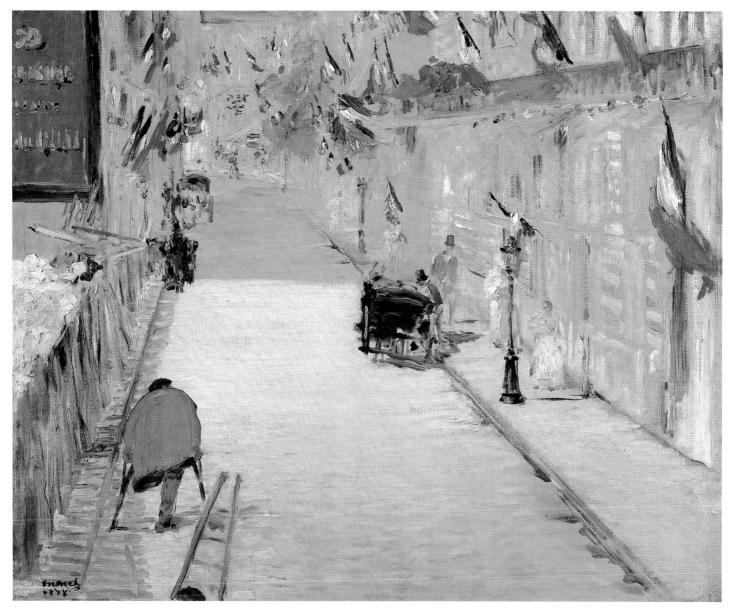

119 Edouard Manet, *Rue Mosnier Decorated with Flags, with a Man on Crutches*, dated 1878, 64.8 × 80 cm, J. Paul Getty Museum, Los Angeles (cat. 41).

120 View of the rue de Berne (formerly rue Mosnier) from Manet's studio windows; the post office build-
ing on the left conceals the blank end wall of number 7; across the street are the two tall entrance arches of
number 2, photograph, Musée d'Orsay, Paris.

Day. Two of the rue Mosnier paintings show the street decked out with flags for the *Fête*
of 30 June 1878 (figs. 119, 121). Another picture, which may or may not be of the same
date, shows pavers toiling in the foreground (fig. 122). In all these works, Manet empha-
sizes the mixed and mainly popular nature of those who frequented the street.[106]

As in the case of Monet's views of the Gare Saint-Lazare, the amount of accurate
detail in Manet's "impressionistic" paintings and even the sketchiest and most sponta-
neous of his drawings is a measure of his powers of perception. Manet's attentive,

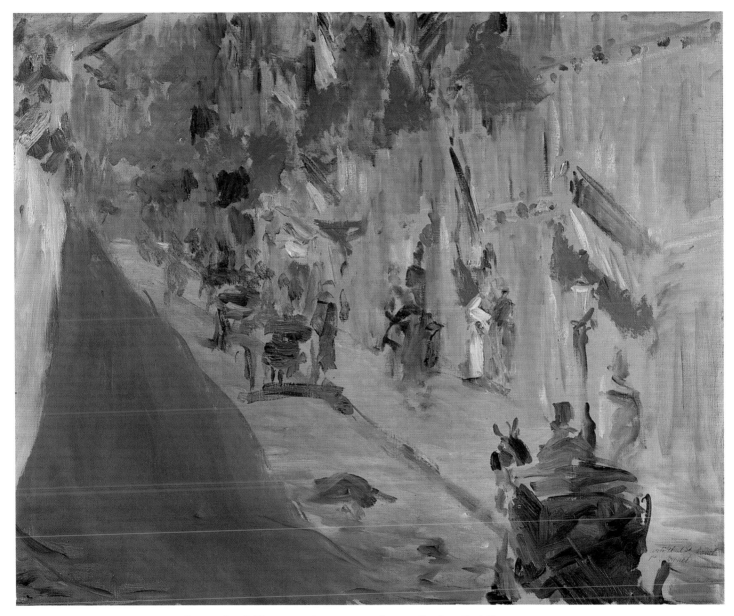

121 Edouard Manet, *Rue Mosnier Decorated with Flags*, 1878, 65 × 81 cm, private collection, Zurich.

122 Edouard Manet, *Rue Mosnier with Pavers*, signed, 1878?, 64 × 80 cm, private collection; photograph, Kunsthaus, Zurich.

analytical vision could grasp at a glance all the significant elements of the scene before him. However freely Manet has depicted them, the façades of the houses in the rue Mosnier paintings correspond to a remarkable degree with the actual buildings, as they exist in the street today. Although this fact may seem irrelevant to our perception of the pictures as works of art, it is this true-to-life quality, which the artist's bravura handling of brush or pencil enhances, that infuses each work with an irresistible sense of reality. The viewer, who normally has no knowledge of the actual scene depicted, is thereby enabled to perceive it as satisfying and convincing. At the same time, Manet's paintings also reveal a carefully calculated construction and, in the case of the *Pavers*, a

123 Edouard Manet, *Knife Grinder and Street Lamp, Rue Mosnier*, 1878, 40.6 × 32.7 cm, Philadelphia Museum of Art (cat. 40).

124 Edouard Manet, *Man on Crutches*, 1878, brush and lithographic ink tusche, Metropolitan Museum of Art, New York.

fair amount of rethinking and rework. Even in the absence of a full technical examination of this work, it is clear that Manet has painted out a lamppost in the foreground and made alterations to the workmen. This canvas is closely related to the drawing just discussed and to the small, quickly brushed sketch of a knife grinder behind the same lamppost (figs. 118, 123). Crisscrossed brushstrokes in the *Pavers* indicate underlying strata and suggest Manet's search for pictorial perfection.

This search in turn raises the question of Manet's deeper motivations: the significance of his cast of characters, street sweepers, pavers, knife grinder; the way in which the viewer is drawn into the toiling circle of workers paving the road; the ironic

125 Edouard Manet, *Rue Mosnier in the Rain*, 1878, brush and lithographic ink tusche over graphite, Szépmüvészeti Múzeum, Budapest (cat. 39).

Republican sentiments behind the imagery of the *Fête* and its obligatory flags; above all the one-legged working-class man in blue blouse and black beret, no doubt an anonymous victim of the violence of war or the Commune, who makes his way slowly, on crutches, down the long, almost empty street (fig. 119).[107] The ladder protruding into the picture in the foreground suggests the placing of still more flags, perhaps on the façade of Manet's own building, since in another canvas half the rue Mosnier is obscured by the aggressively billowing red section of the tricolor emblem (fig. 121).

Our understanding of Manet's aims and intentions has recently been complicated by the realization that all the rue Mosnier drawings, not just a songsheet cover design and a study of the man on crutches (fig. 124), were part of an unfulfilled project to make prints. The drawings of the street, first lightly sketched in graphite, then redrawn with brush and lithographic ink, are on tracing paper (as were a number of theater and café

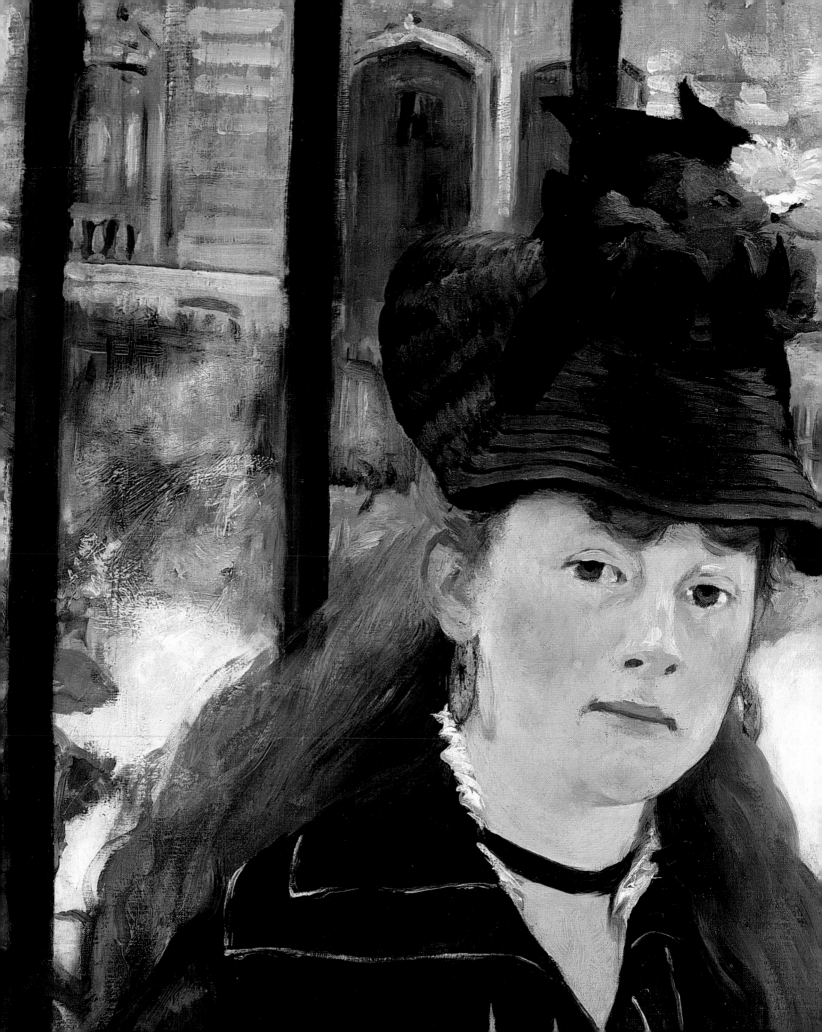

concert scenes of this period).[108] They can therefore be seen as ideas or trials for a print that would have been published as a lithograph or reproduced in a newspaper or journal[109] in order to diffuse to a broad public Manet's views of the street life seen from his windows. The songsheet design links the rue Mosnier paintings and drawings with the radical philosophy expressed in the poems of Jean Richepin's *La Chanson des gueux* (*The Beggars' Song*). These were set to music by Manet's friend the bohemian musician Cabaner, who dedicated to the artist the song entitled "The Beggars," for which Manet drafted his projected cover design.[110] Manet had decided at the beginning of the year not to attempt to exhibit his work in the context of the *Exposition Universelle*. These anti-establishment images may represent an unrealized project to express his opinions publicly at the time of the *Fête de la Paix*.

Manet's very vivid canvases of the rue Mosnier painted from his studio window are complemented by these black-and-white projects for prints that include a witty "rainy day" scene full of umbrellas (fig. 125), reminiscent of Caillebotte's freely handled oil sketch for his *Paris Street, Rainy Day* (fig. 79). Full of pictorial invention and in a variety of techniques, all these works produce an unforgettable, multiple experience of the rather ordinary little road seen from Manet's studio—a perfect illustration of Edmond Duranty's dictum, "From indoors we communicate with the outside world through windows. A window is yet another frame that is continually with us."[111]

The New Studio

The world within the windows at 4 rue de Saint-Pétersbourg was that of the studio into which Manet, then just forty years of age, had moved in July 1872. The building was a classic 1860s rental property. Cross-sections of two typical Parisian apartment buildings published in a magazine in 1883 (fig. 127)[112] show one property located in a "smart neighborhood near the Opera." It had a fashionable café on the ground floor, a restaurant on the mezzanine, an elegant milliner's on the first floor, and a lawyer, a smart tailor, and others on the floors above. In the other building situated in a much less fashionable part of town, the ground floor was occupied by a fencing master and a dancing master; the mezzanine by a clockmaker and a bookseller; the first floor by a picture dealer and antiquarian; the second by a dentist; an upper floor by young women who in the words of the unidentified writer "spend their time making artificial flowers or

MAGASIN PITTORESQUE.

127 Tissandier et Gilbert, *Paris at Work*, gillotage reproduction by P. Grenier in *Le Magasin pittoresque*, 1883 (384, 385), Bibliothèque nationale de France, Estampes, Paris; cross-section of two apartment buildings; the one on the right has a fencing hall on the ground floor.

engaged in some similar occupation;" the top floor by a photographer. Such depictions as these owed more, of course, to journalistic license than they did to fact, but the rental properties erected in great numbers during the Second Empire did not segregate domestic from professional and commercial uses in the way that building and zoning codes force builders to separate them today. We should not therefore be surprised to

128 The studio at 4 rue de Saint-Pétersbourg with the loggia and the staircase leading to a small salon, photograph, Musée d'Orsay, Paris.

find that the upper floors of the building at 4 rue de Saint-Pétersbourg appear to have been devoted to exclusively domestic purposes.

Largely unchanged today, access to the building is through the original carriage entrance, and the studio on the upper ground floor is reached by ascending a short flight of steps at the rear.[113] Manet's studio was entered through large double doors on the landing at the top of these steps. The premises consisted of the very large fencing hall, at one end of which a staircase led to a small salon with a loggia overlooking the main room (fig. 128). Beyond it, there were three small rooms that included

toilet facilities. A service staircase from the landing outside led to a kitchen and pantry on the lower ground floor (figs. 129, 130).[114] Manet had thus acquired a magnificent studio complete with a small but convenient apartment suitable for entertaining his friends. His models could change in comfort, and he could even spend the night there if so inclined. The journalist and novelist Léon Duchemin, who used the pen name Fervacques, and whose description of the view from Manet's windows has already been quoted, interviewed Manet at his studio on Christmas Day 1873, and the account of his visit was published in *Le Figaro* two days later.[115]

> The artist greeted me at the door with a warm smile and a hearty handshake. We make our way into the studio—a huge room with mouldings in old, dark oak; the ceiling alternates exposed beams with dark, colored compartments. The light that pours in through the multipaned windows is clear, soft, and even ... Several of the painter's works hang on the walls. First, the famous *Déjeuner sur l'herbe*, which the Salon jury rejected ... Next, the pictures shown at various Salons: *The Music Lesson*, *The Balcony,* the lovely *Olympia*, this last with the black maid and the strange black cat ...

Fervacques took note of several less notorious, more recent pictures, including a landscape with figures and "a perfect Punch, bold and unapologetic."[116] He describes the artist at work on a watercolor of "another Punch, who poses in the middle of the studio in his charming traditional costume." The journalist then discusses in some detail *Masked Ball at the Opera* (fig. 140), and notes that the canvas stood on an "easel placed at the foot of the oak staircase leading up to the loggia from which the judges scored the thrusts and hits when this splendid studio was a fencing hall. Nothing could be more picturesque, let it be said, than this little gallery of carved oak framed in gilt fillets and hung with crimson curtains." Carried away by the splendor of it all, Fervacques imagines that, if the window opened, one would catch a glimpse of the Mona Lisa or of some glorious beauty by Rubens richly gowned in green and gold brocade. Fervacques's visit took place less than three months before submissions to the Salon of 1874 were due.[117] He did not mention *The Railway*, which was accepted together with a watercolored version of the figures of Punch noted in his article (figs. 1, 139).[118] However, Fervacques would be pained to learn, the following April, that the landscape and *Masked Ball at the Opera* had joined the long list of works rejected by the Salon jury.

129 Document from the cadastre for 4 rue de Saint-Pétersbourg, 1862, Archives de Paris (cat. 81).

130 Document from the cadastre for 4 rue de Saint-Pétersbourg, 1876, Archives de Paris (cat. 82); detail of the entry for the *Rez de Chausée* (ground floor) apartment no. 1 showing the principal room designated *Atelier* and Manet's occupancy noted until his replacement in 1879.

131 The original mantelpiece (now removed) on the end wall of the studio, photograph, private collection, Paris.

The newspapers appear to have had nothing more to say about the studio until 1876,[119] when, following the rejection of the two paintings that Manet had submitted to the Salon jury, he invited critics and the public to see them in his studio. Like those of many other journalists, the account of a visit to the rue de Saint-Pétersbourg studio by Gérôme, in the gossip column of *L'Univers illustré*, took pains to present both the artist and his surroundings as eminently respectable:

I went to M. Manet's. His studio is large and well lighted. Its beamed ceiling recalls those of the Middle Ages or the Renaissance; touches of gold enliven the beams, which have been painted brown. It is the cleanest and best kept studio that I have ever seen. There is not the slightest trace of revolution in these surroundings, which are as calm and composed as M. Manet himself—one of the least offputting artists of my acquaintance.[120]

The journalist warns his readers not to confuse this quiet and elegant gentleman with the wild and unkempt bohemian whom descriptions of Manet as a reckless innovator might lead them to imagine.

Other accounts dating from the time of Manet's studio exhibition focus on objects in the room: the mantelpiece (fig. 131) and its bric-à-brac that included a stuffed raven perched on a plaster bust of Athena;[121] the sofa, divan, café table, and garden chairs that appear in many of Manet's pictures; even the piano (one of the most informative writers could not resist listing the books and journals piled on it).[122] Despite a certain casual disarray, the journalists who visited the studio agreed that its occupant had made no attempt to create a self-consciously "artistic" ambiance, and almost all commented on the sobriety of its décor, one going so far as to compare the studio with a room in the Louvre museum.[123] Charles Toché, who had met Manet in Venice in 1874, returned to Paris in 1876 and promptly visited the rue de Saint-Pétersbourg studio. Years later, in conversation with Ambroise Vollard, he recalled its "monastic simplicity: Every piece of furniture had a function. No gewgaws. Brilliant studies on the walls and on easels. At the end of the room, on the mantelpiece, a plaster cat with a pipe in its mouth . . ."[124] The effect of the "brilliant studies" in the large room with its dark ceiling, its oak staircase, loggia, and mantelpiece, and its walls painted red, must have been all the more remarkable considering that some if not all these canvases were evidently displayed in white frames with blue fillets.[125] The walls are no longer red, the original leaded inner windows seen in a contemporary photograph (fig. 42), and the elaborate fireplace at the far end of the room are no longer there, but in virtually all other respects the studio has remained just as the contemporary writers describe it, even to quite insignificant details.[126]

Manet came every day to spend the morning hours at work in his studio. He returned home, up the street, for a late lunch or met friends at a restaurant in town. On Sundays he kept open house in the studio to receive his friends and patrons and show them his works but above all to display and promote those of his younger colleagues:

"his principal concern . . . was to make a good case for all the Batignolles artists. Forgetting his own works, he put their canvases in a good light and tried to find buyers for them."[127] Manet also welcomed those more fashionable young artists whose company he most enjoyed: Henri Gervex, whose early triumphs delighted him, and Jean Béraud, "a handsome cavalier," who remained unspoilt by success and whose good-natured charm and discretion earned him Manet's warm affection.[128]

Mallarmé and Manet

The most regular and certainly the most significant visitor to Manet's studio was the young poet Stéphane Mallarmé (fig. 133). Poet and artist probably met in 1873. Their sustained relationship was essential to the development of both and their direct collaboration resulted in two of the most remarkable of nineteenth-century illustrated books. From 1872 to 1875, Mallarmé lived with his wife and children at 29 rue de Moscou, just up the street and around the corner from the studio at 4 rue de Saint-Pétersbourg. In 1876, he moved to 87 rue de Rome, beyond the boulevard des Batignolles. Years later, he recalled his daily visits to Manet's studio, where he stopped every weekday evening on his way home from the *lycée* in which he taught (fig. 132).[129]

It was in 1876 that Manet painted a small, unforgettably intimate portrait of Mallarmé (fig. 133). The poet reclines on a couch in the studio, propped against a cushion, in front of the oriental wall-covering that was used in other paintings (figs. 135, 160).[130] Off-center, poised yet withdrawn, lost in thought, Mallarmé's dreamy gaze and the tilt of his body draw the viewer's eye inexorably to the pages pinned down by the poet's hand and literally underlined by the artist's signature below. The smoking cigar held lightly between index and thumb, the curve of the thumb emerging from the jacket pocket, the fullness of the lower lip express Manet's understanding of Mallarmé's deeply sensual nature. The poet's finely chiselled head is a marvel of painterly precision. Elsewhere scurrying brushstrokes suggest the free-flowing fantasy of the slight but authoritative figure on the couch, "the author of the most advanced poetry of his day and who would leave his century far behind before it even ended."[131]

Mallarmé became the artist's principal champion and apologist, assuming for the 1870s the role that Zola had filled in the preceding decade. It was Mallarmé, ten years Manet's junior, who in 1874 took the Salon jury to task when its members presumed to discriminate between Manet's paintings and selected one for exhibition while rejecting

132 Dornac, Stéphane Mallarmé in the salon of his apartment in the rue de Rome, with Manet's portrait of him on the wall behind, before 1895, photograph, from *Les Contemporains chez eux*, Bibliothèque nationale de France, Estampes, Paris.

the two others (figs. 1, 140). In 1876, it was again Mallarmé who, when the jury rejected both of Manet's submissions, took up the cudgels on his behalf. In a carefully balanced article he related Manet's work to that of his colleagues in the almost concurrent second Impressionist exhibition. Mallarmé's seminal study of the new movement, "The Impressionists and Edouard Manet," followed hard on the heels of Edmond Duranty's pamphlet, *The New Painting*.[132] An apostle of realism in the 1860s, Duranty had come to appreciate that the most serious and accomplished members of the new group were as realist in their goals as the painters who had restricted realism to subject matter.

Published to coincide with the second Impressionist exhibition held in April 1876 and thus contemporaneous with Manet's studio showing of his rejected paintings, Duranty's essay demonstrated that the radical challenge to the old order, which for Manet was still located in the Salon, had shifted for Degas and his younger colleagues to the independent exhibitions, which were usually held just before the Salon opened its doors. The critical spectrum was inevitably very wide, ranging as it did from such arch-conservatives as Manet's own bête noire Albert Wolff, who wrote for *Le Figaro* and *Le Gaulois*, and the perpetually mocking Louis Leroy in *Le Charivari*, to such relatively sympathetic writers as Jules Noriac in *Le Monde illustré* and Castagnary in *Le Siècle*. Duranty and Mallarmé undertook to open the eyes of critics and public alike to the larger, historical perspective and to explain why the new art, in its finest manifestations (for they were well aware that the work shown in the group exhibitions was uneven in quality), was the only acceptable and valid expression for contemporary society.

From his student days onward, Manet's own dictum had always been, "One must be of one's own time, do what one sees."[133] Steeped in tradition, having learned from Old Masters studied in the Louvre and on his travels in Italy, Holland, and, Spain, he was all too aware that in earlier centuries artists had placed their Biblical scenes in contemporary settings to make them immediately accessible to contemporary viewers. Like Duranty and Mallarmé, Manet despised the "archeological" and "historicizing" schools of painting promoted by the Ecole des Beaux-Arts,[134] and he brought the contemporary world into his studio at 4 rue de Saint-Pétersbourg. Apart from such outdoor, ostensibly *plein air* scenes as *The Railway* (fig. 1), no doubt largely if not wholly painted in the studio, Manet embarked on a long line of portraits and "types" posed by friends and acquaintances. One of the first of these was *Le bon bock*, his study of the engraver Emile Bellot at a café table—a piece of studio furniture—that earned him plaudits at

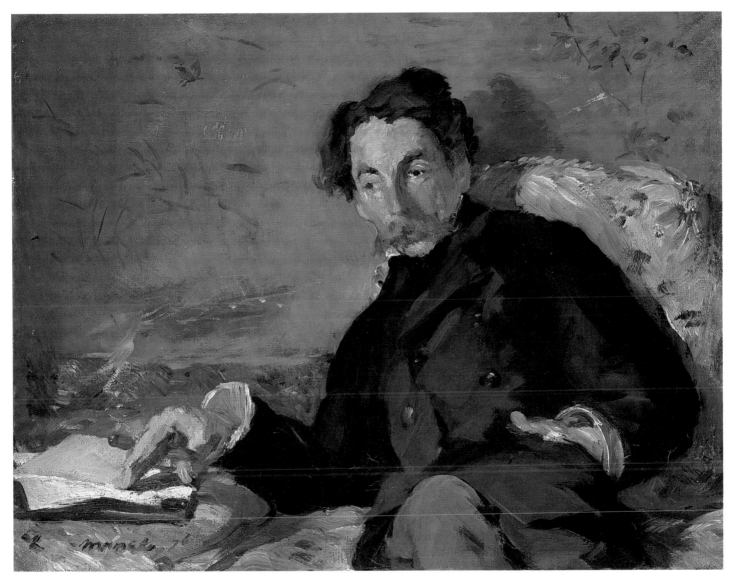

133 Edouard Manet, *Portrait of Stéphane Mallarmé*, dated 1876, 27 × 35 cm, Musée d'Orsay, Paris (cat. 32).

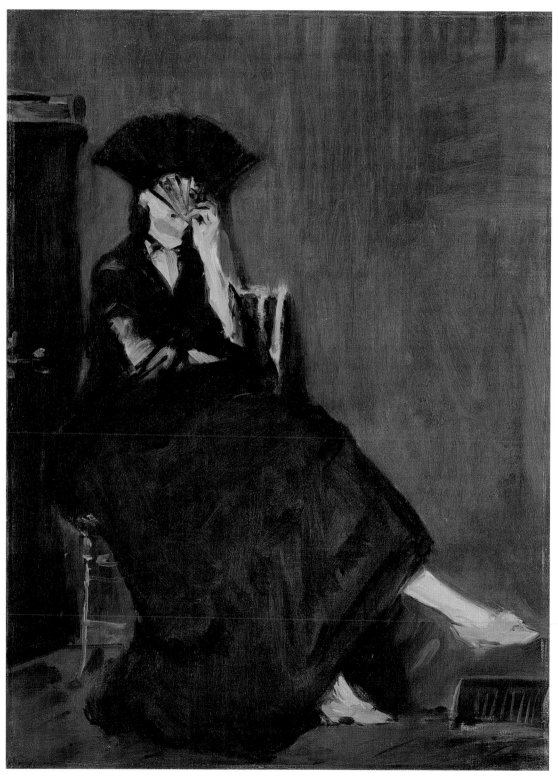

134 Edouard Manet, *Berthe Morisot with a Fan*, 1872, 60 × 45 cm, Musée d'Orsay, Paris (cat. 23); Berthe's foot is raised over a hot air vent in the studio floor.

the Salon of 1873 (fig. 156). His sitters also included a galaxy of women ranging from Berthe Morisot and Nina de Callias (figs. 134, 135) to Ellen Andrée, Henriette Hauser (figs. 15, 160), and the rather less celebrated but infinitely more gracious Méry Laurent, the friend of both Mallarmé and Manet.

Berthe Morisot had posed for Manet in 1868 and 1870, in the rue Guyot studio, for large-scale figure compositions.[135] In 1872 and 1873, Berthe was captured by Manet in a whole series of intimate portraits and studies painted in the elegant comfort of his new studio. In one (fig. 113), she sits on a bamboo chair, a studio prop that appears in several pictures and in the symbolic final illustration for *Le Corbeau* (fig. 145). Gazing quizzically at Manet through the sticks of her fan, she holds a pink-slippered foot over one of the brass warm-air vents set into the studio floor.[136] Not long after this series of works in homage to Berthe's vitality, offbeat beauty, and charm, she became engaged to and then married Manet's brother Eugène.

Something of the same informal tone prevails in a large canvas usually titled *Lady with Fans* (fig. 135). The lady in question, Nina Gaillard, also known as Nina de Callias and Nina de Villard,[137] was an exceptionally lively and talented woman who presided over a brilliant, if a trifle eccentric, group of individuals whose merits were not generally acknowledged until much later.[138] Manet, who knew Nina in her *salon* setting, recreated a suitable décor in his studio by posing her against the oriental wall hanging that is seen in his portrait of Mallarmé (fig. 133) and in his evocation of *Nana* (fig. 160). The painting is large and very broadly brushed, and evidence of reworking on the canvas suggests a possible relationship with alternative versions of the portrait known from two wood engravings. Both show Nina not in her exotic "Algerian" costume but as "A Parisienne"—the title of one of the prints—in a day dress and hat and with or without a fan pinned to the wall behind her. One of the wood engravings was published in *La Revue du monde nouveau*, a short-lived, avant-garde magazine in which it faced a poem by Nina's lover, the writer and inventor Charles Cros (fig. 136). The poem, titled "Studio Scene" and dedicated to Manet, describes the artist's endeavors to keep his model amused and quiet while he captures the pose. There were evidently several print projects afoot, and a lively preparatory drawing for a bust portrait of Nina survives on a tiny woodblock (fig. 137), presumably because the engraver did not have the heart to cut into and destroy it but instead used another block to prepare the image used for printing.[139]

The following year, Cros asked Manet to illustrate a poem that he had just composed

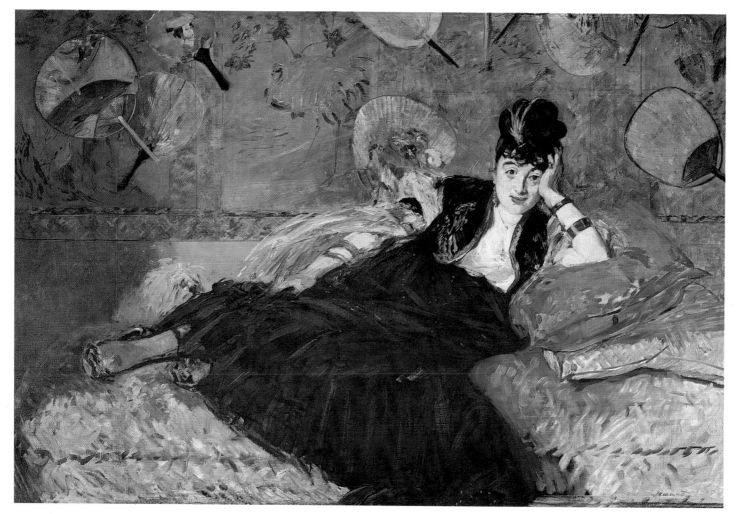

135 Edouard Manet, *Lady with Fans. Portrait of Nina de Callias*, 1873–1874, 113 × 166 cm, Musée d'Orsay, Paris (cat. 24).

136 Alfred Prunaire, after Manet, *The Parisienne*, 1874, wood engraving, in *La Revue du Monde nouveau*, no. 1, 15 February 1874, Bibliothèque nationale de France, Imprimés, Paris (cat. 58); with the print by Prunaire opposite "Scène d'atelier," the poem by Charles Cros dedicated to Edouard Manet.

and wanted to dedicate to him, hoping that Manet would provide "two or three etchings to go with it."[140] *Le Fleuve* (*The River*), published in December 1874, is considered to be one of the very first illustrated books in the modern meaning of the term. Manet's small yet vivid etchings are integrated with text to convey the sense of Cros's poem about the river winding its way to the sea (fig. 138).

During the 1870s Manet branched out from his normal focus on painting into a variety of related activities, which included prints and drawings for the illustration of books and journals and single-sheet prints intended to keep himself and his work in the

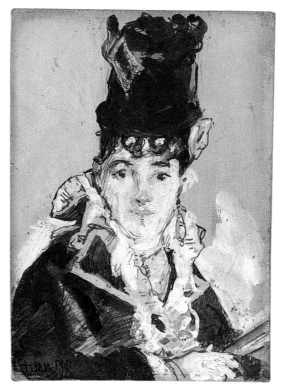

137 Edouard Manet, *The Parisienne. Nina de Callias*,
1874, gouache and graphite on a woodblock, 9.9 ×
7.3, Musée d'Orsay–Louvre, Arts graphiques, Paris
(cat. 25).

public eye. His lithograph *Civil War* (fig. 25) was published on 20 February 1874. Two days later, his lithographic image of the Café Guerbois was reproduced in a radical Belgian periodical that the French police promptly seized.[141] The studies of Punch that Fervacques had observed in the making when he visited Manet's studio in December 1873 were put to use not only for paintings but also for a print of *Polichinelle*, the only color lithograph in Manet's oeuvre. A hand-colored proof of his original line drawing on the lithographic stone survives, inscribed with the distich that Manet requested from Théodore de Banville after holding a competition among his friends (fig. 139).[142] The police seem to have seized and destroyed a first printing because the jaunty, bewhiskered figure of *Polichinelle* was suspected to be a caricature of Marshal MacMahon,

138 Charles Cros and Edouard Manet, *Le Fleuve* (*The River*), 1874, poem by Cros and eight etchings by Manet, Bibliothèque nationale de France, Estampes, Paris (cat. 30); title page and pages of the poem with Manet's etchings in the text.

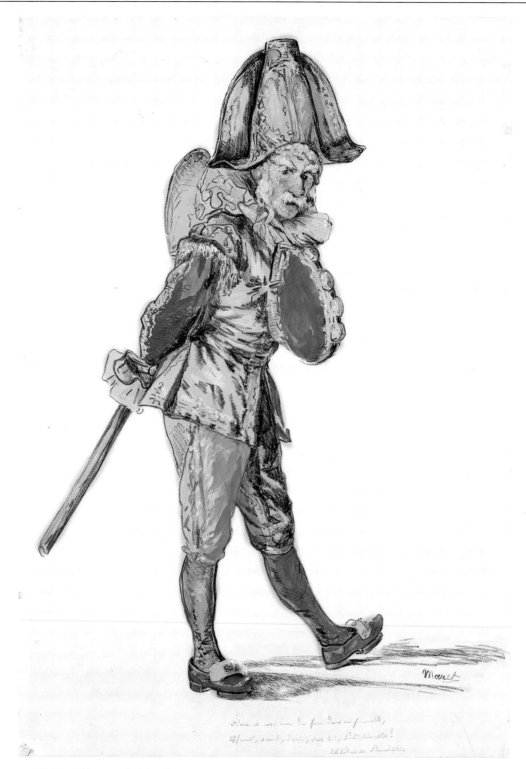

139 Edouard Manet, *Polichinelle*, 1874, gouache and watercolor over lithograph, first state, inscribed with the distich by Théodore de Banville, 48 × 32.3 cm (sheet), National Gallery of Art, Washington, Gift (Partial and Promised) of Malcolm Wiener (cat. 27); the hand-colored proof was exhibited at the Salon of 1874.

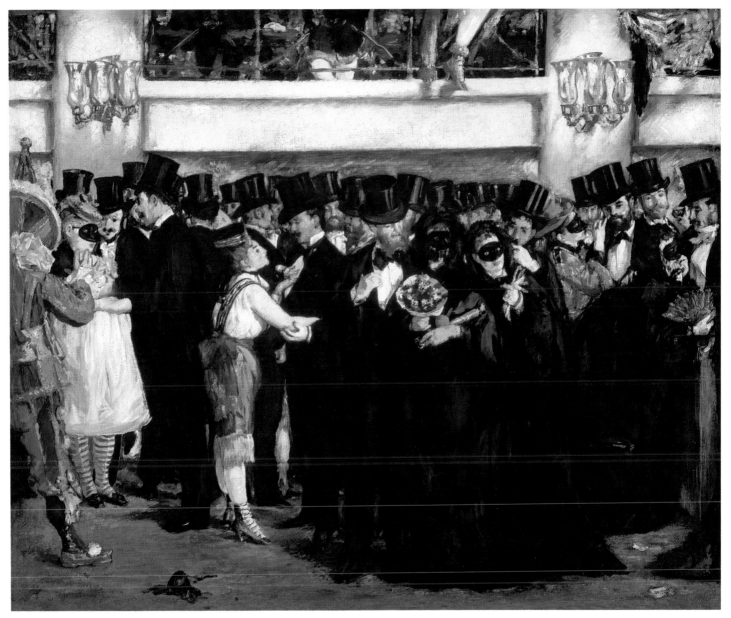

140 Edouard Manet, *Masked Ball at the Opera*, 1873, 59 × 72.5 cm, National Gallery of Art, Washington (cat. 26); Manet's signature appears on a dance card at the lower right; the picture was sold to Faure and rejected by the Salon jury in 1874.

141 Henry Charles Stock, *Revue du Salon par Stock*, June 1874, colored gillotage, Bibliothèque nationale de France, Estampes, Paris (cat. 80); the single sheet print is dedicated "To Monsieur E. Manet" and Manet's *Polichinelle* is seen presenting the Salon pictures to the public: "O noble bourgeois, who are so favorably inclined toward the arts! . . "; the pictures, identifiable by their Salon catalogue numbers and the artists' names, are accompanied by artists' autographs including one by Manet (fig. 142).

142 Verso of fig. 141, detail showing Manet's autograph: "What good eyesight you have, if you managed to spy me up there. Thanks. Ed. Manet.

second president of the new Republic, who was almost as commonly known as "Marshal Baton" for the repressive policies on which he relied to uphold his notions of law and order.[143] It was no doubt the rare first state of the print, hand-colored with watercolor and gouache, that Manet submitted to the Salon jury in 1874 and that the jury accepted along with his oil painting of *The Railway*. The traditionally subversive figure of Punch also appears at the edge of the rejected *Masked Ball at the Opera* (fig. 140). On 22 May, the caricaturist Stock wrote to Manet requesting permission to reproduce his watercolor in the satirical journal named *Polichinelle*, together with a brief autograph message. Stock wrote again on 1 June to report that "All is going well," the censors had accepted the caricature, and the issue would shortly be on sale (fig. 141).[144] Headed "To Monsieur E. Manet" and with Manet's *Polichinelle* introducing the entire Salon, which is symbolized by an array of thirty paintings, the sheet carries many artists' autographs. Manet's comes with a wry comment on the way in which his work had been hung on the Salon's walls: "What good eyesight you have if you managed to spy me up there. Thanks. Ed. Manet."[145]

It was with Stéphane Mallarmé that Manet collaborated on an extraordinarily ambitious and radical project, the publication in 1875 of Edgar Allan Poe's *The Raven* in a sumptuous folio edition that was to present the original English on pages facing Mallarmé's prose translation. One of the most famous and popular poems of its time, this "gothick" tale of loss and despair had made a profound impression on the preceding generation, most notably Charles Baudelaire, and it continued to influence at least the next two generations of French writers. Manet's contribution consisted of four

143 *Beneath the Lamp.*

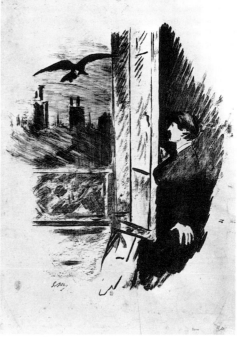

144 *At the Window.*

145 *On the Bust.*

146 *The Empty Chair.*

143–146 *Le Corbeau* (*The Raven*), poem by Edgar Poe, French translation by Stéphane Mallarmé, illustrations by Edouard Manet, 1875, Bibliothèque nationale de France, Estampes, Paris (cat. 31).

large-scale lithographic illustrations (figs. 143–146), a book plate *ex-libris* showing the raven in flight, and a parchment wrapper for the unbound sheets ornamented with a profile silhouette of the titular raven. The preparation and publication of the volume was a complex story. For Mallarmé and Manet, it was a labor of love whose public impact fell far short of the collaborators' expectations. The large format and the startlingly bold illustrations in an "unrealistic" oriental brush technique ran counter to all the norms of the day, and only a few very enlightened observers were able to appreciate its qualities. As in many other of Mallarmé's publishing ventures, this work, which now commands universal respect and admiration, was a resounding commercial failure.[146]

Turning to a more intimate format resembling that of *Le Fleuve* (fig. 138), the poet and the artist worked together again in the following year on the exquisitely crafted presentation of Mallarmé's poem *L'Après-midi d'un faune*, which François Coppée and Anatole France had excluded from the third *Parnasse contemporain* (fig. 147). Mallarmé wanted a "true masterpiece of French bookmaking art … illustrated with wood engravings printed in muted tones, pink and grey: the first attempt in Europe to reproduce Japanese techniques,"[147] and Alphonse Derenne agreed to publish it. Much thought went into the choice of papers, ink, and binding. Whereas Manet's illustrations for *Le Fleuve* had been copperplate etchings and those for *Le Corbeau* had been printed by transfer lithography, the technique of wood engraving was chosen for the new "oriental" publication. Manet drew directly on woodblocks, which he then handed over to a professional engraver to be cut. Delicate watercolor washes of pink or of pink and green tint the prints—in a cost-cutting move, Manet applied the washes himself—and the resulting work is indeed every bit the "costly candy-wrapper yet vaguely oriental *plaquette* (little book)" of which the poet had dreamed, "Japanese matte paper, gilt title, China rose and black silk cords, and all."[148]

The publication demonstrates Manet's ability to adapt his methods and manner to very different types of illustration. Over the next few years he produced many drawings and some additional prints as illustrations for books and magazines, and he did not disdain to provide designs for the most ephemeral of venues. One such was the sketch that he offered in 1876 to illustrate a short-lived weekly called *Le Type*. The front page of the 23 April issue placed a caricature of the artist (as *The Artist*, one of the rejected pictures then on view in his studio), next to a sketch by him (fig. 148). The illustrations were accompanied by a droll letter to the paper's editor signed by Manet and a brief, tongue-in-cheek biographical note.

147 Stéphane Mallarmé, *L'Aprés-midi d'un faune*, 1876, poem by Stéphane Mallarmé with wood engravings (by Alfred Prunaire?) after designs by Edouard Manet, Bibliothèque nationale de France, Estampes, Paris (cat. 33); the cover with its pink and black silk cords is shown with the *The Faun* frontispiece and *Nymphs* at the beginning of the poem.

148 *Le Type*, volume 1, no. 3, Sunday 23 April 1876, Bibliothèque
nationale de France, Imprimés, Paris (cat. 87).

Manet, Jury, and Public

During Manet's years in the rue de Saint-Pétersbourg studio, this mature artist, whose
work had been exhibited continuously at the Salon from 1868 to 1873, faced rejection at
the hands of ultra-conservative juries in 1874, 1876, and 1877. In 1874 the exclusion of
one of his most highly finished and remarkable works had almost as much impact on
public perceptions of the artist and his work as inclusion of *The Railway. Masked Ball at*

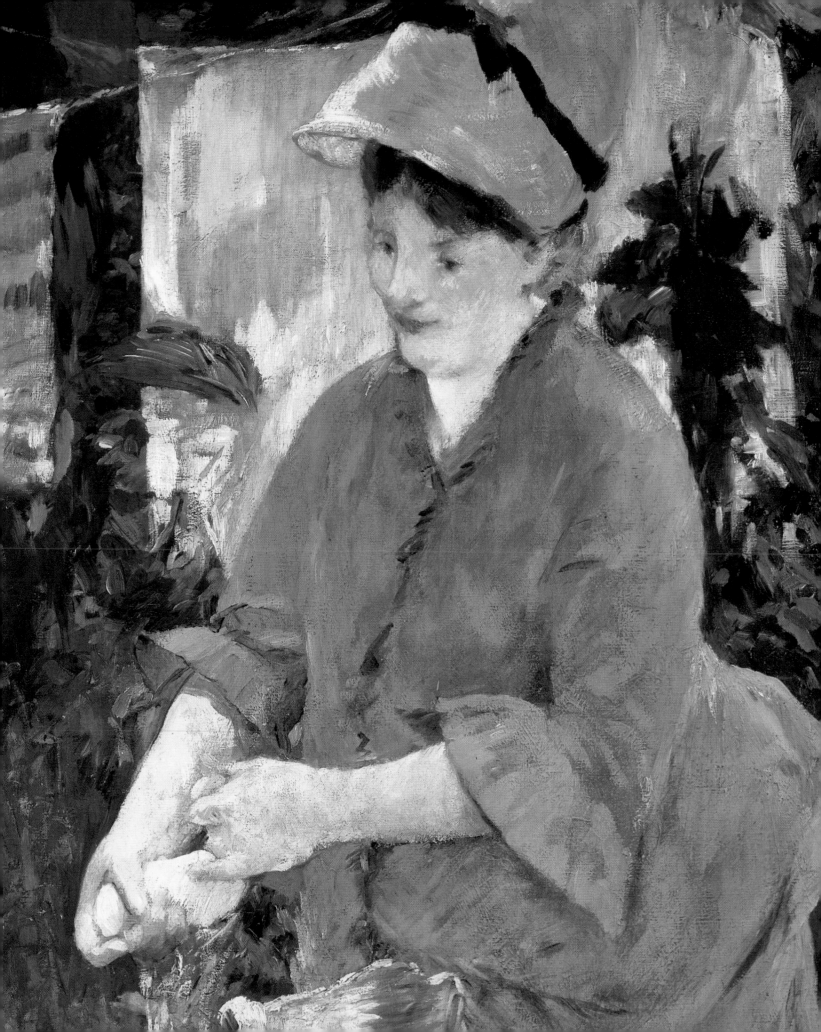

the Opera shows, on a small scale but in vivid detail, the crowded promenade of the old Opera on the rue Le Peletier. A throng of top-hatted men in evening dress jostles and flirts with young women, some in black dominoes, others in costume. In his description of Manet's studio, Fervacques had hailed the painting as "outstanding," drawing attention to the fact that it was intended for Manet's patron Jean-Baptiste Faure and wondering whether the public's response to the picture at the forthcoming Salon would be as enthusiastic as his. The erotic subtext of the composition and its implicit commentary on contemporary morals would have been evident in Fervacques's detailed description in *Le Figaro*, which was widely read both by those depicted in Manet's painting and by those whose business it was to publicize their behavior.[149] Théodore Duret, who himself posed as one of the revelers, commented on Manet's habit of choosing models from the class of persons he wished to represent and cited the names of friends, patrons, and artist colleagues. Duret also noted Manet's insistence that they pose naturally in the studio, wearing their hats as they normally did, "without any affectation," in order to achieve the most varied, life-like effect.[150] When it became known that the Salon jury had rejected the work, Mallarmé published his condemnation of the jury's action and a defense of the picture that emphasized not only the modernity of its subject matter but above all the distinction of its formal realization. It was the latter, in Mallarmé's view, that conferred artistic *gravitas* on an otherwise risqué suject: "There is thus nothing disorderly, nothing scandalous about the painting or that wants to jump out of the canvas but just the opposite: the noble attempt to hold within it, by the means exclusive to this art, a whole vision of the contemporary world."[151]

The jury blackballed Manet's two submissions to the Salon of 1876—*Laundry* (*Le Linge*) and *The Artist*—in early April. Instead of waiting for the jury to reconsider its decision, a process that followed the first round of judging, Manet immediately withdrew both pictures. The papers reported these events as they happened, as they did the artist's decision to open his studio to the public and put on view the two works deemed unworthy by the Salon jury. Announcements were placed in the papers. Elegant invitations were despatched to the press (fig. 151). A clipping service sent Manet a total of seventy-eight articles and mentions culled not only from Parisian but also from provincial newspapers and magazines (fig. 154). Manet had become a household name. Crowds flocked to the studio, which remained open for two weeks. Visitors wrote their names or comical pseudonyms and their remarks on sheets of paper that were set out

> *Faire vrai. Laisser dire*
>
> M. Manet prie Monsieur Stéphane Mallarmé de lui faire l'honneur de venir voir ses tableaux refusés par le Jury de 1876. qui seront exposés dans son atelier, du 15 Avril au 1er Mai.
>
> De 10 à 5h
>
> 4, rue St. Pétersbourg. au rez de chaussée.

151 Card from Mr. Manet inviting *Monsieur Stéphane Mallarmé* to view the pictures rejected by the Jury for 1876 that would be exhibited in his studio from 15 April to 1 May between 10 A.M.. and 5 P.M., 4 rue de St Pétersbourg, on the ground floor, Musée départemental Stéphane Mallarmé, Vulaines-sur-Seine (cat. 83).

each day for that purpose. Only one of the sheets, dated 22 April, survives (fig. 155). The sample of abuse, mockery, and praise that it preserves is clearly representative of the response that the studio's visitors accorded the artist's work.[152] The very same day, Jules Noriac had come to Manet's defense in the gossip column over which he presided for *Le Monde illustré*. This opened with a quip: "Her Majesty the Queen of Spain opened her salons on Easter Sunday, and Mr. Manet opened his on Monday." Support also came in the form of the April issue of *La Galerie contemporaine*, which featured Manet. It included a photographic print of *Le bon bock* and a photographic portrait of the artist (fig. 156), together with a defiant, signed autograph statement—"I've always felt that first place isn't *given*, it's *taken*."[153] Both pictures were photographed by Godet, who had already published a portfolio of photographs of Manet's paintings,[154] and a print of *The Artist* served as the basis for a wood engraving published in *L'Univers illustré* in May 1876 (figs. 152, 153).

152 Jules-Michel Godet after Edouard Manet, *Laundry*, albumen print, c.1875–1876, Pierpont Morgan Library, Tabarant collection, New York (cat. 84).

153 Auguste Trichon after Godet after Edouard Manet, "*Portrait of an Artist*, Painting by M. Manet, Refused at the Salon of 1876 (After a Photograph by M. Godet), Debrousse collection," wood engraving in *L'Univers illustré*, 13 May 1876, Bibliothèque nationale de France, Estampes, Paris (cat. 61).

154 Press clippings related to the rejection of Manet's paintings by the Salon jury and the exhibition held in his studio in April 1876, Pierpont Morgan Library, Tabarant collection, New York (cat. 86).

155 Commentaries and signatures by visitors to Manet's studio exhibition at 4 rue de Saint-Pétersbourg, sheet dated 22 April [1876], Pierpont Morgan Library, Tabarant collection, New York (cat. 85).

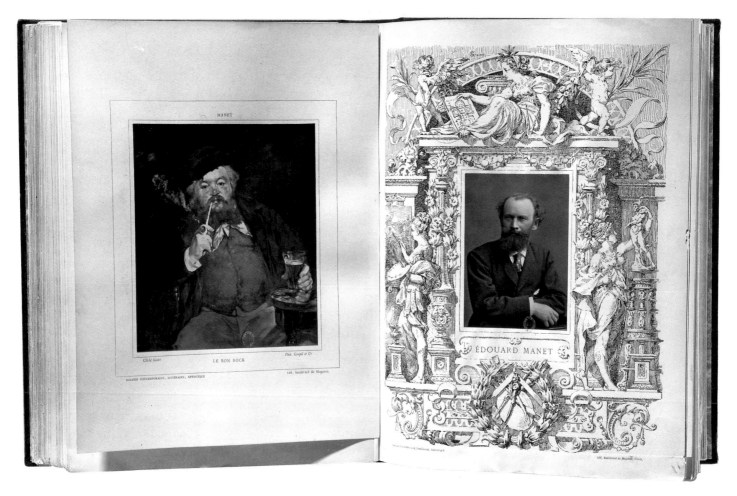

156 *La Galerie contemporaine*, April 1876, Bibliothèque nationale de France, Imprimés, Paris (cat. 88); a double-page spread of the issue devoted to Edouard Manet with an albumen print by Godet of *Le bon bock* on the lefthand page and a photographic portrait of the artist on the facing page.

In preparing his paintings for the Salon of 1876, we know from an unpublished text by Mallarmé that Manet originally planned to submit his study of Ellen Andrée as a fashionable *Parisienne* (fig. 15), together with *Laundry* (fig. 157).[155] In the end he decided to substitute his portrait of *The Artist*, posed by Marcellin Desboutin, a ruined aristocrat, talented painter and drypoint engraver, and pillar of bohemian society (fig. 153). The subject of *Laundry*, a picture that shows a mother and a little child standing beside a

157 Edouard Manet, *Laundry*, dated 1875, 145 × 115 cm, The Barnes Foundation, Merion Station; rejected by the Salon jury in 1876 and exhibited in Manet's studio 15 April to 1 May.

washing tub in an overgrown garden, is best expressed in the words of Mallarmé, for whom it was Manet's absolute masterpiece at that date. He describes the picture as

> deluged with air. Everywhere the luminous and transparent atmosphere struggles with the figures, the dresses, and the foliage, and seems to take to itself some of their substance and solidity; whilst their contours, consumed by the hidden sun and wasted by space, tremble, melt, and evaporate into the surrounding atmosphere . . .[156]

It is one of the most densely worked of Manet's paintings, in which the artist achieved an ideal balance between the spontaneous effect of a *plein air* impression and the refinement that comes only from long meditation and reworking in the studio.

The picture was mocked by visitors and misdescribed by the critics. One of the visitors to the gallery who was evidently most impressed by *Laundry* and whose presence gave Manet the greatest pleasure was Méry Laurent, a young woman of singular beauty and charm, the friend of Stéphane Mallarmé and Alphonse Hirsch to whom Antonin Proust improbably attributed Méry's meeting with Manet.[157] The house in which Mallarmé and Méry Laurent had apartments was only five minutes' walk from Manet's studio, and it seems likely that Méry had been introduced to the artist by Mallarmé or other mutual friends at a somewhat earlier date. She was to play a major role in Manet's life and often posed for him, immaculately dressed and, on occasion it seems, undressed (fig. 158). Manet's letters to Méry, written and illustrated in the 1880s, are among his most delightful productions.[158]

Mallarmé maintained his close contact with Manet and his studio, as a text composed as a memorial to the painter in the early 1890s recalls.[159] He will therefore have watched the development of such projects as Manet's portrait of his patron Jean-Baptiste Faure, of which he owned an early pastel version. Thus he was privy to Manet's preparations for the Salon of 1877. Had the jury accepted the two pictures that Manet submitted, they would have formed a strikingly contrasted pair. The portrait of Faure, dressed in black doublet and hose as Hamlet in Ambroise Thomas's opera (Museum Folkwang, Essen), was ill received both by Faure himself and by the Salon-going public, though Duranty praised it in the *Gazette des Beaux-Arts*. It was reproduced in that journal by Manet's translation of the large canvas into a lively drawing (fig. 159).[161]

The unfavorable reception given to the Salon portrait was in part due to the notoriety already achieved by the other work that the artist had submitted. This was a life-size study

158 Edouard Manet, *Woman in the Tub*, c. 1878–1879, pastel on canvas, 55 × 45 cm, Musée d'Orsay, Paris (cat. 37); a poem by Henri de Régnier suggests that Méry Laurent was the model for this intimate pastel.

159 Edouard Manet, *Faure in the Role of Hamlet*, 1877, pen
and black ink with white gouache, private collection (cat.
35); executed for reproduction in the article by Duranty
on the Salon of 1877 in the *Gazette des Beaux-Arts* where it
appeared in the July 1877 issue, page 67.

of a high-class tart in her boudoir. The painting had been rejected by the Salon jury, and
Manet immediately arranged for its exhibition in a fashionable shop window on the boule-
vard des Capucines, where according to a report by J.K. Huysmans it drew "cries of indig-
nation and derision" from the assembled crowds.[162] Huysmans begins by roundly
criticizing the "singular deficiencies" he sees in Manet's painting, but while comparing its
"awkward execution" with the amiable polish of pictures "with such inane titles as *First
Stirrings*"—by Alphonse Hirsch (fig. 36)—he notes that "no non-Impressionist artist has

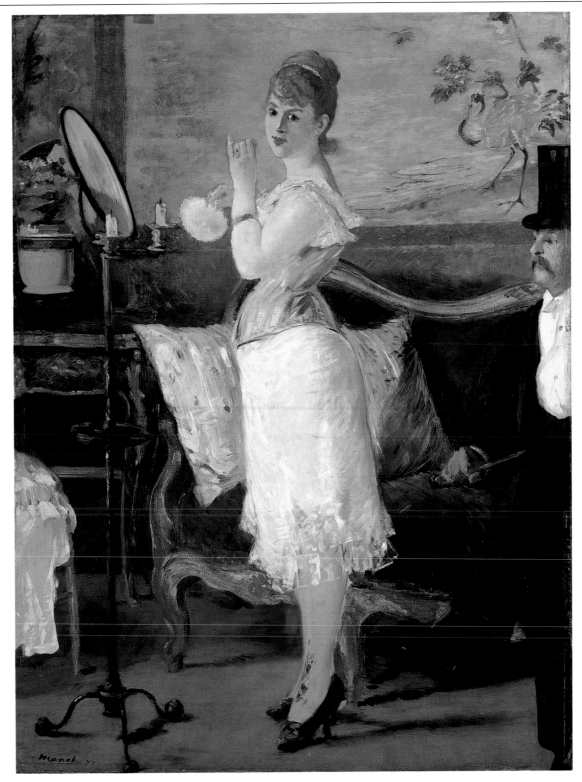

160 Edouard Manet, *Nana*, dated 1877, 154 × 115 cm, Hamburger Kunsthalle (cat. 34); rejected by the Salon jury in 1877 and exhibited in the window of a shop on the boulevard des Capucines.

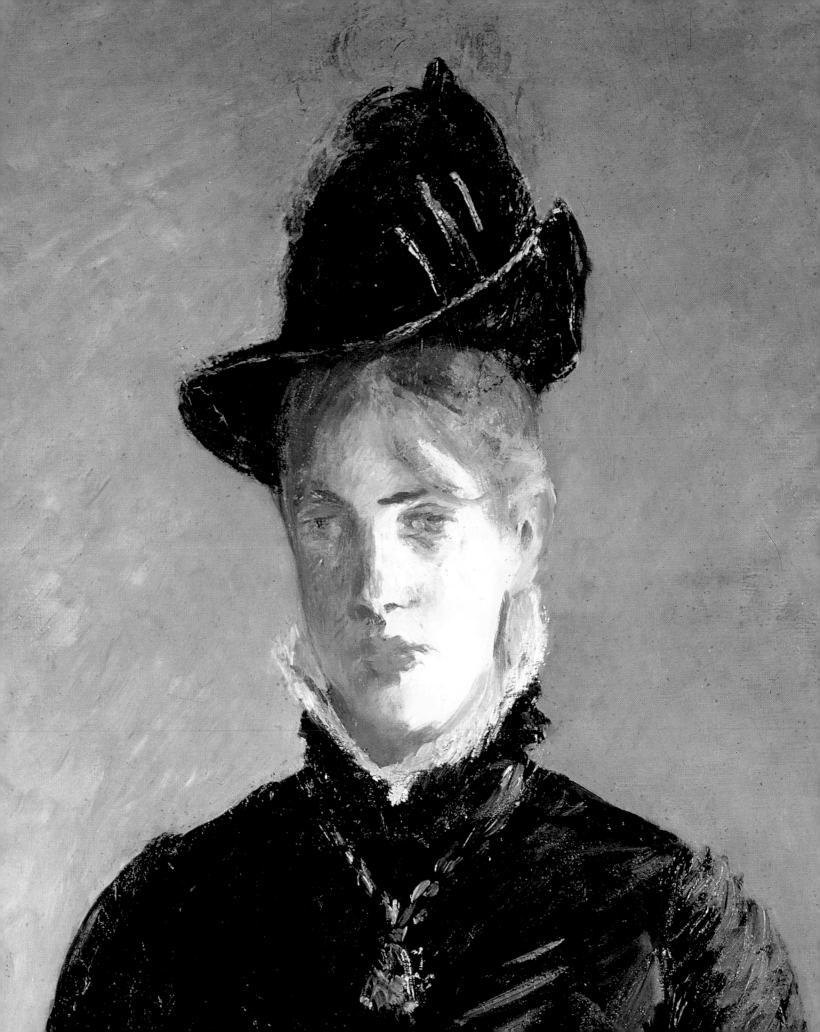

known how to portray a whore!" The demimondaine Henriette Hauser posed for Manet's recreation of a real-life scene he titled *Nana* (fig. 160).[163] Using the props and furniture in his own studio, Manet created a picture that is at once a portrait and a genre scene, a study of a very particular Parisian in a setting typical both of her social status and her calling. In 1878, the year in which Manet moved his studio from the rue de Saint-Pétersbourg to the rue d'Amsterdam, he commented to Antonin Proust and the critic Arsène Houssaye that, although the Second Empire woman typified her period, no one had painted her, nor had he—"but," he added, "I did those who came afterwards," and he cited the names of Nina de Callias, Ellen Andrée, and Henriette Hauser (figs. 15, 135).[164] In his depiction of Henriette Hauser as *Nana*, Manet goes beyond a direct portrait study and beyond the simple description of a situation in a characteristic décor. Every element of the composition—furniture and bibelots, the curving lines of the couch—has been calculated to enhance and echo the visibly readjusted outlines of Nana's shapely figure. Her stance is echoed in the background wall-hanging by that of the crane (the popular meaning of its French name *grue* is tart). The male visitor intrudes into the picture at the right edge with his tense, almost aggressive body language, while Nana turns her head to glance amiably at the spectator. While the public found the presence of the male visitor a tasteless addition, Edmond Bazire regretted it from a compositional point of view and affirmed that the figure had been added at a late stage.[165]

The practice of simulating such a particularized setting as Nana's boudoir in his studio was something that Manet would develop consistently until his recreation of *A Bar at the Folies-Bergère* (Courtauld Galleries, London), his last Salon picture. In *Le bon bock* of 1873 (fig. 158), the artist had posed his drinker at a marble-topped café table against a dark, neutral background. In *Plum Brandy* of some five years later, the café setting with its blond, almost *plein air* tonality, was no doubt created partly with Manet's studio furniture and partly from records of actual café interiors (fig. 162). In both pictures, Manet made significant alterations to the figures; in *Plum Brandy* the pensive girl's drink was originally a tall glass of beer as in the earlier picture, and the framing behind the girl's head was twice modified for pictorial reasons.[166] In contrast to Degas's famously depressing depiction of Ellen Andrée and Marcellin Desboutin in *L'Absinthe* (Musée d'Orsay, Paris), Manet's young prostitute embodies the mingled pleasure, melancholy and humor of an enduring aspect of Parisian life that he would continue to explore until his dying day.

A remarkable lightening of Manet's palette and his continuing search for scenes of

modern life are evident from a comparison of these two pictures of café customers. In *The Railway*, begun in 1872, Manet had already found a quintessentially modern subject and adopted a *plein air* illumination that could be elaborated and perfected in the studio. Yet when Manet's picture is compared with the works of his younger colleagues in the Impressionist exhibitions—Monet's magnificent, freely improvised scenes of the Gare Saint-Lazare (figs. 94–112), Caillebotte's precisely delineated perspectives and carefully positioned figures on the monumental *Pont de l'Europe* and in *Paris Street, Rainy Day* (figs. 68, 76)—it is clear that Manet's aims were more complex than theirs. He both presents and obscures the "reality" of his scenes, disdaining to clarify the story-telling elements that he despised in the history and genre painting so popular in his day, and to which *Nana*, so lovingly crafted as a work of art, was perhaps the closest he ever came.[167]

We have seen that *The Railway* is concerned with very concrete aspects of modern life in general and with Manet's own life in particular. Yet it is also a creation whose claim to be considered as a piece of picture-making is primordial. Its obscurities, its surprises are in part Manet's way of drawing attention to the application of paint to canvas that alone should express what he has to say, just as Mallarmé's arrangements of words creates the meaning of his poems. Elements of the visible world are juxtaposed, sometimes surprisingly, sometimes almost shockingly in the child's bare arm and neck seen from behind against the iron railings and the blank white area of smoke and steam. And by declining to spell out the meaning of his canvases, Manet risked being as misunderstood as Mallarmé was with his use of words.[168]

Manet consistently refused to adopt a formula, to rely on a tried and true method that would have reassured his critics and the public: "I have only one ambition: *not* to stay equal to myself, *not* to do the same thing day after day. I want to keep on seeing things from new angles. I want to try and make people hear a new note."[169] Manet's constant renewal of his means of expression enabled him to capture new experiences on the wing. Above all, he was able to find ways of fusing life and art, of expressing the energy and change of modern life, and of capturing the humanity in his subjects. Through the inescapable presence of two figures pinned against the surface of his canvas—and regarded as prisoners by the shocked Salon public—Manet found a new freedom with which to depict his vision of the modern world on a two-dimensional canvas. *The Railway* signals a new direction after the collapse of a political system and the death and destruction of war. It also points to the future of painting as we have come to know it in its many manifestations today.

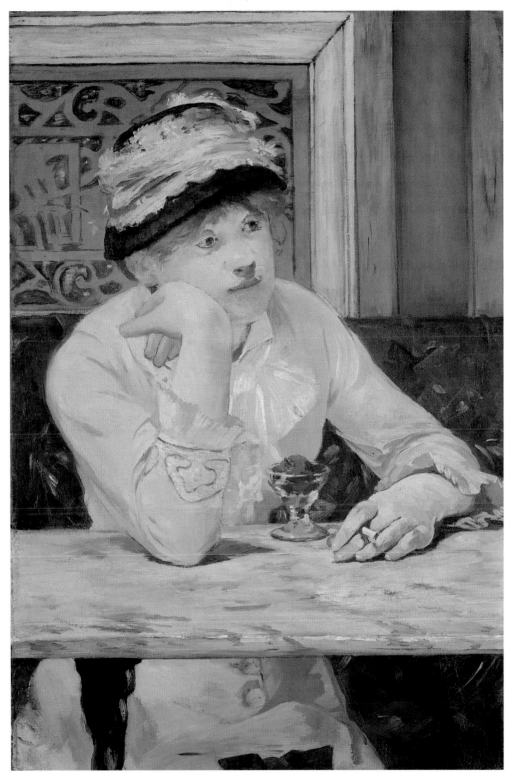

162 Edouard Manet, *Plum Brandy*, c. 1877–1878, 73.6 × 50.2 cm, National Gallery of Art,
Washington (cat. 36).

1 See the discussion of Manet's *"Railway"* in Perspective, p. 41.

2 For accounts of the workings of the Salon in the 1860s and 1870s, see Jane Mayo Roos, *Early Impressionism and the FrenchState (1866–1874)* (Cambridge, 1996); Patricia Mainardi, *The End of the Salon. Art and the State in the Early Third Republic* (Cambridge, 1993).

3 Charles S. Moffett, *The New Painting: Impressionism 1874–1886* [exh. cat., The National Gallery of Art and The Fine Arts Museums of San Francisco] (San Francisco, 1986), 91–142.

4 Stéphane Mallarmé, "The Impressionists and Edouard Manet," *The Art Monthly Review*, 1(9), (30 September 1876), 117. This essential text (reprinted in San Francisco 1986, 27–34) is known only from the English translation attributed to George T. Robinson.

5 The street was opened in 1859 and officially registered in 1860. The location of the building, rediscovered through documents at the Archives de Paris, is now 8 rue Médéric at the intersection with rue Léon Jost (formerly impasse, then rue Roussel) in the 17th arrondissement (AP: D1P4 526 (1862): 1861–1872 *Edouard Manet / art[ist]e Peintre*; VO11 1468). The address that Manet gave as his residence when he was first recorded at the rue Guyot studio was 69 rue de Clichy, where his parents rented two apartments, for themselves and their sons; the rental is recorded under the name Manette from 1855 to 1864 (AP: D1P4 283). The dates supplied by the cadastre confirm those noted by Léon Leenhoff and based on original documents in his possession (see the manuscript register of works by Edouard Manet (circa 1883), Bibliothèque nationale de France, Département des Estampes, Yb3 4649, 8° Rés., front guards (Juliet Wilson-Bareau, "L'année impressioniste de Manet: Argenteuil et Venise en 1874," *Revue de l'art* 86 (1989), 31 fig. 8); and the information in the manuscript notebook "Copie pour Moreau-Nélaton de documents sur Manet . . .," (circa 1910), Bibliothèque nationale de France, Estampes, Yb3 2401, 8° Rés., 67).

Documents show that the street numbers were altered in 1874, and the renumbering led investigators to misidentify the site of the studio building. The documents also confirm that Manet was renting the studio in 1861 and reveal that he kept it until 1872, longer than thought. It was the critic and biographer Duret who maintained that the studio was demolished soon after the end of the siege of Paris (Théodore Duret, *Histoire de Edouard Manet et de son oeuvre* (Paris, 1906), 113, 143).

The so-called "calepins du cadastre" (series D1P4), fact sheets filled in by agents of the cadastre, record information used to calculate real estate taxes, but they also identify the occupants of apartments, houses, and leasehold and rental properties throughout Paris (see Michel Fleury, "Deux sources de l'histoire topographique de Paris conservées aux Archives de la Seine, le Sommier foncier et les Calepins du cadastre," *Bulletin municipal officiel de la Ville de Paris* (19–20 February 1956), 330–331; A. Fierro, *Histoire et Dictionnaire de Paris*, (Paris, 1996), 740, 1483). The dates noted are the dates by which a new occupant had arrived. In the absence of other information, such as a signed lease, they therefore do not allow us to say precisely when a given individual or family takes occupancy. Another very ample but less coherent set of documents, pertaining to the "Voirie"—the administration of public thoroughfares—(series VO11), contains information about the renumbering of individual buildings that helps to confirm the information in the cadastre. Manet's studio at 81 (later 8) rue Guyot is now an apartment and has lost its original studio window. On the second floor of the wing flanking the then impasse Roussel (now rue Léon Jost), it has a floor area of 45 square meters (485 square feet). Manet's sketch of his own studio, painted in 1870, shows Eva Gonzalès and Léon Leenhoff, the illegitimate son of Suzanne Leenhoff, the young Dutch pianist whom Manet married after his father's death in 1863 (reproduced in Juliet Wilson-Bareau, ed., *Manet by himself* (London, 1991), plate 108). On the plaine de Monceau and Manet's studio, see Theodore Reff, "Manet and the Paris of His Time," in *Kunst um 1800 und die Folgen. Werner Hofmann zu Ehren*, ed. Christian Beutler, Peter-Klaus Schuster and Martin Warnke (Munich, 1988), 247–262.

6 In 1863, the other studio was occupied by a now unknown painter named as Eugène Bennetter, who also lived in the building.

7 Douglas Druick and Michel Hoog, *Fantin-Latour* [exh. cat., Grand Palais, Paris, Galerie nationale du Canada, Ottawa, California Palace of the Legion of Honor, San Francisco] (Ottawa, 1983), 203–214.

8 See Françoise Cachin, Charles S. Moffett, Juliet Wilson-Bareau, *Manet 1832–1883* [exh. cat. Grand Palais, Paris, The Metropolitan Museum of Art, New York] (New York, 1983), 67.

9 Antonin Proust, "Edouard Manet. Souvenirs," *La revue blanche* (1897), 133; (Caen 1988; Paris 1996), 21; Wilson-Bareau 1991, 27.

10 For the transformation of this painting, see Juliet Wilson-Bareau, *The Hidden Face of Manet* [exh. cat., Courtauld Institute Galleries] (London, 1986), in *The Burlington Magazine*, 128 (April 1986), (after 314) 37–41. Suzanne Leenhoff had posed for Manet's earlier nudes.

11 Victorine's life and her later career as an artist have been pieced together from sometimes unsourced documents; much remains to be clarified. See Jacques Goedorp, "'L'Olympia' n'était pas montmartroise," *Journal de l'amateur d'art*, 385 (10–25 February 1967), 7; 387 (10–25 March 1967), 7. See also New York 1983, no. 31; Margaret M.A. Seibert, "A Biography of Victorine-Louise Meurent and her Role in the Art of Edouard Manet," PhD. Dissertation,The Ohio State University, 1986; Eric Darragon, *Manet* (Paris, 1989), 69–73. Besides the mention in Manet's early *carnet* (now in the Pierpont Morgan Library, New York) cited by Goedorp, Victorine's name and an address at 195 rue du Faubourg Poissonnière appear in one of Degas's notebooks (Theodore Reff, *The Notebooks of Edgar Degas* (London, 1976, New York, 1985), carnet 8, 221.

12 Proust 1897, 170; (Caen 1988; Paris 1996), 28.

13 Theodore Reff, *Manet and Modern Paris* [exh. cat., National Gallery of Art] (Washington, 1982), 18–20, 171–173; T.J. Clark, *The Painting of Modern Life. Paris in the Art of Manet and his Followers*, (New York, 1985), 23–78; Reff 1988; Jean des Cars and Pierre Pinon, *Paris-Haussmann* [exh. cat., Pavillon de l'Arsenal] (Paris, 1991), 126–134.

14 Proust 1897, 132; (Caen 1988; Paris 1996), 20.

15 Mallarmé 1876, 118; in San Francisco 1986, 29.

16 London, 1986, 42–47.

17 *Edouard Manet. Voyage en Espagne*, ed. Juliet Wilson-Bareau (Caen, 1988) 41; Wilson-Bareau 1991, 34.

18 For interpretations of Manet's picture, see the references in New York 1983, no. 96.

19 Mallarmé 1876, 118; in San Francisco 1986, 30

20 Emile Zola, *Ed. Manet. Etude biographique et critique* (Paris, 1867), with an etching by Manet of *Olympia*; first published in the *Revue du XIXe siècle* (1 January 1867), 43–64.

21 André Fontainas, "De Mallarmé à Valéry," *La Revue de France* 7 (18) (15 September 1927), 330.

22 See *Edouard Manet and the "Execution of Maximilian"* [exh. cat., Brown University] (Providence, 1981); Juliet Wilson-Bareau *et al.*, *Manet: The Execution of Maximilian. Painting, Politics and Censorship* [exh. cat., The National Gallery] (London, 1992).

23 Bracquemond's etchings are accompanied by a text that quotes Théophile Gautier, "L'Art pendant le siège," republished as *Tableaux de siège, Paris, 1870–1871* (Paris, 1871).

24 Wilson-Bareau 1991, 60.

25 Adolphe Tabarant, "Une correspondance inédite d'Edouard Manet. Les lettres du siège de Paris (1870–1871)," *Mercure de France*, (1935), 262–289; *Manet raconté par lui-même et par ses amis*, ed. Pierre Courthion (Geneva, 1953) 1: 53–74; Edouard Manet, *Lettres du siège de Paris* (Paris, 1996); see also Wilson-Bareau 1991, 57–65.

26 X-radiography and infra-red reflectography examinations carried out by the conservation department at the Walters Art Museum and the staff of the Laboratoire de recherche des musées de France show changes in both paintings, in particular in the underdrawing of the Paris composition. This proves that the latter was indeed the preparatory sketch (no doubt subsequently reworked for sale as a "finished" picture) and not a later repetition of the large work. The numerous preparatory drawings require further study to establish their probable sequence. Alexandra Murphy has noted the transformation of the olive branch into a sprig of oak, symbol of France (letter dated September 1996 in the conservation files, Walters Art Gallery).

27 Part of the hostility toward Puvis's painting stemmed from the fact that, as a member of the Salon jury, he had supported Courbet, recently released from the detention that followed condemnation of his active role in the Commune. (See *Le Grelot au Salon* (1872), 1: 8).

28 Adolphe Tabarant, *Manet* (Paris, 1947), 182–183; Wilson-Bareau 1991, 56.

29 At an unspecified date in 1873 the agent of the cadastre recorded the studio as "unoccupied." In 1873 or 1874, an artist named Molé moved in (AP: D1P⁴ 526: 1862).

30 The list of works sold to Durand-Ruel appears on two facing pages of "a little pocket book used by Manet as an address book," described and transcribed by Etienne Moreau-Nélaton, *Manet raconté par lui-même* (Paris, 1926), 1: 132. The present location of the address book is unknown, and it is reproduced here from an unidentified magazine clipping (Moreau-Nélaton archives, Musée d'Orsay, documentation boxes: Manet).

31 Manet's new studio is discussed on pp. 131, 145–146. Manet seems first to have rented a studio at the top of the rue de Saint-Pétersbourg, next to the family home at number 49. On 12 January 1872, Henri Hecht wrote to Manet asking where he had finally settled and whether he could be visited to discuss the purchase of a picture (Moreau-Nélaton 1926, 1: 136). In March, an artist colleague, Palizzi, wrote promising Manet first refusal on the lease of his studio, without giving an address (Bibliothèque d'art et d'archéologie, carton 59, d. 3, nos. 37 and 30). According to the cadastre, in 1872 Manet rented a ground floor room with a window on the street at 51 rue de Saint-Pétersbourg, a building (since destroyed) on the site now numbered 43 (AP: D1P⁴ 1054). Madame Manet *mère*, widowed in 1862, moved to a house built in 1863. She was first tenant of the first floor apartment, above the *entresol*, at 49 rue de Saint-Pétersbourg (previously numbered 33, then 35; from 1880, 41). The cadastre recorded her name in 1865, the year before the artist and his wife joined her there. The rental was transformed into a lease in April 1872, and the Manet family occupied the apartment until 1881; the agents of the cadastre recorded the tenancy variously in the names of *Dame Manet*, *Gustave Manet avocat* (lawyer), or *Edouard Manet peintre*.

32 Little appears to have been recorded about the life and career of Alphonse Hirsch (1843–1884). A pupil of Meissonier and Bonnat, he exhibited prints and drawings at the Salon from 1869, then genre pictures—Goupil photographs record those at the Salon from 1873 to 1876—and, in his later years, portraits. Hirsch exhibited a genre scene titled *Premier trouble* (First Stirrings) at the Salon of 1876 (fig. 36). It was noticed at the time—"M. Hirsch . . . has seen like Manet but painted like Bouguereau" in *Zigzags* 4 (21 May 1876), 6—and Huysmans ridiculed Hirsch's picture in "La Nana de Manet" the following year as typical of one kind of Salon painting (see note 162). For Hirsch's extensive modern print collection, see Frits Lugt, *Les marques de collection de dessins et d'estampes* (Amsterdam, 1921), 24. Drypoint portraits of Hirsch by Degas and de Nittis were made in reciprocal portrait sessions in 1875 (Michel Melot, *The Impressionist Print* (New Haven and London, 1996), 145–147). Nothing is known of a marriage which might support Tabarant's assertion that the child in *The Railway* is "believed to be Hirsch's little daughter" (Tabarant 1947, 222). A letter from Albert Wolff to Manet refers to a serious rift between the two friends (Pierpont Morgan Library, New York; see Tabarant 1947, 310). There is no proof that the two references to "Hirsch" in the Goncourt journal indicate Alphonse Hirsch, rather than others of the same name, including the orientalist painter Auguste-Alexandre Hirsch (1833–1912).

33 The building plot at 58 rue de Rome was acquired in July 1867 from the banker and developer Emile Pereire, and the property was constructed the following year with two artists' studios on the fourth floor of the building at the rear. Described in detail in the cadastre (AP: D1P⁴ 973), the property included two shops on the street front, a coffee merchant on the right and, in 1873, a greengrocer on the left (a possible source for the bunch of grapes added at a late stage in Manet's picture). In the building at the rear, the fourth-floor studio was leased to *Hirsch peintre* from July 1872, and in October 1874 he took a further six-year lease on the premises. In 1872 or 1873, the third-floor apartment was rented to *Hirsch veuve*, presumably the artist's widowed mother who had previously been at 70 rue de Rome; from this date, Alphonse Hirsch is referred to as *Hirsch fils*. Ownership of the ground floor *atelier* and the adjoining garden at the rear remains unspecified in the cadastre records (1862–1900); it is possible that the *atelier* served as a common workshop and storage area rather than as an artist's studio.

Tabarant's indications concerning "Hirsch's garden" and his erroneous identification of the view have led to subsequent misunderstandings about the site of Manet's painting (Adolphe Tabarant, *Manet. Histoire catalographique* (Paris, 1931), 236–237). Apart from Burty's early error in designating the site as the place des Batignolles (see below and note 35), Tabarant was the principal culprit. Although he recognized that Manet's viewpoint was from what he called "Hirsch's garden" at 58 rue de Rome, he described it as forming "a small triangular enclosure between what

is now 2 rue de Constantinople and the first left-hand support of the pont de l'Europe" (Tabarant 1931, 237). In fact, all the houses, including 2 rue de Constantinople and numbers 54, 56, and 58 rue de Rome, have identical small gardens extending along the railway cutting. Tabarant compounded his error by stating that the background view on the left represented an apartment building on the rue de Rome—an absolute impossibility. The problems caused by this confusion are illustrated in Reff 1988, 251 (where the garden has been relocated at 2 rather than 1 rue de Constantinople in order to incorporate the "triangular" garden—as well as the rear elevations of 50 and 52 rue de Rome and 2 rue de Madrid—on the place de l'Europe itself); see also the analysis of the problem in Robert L. Herbert, *Impressionism. Art, Leisure, and Parisian Society* (New Haven and London, 1988), 28, note 40.

34 See Reff 1988, 251, where "the building where [Manet's] studio was located, with its windows overlooking the Place de l'Europe" is identified in terms that are linked to the journalist Fervacques's description of Manet's studio (". . . les verrières qui donnent sur la place de l'Europe."). The studio windows do not in fact "overlook" the place and pont de l'Europe.

Word reached the present writer in September 1997 that Malcolm Park, PhD. candidate at the School of Art History and Theory, College of Fine Arts, University of New South Wales (Sydney, Australia), had independently identified the sites of Manet's painting, both the viewing point on the rue de Rome and the façade at 4 rue de Saint-Pétersbourg. Mr. Park has provisionally titled the forthcoming dissertation that he is preparing "The Engagement of Space Within the Surface of Manet's Paintings as a Conflation of Past and Future."

35 Philippe Burty, "Les Ateliers," *La Renaissance littéraire et artistique* (2 November 1874), 220–221.

36 No precise record of the sale has survived, but the picture was listed in the 1874 Salon catalogue, no. 1260, as belonging to Faure.

37 Stéphane Mallarmé, "Le jury de peinture pour 1874 et M. Manet," *La Renaissance littéraire et artistique* (12 April 1874), 155–157. Manet responded with characteristic frankness in an autograph note: "Thanks. If I had a few more supporters like you I wouldn't give a f . . . for the jury." (Musée départemental Stéphane Mallarmé, Vulaines); illustrated and quoted in Wilson-Bareau 1991, 167.

38 No. 1395: see the plan of the Salon galleries in *Le Temps* (13 May 1874), 3; reproduced in Akiya

Takahashi and Ruth Berson, *Paris en 1874: L'Année de l'Impressionnisme* [exh. cat., National Museum of Western Art] (Tokyo, 1994), 228–229.

39 A., "Au Salon," *La Vie parisienne* 12 (9 May 1874), 267–268.

40 *Le bon bock* was probably the best known of Manet's paintings in his lifetime and was chosen for photographic reproduction in a feature on the artist at the time of his studio exhibition in 1876.

41 [Emile Zola], in *Le Sémaphore de Marseille* (3–4 May 1874); see Emile Zola, *Oeuvres Complètes*, ed. Henri Mitterand 1969), 12: 915; Riout 1989, 167; Emile Zola, *Ecrits sur l'art*, ed. Jean-Pierre Leduc-Adine (Paris, 1991), 272.

42 Ernest Chesneau, "Le Salon sentimental. XII. L'Art et la vie parisienne," *La Revue de France* 11 (July 1874), 113.

43 [Philippe Burty], "Le Salon de 1874. VIII," *La République française* (9 June 1874), 2–3.

44 Technical examination carried out by the staff of the National Gallery Conservation Department has provided much information, not all of it easy to interpret. Infra-red reflectography has revealed underdrawing marks that relate to many of those in the little notebook sketches, although the marks in other areas in the infra-red image lack clear explanation. X-radiography has shown not only the alterations carried out in the course of work but also the strong reserves around the figures, indicating that Manet did not shift their positions, although some adjustments were made, for example, to extend the child's skirt to the left and reduce the outline of Victorine's skirt on the right. The expertise of Sarah Fisher, Ann Hoenigswald and Kristi Dahm is gratefully acknowledged for the interpretation of complex imaging techniques and the scientific material available on the painting.

45 Georges Jeanniot, cited in Moreau-Nélaton 1926, 2: 92; Wilson-Bareau 1991, 302.

46 For references to sources in past art and the iconographical program and significance of *The Railway*, see Seibert 1986, especially 242–244, suggesting sources in Ripa and the *Iconologie* of Boudard; Harry Rand, *Manet's Contemplation at the Gare Saint-Lazare* (Berkeley, Los Angeles, London, 1987); and Michael Diers, *Edouard Manet, Gare Saint-Lazare oder Allegorie des Augenblicks* (provisional title, forthcoming). While Victorine's blue dress and her pose with a book recall images of the Virgin Annunciate or of the Holy Family—such as Raphael's *Alba Madonna* (National Gallery of Art, Washington)—the influence of such early Renaissance masters as Pisanello and Ghirlandaio,

whom Manet could study in the Louvre, is suggested by the child's altered hairstyle and the profile of her head and neck.

47 On Godet, see Elizabeth Anne McCauley, *A.A.E. Disdéri and the Carte de Visite Portrait Photograph* (New Haven and London, 1985), 193.

48 Jeanne Pronteau, "Construction et aménagement des nouveaux quartiers de Paris (1820–1826)," *Histoire des Entreprises*, 2 (November 1958), 8–32.

49 The first stations in Paris were named after the destinations of the trains that departed from them. Thus the earliest name of the Gare Saint-Lazare was *Embarcadère de l'Ouest*, because the trains that left from it took travelers to Normandy and locations up the river Seine. For a brief but comprehensive account of the development of the Gare Saint-Lazare, see Karen Bowie, "La Gare Saint-Lazare," in *Les grandes gares parisiennes au XIXe siècle* (Paris, 1987), 54–68; also Annie Térade, "Le nouveau quartier de l'Europe et la gare Saint-Lazare," *Revue d'histoire des chemins de fer*, 5–6 (1991–1992), 237–260; Marie-Laure Crosnier Leconte, *La naissance des gares* (Musée d'Orsay, Paris, n.d.). It was originally intended for the railway line that passed beneath the place de l'Europe to terminate beside the rue Tronchet behind the Madeleine (see fig. 58).

50 See David H. Pinkney, *Napoleon III and the Rebuilding of Paris* (Princeton, N.J., 1958), 92.

51 The plan was published as a supplement to an article by G. Lenoir, "Chemin de fer de Saint-Germain. Gare de la rue Saint-Lazare," *Journal des chemins de fer* 12 (30) (23 July 1853), 579–580. It shows the size and site of the original Gare de Saint-Germain of 1837 and the newly enlarged Gare Saint-Lazare with its five sets of tracks: the old Gare de Rouen, le Havre and Dieppe, and the Gare de Saint-Germain; then the Gare d'Argenteuil; the Gare d'Auteuil; and, beneath Flachat's giant roof, the new Gare de l'Ouest et de Versailles. The text accompanying the map noted that forty million travelers had used the station since it opened in 1837 and that more than 40,000 travellers were carried on some days.

52 In 1860 a note by G. Danès, "L'ancien quartier de l'Europe. Le boulevard de Malesherbes. Elargissement partiel de la rue Saint-Lazare, etc.," *Revue municipale* (10 March 1860), explained the developments effected since 1826 and published the text of the decree of 30 June 1859 concerning the road works to be carried out around the place de l'Europe; it does not refer to the new bridge. I am grateful to David van Zanten for bringing this

article to my attention.

53 The Hélios photographs taken from the station (figs. 55, 66) do not show the property formed by 2 rue de Saint-Pétersbourg and 40 rue de Berlin (now rue de Liège) that would later front on the place de l'Europe on the right (according to the cadastre it was constructed in 1869). Nor do they show the property on the left, built in 1872, that would form the northwest corner of the place at 2 rue de Constantinople and 54 rue de Rome. The elegant uniformity of the elevations and gardens that form the place de l'Europe was in line with those that Baron Haussmann had imposed on the place de l'Etoile; see Pinkney 1958, 63.

54 The site was acquired by Martial Caillebotte, a wealthy businessman, from the city of Paris in January 1866, and construction of a splendid private residence had been completed by November 1867. See Herbert 1988, 19; Anne Distel, Douglas Druick *et al.*, *Gustave Caillebotte 1848–1894* [exh. cat., Galeries nationales du Grand Palais, The Art Institute of Chicago] (New York, 1995), no. 59; also the revised [exh. cat., Royal Academy of Arts] (London, 1996), no. 13. It should be pointed out that the attribution to Caillebotte of a supposed oil sketch in the Albright-Knox Art Gallery, Buffalo, appears highly questionable to this writer, and that the de Nittis painting of a bridge, reproduced as a comparative figure in the exhibition catalogues, does not represent the pont de l'Europe.

55 Kirk Varnedoe, through monographs and exhibition catalogues, has been largely responsible for redefining the importance of Caillebotte's work.

56 The bridge is a central motif in Zola's *La Bête humaine*, which was written in 1888–1889 but whose action is set in 1869–1870.

57 See the discussion of these effects by Peter Galassi in Varnedoe 1987, 27–34, and Varnedoe's analysis, 72–79. Malcolm Park's forthcoming dissertation (see note 34) will address these issues.

58 X-radiography and an infra-red examination were carried out in the Laboratoire de recherche des musées de France in August 1997. I am very grateful to Anne Roquebert and Patrick Le Chanu for making this possible.

59 In *L'Evénement* (6 April 1877), 2; Ruth Berson, *The New Painting. Impressionism 1874–1886. Documentation* 2 vols. (San Francisco, 1996), 1 *Reviews*:145.

60 This problem was addressed in a small oil study of the bridge structure; see Varnedoe 1987, 79, fig. 15t; New York 1995, 142–143, no. 30.

61 Washington 1982, no. 13 (the sketch for this picture); New York 1995, no. 31.

62 See the analysis of Caillebotte's paintings in Herbert 1988, 22–24; Varnedoe 1987, 80. For a recent study of Caillebotte's relationship to urban development in Paris and to the political and social context within the Europe district, see Julia Sagraves, "The Street," in London 1996, 64–77.

63 The intersection known as the carrefour de la rue de Moscou was officially renamed place de Dublin in January 1987.

64 See note 31.

65 New York 1995, nos. 37–55.

66 See Galassi in Varnedoe 1987, 36–38.

67 Significantly, a critic who called Caillebotte's painting the *Carrefour de la rue de Moscou par un temps de pluie* gave it a more precise title than it had in the exhibition catalogue, but he then went on to argue that neither the subject, the figures, nor the painting itself were of any interest (Charles Bigot in *La Revue politique et littéraire* (28 April 1877); Berson 1996, 1: 135). The nature of the paving stones, of which Caillebotte made a special study (see New York 1995, no. 38) had been specified with great precision by the roads and bridges department of the city of Paris in 1878. On 23 March 1878, the Tramways-Nord company was informed that from the boulevard des Batignolles to the carrefour de la rue de Moscou the *pavés* were top-quality 13 × 20 cm. stones from the Arkose quarry, while those from the carrefour to the pont de l'Europe were top-quality 10 × 23 cm. stones from the Yvette quarries (AP: VO[11] 3370, file on the "prolongement de la ligne de tramway").

68 The proposal for the islands, put forward in November 1877 and implemented the following January, pointed to their "undoubted usefulness with regard to the traffic, which crosses in every direction and which the pedestrians often have great difficulty in avoiding." (AP: VO[11] 3370, "Projet de Refuges R. de S[nt] Pétersbourg.")

69 See the forthcoming catalogue raisonné by Patrick Offenstadt; I am grateful to Mme. Nicole Castais of the Wildenstein Institute, Paris, for information concerning Béraud's paintings.

70 Béraud's *Return from the Burial* (Offenstadt no. 323) and Goeneutte's *Boulevard de Clichy Under Snow* (National Gallery, London). Goeneutte's etching after his Salon picture was published by Cadart in *L'Illustration nouvelle*: see Christian Duvivier, *Norbert Goeneutte 1854–1894* [exh. cat., Musée de Pontoise] (Pontoise, 1994), 69, no. 108.

71 A. Joanne, *Paris illustré en 1870* (Paris, 1871), 134. The land was acquired by Jules Adolphe Clairin from the city of Paris in January 1867, and the house was

completed in the following year (AP: D1P[4] 973). The Clairin family resided in the grandly conceived building, whose top floor fronting the street was leased to the architect Edmond Petit de Villeneuve from 1869 (see Anne Dugast and Isabelle Parizet, *Dictionnaire par noms d'architectes des constructions élevées à Paris aux XIXe et XXe siècles*, ed. Michel Fleury (Paris, 1996), 4: 32, no. 3876). The rear building overlooking the railway consisted of artists' studios. One of two very large ground floor studios was occupied by Firmin Girard (1838–1921), the other by an artist named Colinet. In 1873, Georges Clairin took over Girard's studio and later the whole ground floor. A very large studio on the first floor was leased to Maxime du Camp, the writer, chronicler of Paris, and friend of Flaubert, who evidently lived there from 1870 until 1887, when Henri Gervex took over the premises. Norbert Goeneutte moved into the third floor studio vacated by Gervex. Photographs of Gervex in the third floor studio are known (reproduced in *The Studio* 9 (1896), 27; see John Milner, *The Studios of Paris* (New Haven and London, 1988), 168 fig. 196; Jean-Christophe Gourvennec *et al.*, *Gervex* [exh. cat., Musée des Beaux-Arts] (Bordeaux, 1992), 32.

72 The pastel shown in 1884 has not been identified. De Knyff, Goeneutte's biographer, seems not to have known about the third-floor studio and refers only to views taken on the bridge itself or identified by him as from the boulevard des Batignolles (Gilbert de Knyff, *L'Art libre au XIXe siècle ou la vie de Norbert Goeneutte* (Paris, 1978)). The etching *Woman with a Little Dog* combines Caillebotte's *On the Pont de l'Europe* (fig. 75) with the fashionable female figures in Béraud's painting (fig. 84). See Christian Duvivier, *Norbert Goeneutte 1854–1894*, [exh. cat., Musée de Pontoise] (Pontoise, 1994) 42, no. 47.

73 Salon of 1887, no. 1059, *Crépuscule parisien*; Salon of 1888, no. 1151, *La Fin du jour*. On 11 March 1888, Goeneutte wrote to George Lucas, the Baltimore collector and art dealer then resident in Paris, inviting him to see the picture that he intended to send to the Salon (letter in the Baltimore Museum of Art). Lucas's diaries show that he bought the painting the following day: "At Goeneutte's & bought picture Pont de l'Europe for 200 fr." (see Checklist). I am grateful to Jay Fisher for his help in documenting this picture.

74 The painting with the scaffolding, present location unknown, was last exhibited in 1983: *Fine Paintings 1880–1930* [exh. cat., Whitford and Hughes] (London, Summer 1983), no. 14, color reprod., incorrectly identified with the 1884 pastel. I am

grateful to Adrian Mibus for help in trying to locate the painting.

75 For a photograph of the studio occupied by Anquetin at 62 rue de Rome, see Milner 1988, 167, fig. 194.

76 AP: D1P⁴ 556 (1862): 1872–1875 *Monnet* (sic). Daniel Wildenstein, *Claude Monet. Biographie et catalogue raisonné*, 4 vols. (Lausanne-Paris, 1974–1991), 1: 83; John House, *Monet: Nature into Art* (New Haven and London, 1986), 147; Paul Hayes Tucker, *Claude Monet: Life and Art* (New Haven and London, 1995), 49–51; Daniel Wildenstein, *Monet or The Triumph of Impressionism*, 4 vols. (Cologne, 1996), 1: 91–92.

77 This *esquisse* was painted over a thinly worked *ébauche*, probably a landscape (since green shows through in the sky) whose more heavily impasted brushstrokes are visible beneath the surface, and thinly applied colors extend around the stretcher. X-radiography undertaken at the Laboratoire de recherche des musées de France was unable to reveal the identity of the underlying composition. The cooperation of Mr. Christian Olivereau is gratefully acknowledged.

78 See Tucker 1995, 53–90.

79 See Tucker 1995, plates 82 and 85.

80 Letter to an unknown correspondent, dated Argenteuil, 7 January 1877. Wildenstein 1974–1991, 1: 431, no. 100. The letter refers to unsuccessful negotiations to obtain permission to paint in the station and hopes for the intercession of a M. Coindant.

81 Richard R. Bretell, "The First Exhibition of Impressionist Painters," in San Francisco 1986, 189.

82 AP: D1P⁴ 741 (1876): 1877–1879 *Caillebotte*. For the letter to Charpentier, see Wildenstein 1974–1991, 1: 83, 431, no. 101.

83 The 1877 exhibition catalogue (see San Francisco, 1986, 205) provides unequivocal identification of three paintings—nos. 97, 98 and 100 (figs. 98, 99 and 103), those loaned by de Bellio and Hoschedé—and almost certainly that of no. 102, the *Vue intérieure de la gare Saint-Lazare* (fig. 94). Three further works, catalogued simply as *Intérieur de la gare Saint-Lazare, à Paris*, remain to be identified among five extant paintings (figs. 100, 102, 106–108) that show the "interior" of the station—the area between the station buildings and the pont de l'Europe—as opposed to the "exterior" views of the tracks beyond the bridge (figs. 111–114). In notices of the show, critics cite between five to six and eight to ten views of the station by Monet (see Berson 1996, 1: Bernadille, Bigot, Descube, de

Lora, Maillard). More than one critic indicates that some pictures did not have catalogue numbers on their frame, and these statements have sometimes been considered as authorizing the interpretation that the show included additional works that were not listed in the published catalogue. One such unnumbered, "supplementary" picture, characterized by "a fiercely threatening disc that dominates the foreground" ("un disque menaçant et farouche qui domine le premier plan," see Berson 1996,1: 139; 2 *Exhibiterd Works*: 78, no. III-HC10), has been identified with the canvas now in Hannover (fig. 107). However, another picture that lacked a number on the frame can clearly be identified as no. 97 (fig. 99; Berson 1996, 1: 134), and there appears to be no proof that more than the seven catalogued works were exhibited.

John House has expressed the view to this writer that the description of "a fiercely threatening disc that dominates the foreground" of the canvas could apply, in terms of nineteenth-century critical response, to a very bold picture that Monet initialed and dated—one of three that he sold to Hoschedé in March 1877 (fig. 108)—and that this is more likely to have been the picture shown in April. Yet only the Hannover canvas appears to correspond with the one described by Rivière (admittedly in his November 1 "Souvenirs" of the show): "Another picture is a mass of disks; a train has just gone by, and the smoke billows over the track in big, heavy clouds" (Berson 1996, 1: 187). For comment on the number of Monet's views of the station exhibited, and their identification, see Berson 1996, 2: 76, no. III-97.

84 Bernadille in *Le Français* (13 April 1877), 2; Berson 1996, 1: 130. Bernadille was the pseudonym of the writer Victor Fournel (Brunet 1889), col. 8. For the identity of Fervacques , see Gustave Brunet, *Dictionnaire des ouvrages anonymes suivi des supercheries littéraires dévoilées* (Paris, 1889), col. 8; J. Richardot, *Dictionnaire de biographie française*, (1967), 11: cols. 1218–1219.

85 E. Zola in *Le Sémaphore de Marseille* (19 April 1877): Denys Riout ed., *Les écrivans devant l'impressionnisme* (Paris 1989), 167; Berson 1996, 1: 191. See also Tucker 1995, 96. A more critical reviewer expressed surprise at the number of pictures of the Gare Saint-Lazare and wondered whether they constituted a homage to the absent Manet, "a precursor whose splendid studio shines over the place de l'Europe, looms over the Pont de l'Europe, and has for its everlasting horizon the cloud of smoke that rises unceasingly from a hundred

locomotives." The same writer added, "Almost all the 'impressionists' have been through M. Manet's studio, and they still have the smoke of the Gare Saint-Lazare in their eyes." L.G., in *La Presse* (6 April 1877), 2; Berson 1996, 1: 148.

86 Emile Zola, *La Bête humaine*, trans. Leonard Tancock (London, 1977), 19 (the translation slightly emended here).

87 The twelfth painting, a view of the track and a bridge to the north of the Batignolles tunnels (fig. 114), remains unlocated. See Germain Bazin, *L'Epoque impressionniste* (Paris, 1953), plate 36 (reproduced from a Vizzavona photograph).

88 It has generally been assumed that the most finished pictures (figs. 94, 98) were probably the first to have been executed (e.g. Tucker 1995, 96) and that the boldest and most "abstract" were the latest (figs. 107, 108). However, John House has confirmed orally (August 1997) that there is no objective support for this assumption.

89 Wildenstein 1974–1991, 5: D. 125, 150–154. See House 1986, 229–230; Nicolas Wadley, *Impressionist and Post-Impressionist Drawings*, (New York, 1991), 154.

90 Early photographic views of the station are reproduced in Rodolphe Walter, "Saint-Lazare l'impressionniste," *L'Oeil*, 292 (November 1979), 48–55.

91 In John House's opinion, the date was probably added later.

92 See the discussion of this work in note 83. If it was lent to the Impressionist exhibition, Hoschedé's ownership was not recorded in the catalogue.

93 A photograph of 1878 (fig. 113) shows large advertising panels on the wall below the rue de Rome, near the Batignolles tunnels (*La Vie du Rail*, no. 16370).

94 Hugues Le Roux, "Silhouettes parisiennes. L'exposition de Claude Monet," *Gil Blas* (3 March 1889), 1–2; cited in House 1986, 137. I am grateful to John House for initially providing a transcription of part of Le Roux's text. House has suggested that Le Roux erred in placing his recollection of Monet in the summer, but it is at least possible that Monet continued to paint in the Gare Saint-Lazare during and after the April exhibition. House has also expressed to this writer the view that Monet may have added the signature and date 1878 to the "sunny" canvas—and erred in the dating—when Durand-Ruel acquired the picture in the 1890s.

95 Later that year, Rivière referred to "the inventiveness and power of this painter, who endows inanimate objects with the life that others

give to their human figures." Georges Rivière, "Les Intransigeants et les impressionnistes: Souvenirs du salon libre de 1877," *L'Artiste* (1 November 1877), 298–302; quoted in Berson 1996, 1: 187.

96 Moreau-Nélaton 1926, 2: 96; Wilson-Bareau 1991, 261

97 Proust 1897, 178, 203; (Caen, 1988; Paris, 1996), 39, 46.

98 For the money order, see Adolphe Tabarant, "Autour de Manet," *L'Art vivant* 79 (1 April 1928), 349, reproduced. For Monet's campaign to acquire *Olympia*, see New York 1983, 183, "Provenance."

99 Archives de Paris: D1P^4 1054 (1862). The architect was Pierre-Eugène Chauvet (AP: VO11 3370). Alfred Coulomb, an associate of Chauvet, acquired the house in 1881 and added a wing to it (see note 113). There were very few properties on the street until 1861. In 1863, the house at 49 (later 41) was built (see note 31). By 1872 the house at number 4 was one of a virtually uninterrupted sequence of apartment buildings stretching up the street from the pont de l'Europe.

100 Fervacques, "L'Hiver à Paris," *Le Figaro* (27 December 1873), 1; quoted in Moreau-Nélaton 1926, 2: 8–10. For the identity of Fervacques, see Brunet, 1889, col. 35; J. Richardot, *Dictionnaire de biographie française*, (1967), 11: cols. 1218–1219.

101 The area is marked *Docks Napoléon* on some city maps of the early 1860s.

102 AP: D1P^4 773 (1862) and 116 (1876). Armand Mosnier's name first appears, often misspelled (for example, as Arnaud Monsnier), on maps published in 1870. The street is not yet marked on the map titled "Paris en 1871. Les Opérations de Voirie exécutées de 1854 à 1871" in an atlas published in 1889 (fig. 77). The name rue Mosnier was adopted officially in 1881, but the street was renamed rue de Berne, for the Swiss capital, in 1884. In the Didot-Botin of 1870, Mosnier, then living at 28 rue de Moscou, was listed as a *propriétaire-constructeur* and as a *chevalier* of the Legion of Honor. Several if not all the rue Mosnier houses were designed by the architect Joseph Olive, who owned and lived in the large corner building at number 2 and also owned two more properties on that side of the street. The others belonged to Mosnier, who ceded two of them, together with his house on the rue de Moscou, to the Société anonyme de la propriété urbaine in 1874 when he left Paris for Belgium. Very little is known about his career. With Olive as his architect, he constructed apartment buildings and a hotel in Brussels before filing for bankruptcy there in 1879. See Yvon Leblicq, "Les villes

haussmanniennes," *Cahiers Bruxellois*, 26 (1981–1984), 78–80; reprinted in *Hommage à V. G. Martiny* (Institut d'Urbanisme et d'Aménagement du territoire de l'Université libre de Bruxelles, 1985), 38–40; "La Belgique et le modéle haussmannien," in A. Lortie, *Paris s'exporte. Architecture modèle ou modèles d'architecture* (Paris, 1995), 78 and fig. 77; Yvon Leblicq, *L'haussmannisme à Bruxelles* (in preparation).

103 See note 53.

104 Emile Zola, *Nana*, chapter 8: "a quiet new street in the Europe district, no shop fronts, but fine houses with cramped little apartments inhabited by ladies"; "stockbrokers' and merchants' coupés stood by while men walked quickly, raising their eyes to the windows where women in peignoirs seemed to wait." The novel, written in 1878–1879, is set in the Paris of 1869–1870, so only the grander houses on the even-numbered side of the street would in fact have existed. For Zola's notes, in particular the passage on Lucie Lévy, "Chez une grue . . . Rue Monnier" (sic), see Henri Mitterand, *Carnets d'enquêtes. Une ethnographie inédite de la France par Emile Zola* (Paris, 1986), 317.

105 Joris-Karl Huysmans, *A Rebours*, chapter 6: "he'd taken the kid to madam Laure's. In a third-floor flat on the rue Mosnier papered in red, decorated with round mirrors, and furnished with sofas and washstands, she kept a collection of 'florists.'" The novel was published in 1884.

106 In attempting to place Manet's views of the rue Mosnier in their chronological sequence, it is useful to note that the sun casts shadows directly across the street, so the time of day must be early afternoon. There appears to be a measurable difference between the *Pavers* picture and the *Rue Mosnier Decorated with Flags*. In the first the sidewalk is of normal width and continues uninterrupted to the end of the street, whereas in the second the wooden fence encroaches on the sidewalk leaving a space too narrow for pedestrians, and there seem to be piles of rubble behind the fence. It is unclear whether the paving of the roadway would have preceded or followed this stage in the development of the foreground area.

107 See Jane M. Roos, "Within the 'Zone of Silence': Monet and Manet in 1878," *Art History* 11, September 1988), 374–407; Philip Nort, "Manet and Radical Politics," *Journal of Interdisciplinary History* 19 (Winter 1989), 462–465.

108 I am grateful to the staff of the departments of Prints and Drawings and of Paper Conservation at the Art Institute of Chicago and the Metropolitan Museum of Art for enabling me to study their

drawings and for providing technical information. For a discussion of drawings for transfer lithographs, see Juliet Wilson-Bareau and Breon Mitchell, "Tales of a Raven. The Origins and Fate of *Le Corbeau* by Mallarmé and Manet," *Print Quarterly* 6 (September 1989), 279–280.

109 Manet's transfer lithographs were sometimes published as original prints, sometimes reproduced by gillotage, as relief blocks, in newspapers and pamphlets.

110 Manet's cover design for the song "Les Mendiants" features the one-legged man from the rue Mosnier painting. See Juliet Wilson, *Manet dessins aquarelles eaux-fortes lithographies correspondance* [exh. cat. Galerie Huguette Berès] (Paris, 1978), no. 14, reproduced facing no. 83; Wilson-Bareau 1991, 230, plate 180.

111 Edmond Duranty, *La nouvelle peinture. A propos du groupe d'artistes qui expose dans les galeries Durand-Ruel* (Paris, 1876); reprints: San Francisco 1986, 477–484, 482; translated 37–47, 45; (Caen, 1988); Riout 1989, 108–134, 127, 39.

112 Tissandier and Gilbert, "Paris qui travaille," *Le Magasin pittoresque* (1883), 384, 385; reproduced in Dugast and Parizet, 4, 1996, 5 fig. 3, 170 fig. 9.

113 See note 99. A side wing was added to the building in 1882 (AP: D1P^4 1054: 1876), but when Manet occupied the upper ground floor studio the property consisted only of the building fronting on the rue de Saint-Pétersbourg and the courtyard behind it.

114 AP: D1P^4 1054 (1862). The apartment, described as *Rez de Chaussée* (Ground floor), consisted of the *Salle d'armes* [with a later inscription *Atelier*, with four windows on the street] / *par Escal[ier] Intérieur / Petit Salon* [with one window on the street over the entrance] / *avec balcon sur la / Salle d'Armes. / à G[auche] / Petit Carré* [including] / *Ch[ambre] à feu / Cab[inet] de Toilette / Anglaises* (flush toilet) [each with a window on the courtyard] / *par Esc[alier] de Service / au Sous Sol: / Cuisine / Office* [with windows on the street]. In the 1876 cadastre, the main room was described as an *Atelier*.

115 See note 100.

116 The landscape known as *The Swallows* (*Les Hirondelles*) (Denis Rouart and Daniel Wildenstein, *Edouard Manet. Catalogue raisonné*, 2 vols. (Lausanne-Paris, 1975), 1: 166, no. 190; Wilson-Bareau 1991, 166, plate 123), was rejected by the Salon jury together with *Masked Ball at the Opera*. For the *Polichinelle*, see Ronald Pickvance, *Manet* [exh. cat., Fondation Pierre Gianadda] (Martigny, 1996), 104, 231, no. 44.

117 For regulations concerning the Salon of 1874, see

Geneviève Lacambre, "Le Salon de 1874," in Tokyo 1994 (French texts edition), 35.

118 The painting had probably already left the studio, having presumably been completed earlier in 1873 and delivered to Jean-Baptiste Faure.

119 Since Manet was a "gossip column" figure renowned for his witty remarks, it is very possible that further material relating to the man and his studio will come to light if the contemporary press is examined with great care and the examination is extended to pieces unconnected with the annual Salon or the artist's private shows.

120 Gérôme, in the column "Courrier de Paris", *L'Univers illustré*, 1876, 306; quoted in Darragon 1989, 262–263. Gérôme was a pseudonym used by Albert Wolff, among others, in *L'Univers illustré* (J.-M. Quérard, *Supercheries littéraires dévoilées . . .*, ed. Gustave Brunet and Pierre Jannet (Paris, 1869–), 2: col. 171).

121 This was evidently a "souvenir" of Poe's raven and one of the images in *Le Corbeau*, published the previous year (fig. 145).

122 Bernadille in *Le Français* (21 April 1876), included in Manet's collection of clippings (Pierpont Morgan Library, New York, Tabarant collection, sheets 29–34).

123 See Darragon 1989, 261–268, for a montage of newspaper accounts by J. de Paris (A. Marx) in *Le Figaro* (19 April), the anonymous "La journée à Paris. M. Manet chez lui" in *L'Evénement* (20 April), and Junius in *Le Gaulois* (25 April).

124 Ambroise Vollard, *Souvenirs d'un marchand de tableaux* (revised edition, Paris, 1984), 167.

125 For the description of the "walls painted red", see Bernadille in *Le Français* of 21 April (cited at note 122). The portrait of Berthe Morisot dated 1873 shows her reclining against a red-brown wall with decorative motifs, probably the wall of Manet's studio (Marianne Delafond and Caroline Genet-Bondeville, *Berthe Morisot ou L'Audace raisonné* [exh. cat., Musée Marmottan-Claude Monet] (Paris, 1997), 102, no. 34); the same reddish tone appears in the backroom of other portraits painted in the studio (fig. 134). Léon Leenhoff noted the unusual white frames on a number of works in his manuscript register, reproduced in the Lochard photograph albums, e.g. "Départ d'un vapeur pour Folkestone" (Rouart and Wildenstein 1975, 1: 136 no. 146) and "Panneau décoratif—Vase de fleurs" (Rouart and Wildenstein 1975, 1: 214 no. 266), both described as with a "cadre blanc, filet bleu" but subsequently gilded by Nivard for the 1884 Ecole des Beaux-Arts exhibition (Pierpont Morgan

Library, New York, Tabarant collection: Lochard albums, 1: 28, no. 13; 3: 67, no. 15).

126 When the additional wing was constructed in 1882, access to and from the new apartment adjoining the studio was provided through a door near the end wall with the fireplace.

127 Proust 1897, 178; (Caen 1988, Paris 1996), 39.

128 Proust 1897, 203; (Caen 1988, Paris 1996), 46.

129 See note 159.

130 The swiftly brushed motifs of leaves and grasses recall the reeds and rushes in Manet's images in *L'Après-midi d'un faune* of that same year (fig. 147).

131 David Degener, *Mallarmé nous appartient* (forthcoming).

132 Mallarmé 1876 (see note 4); Duranty 1876 (see note 111).

133 Proust 1897, 125; (Caen, 1988; Paris, 1996), 10.

134 "Did it ever pass through *my* mind to kill the duc de Guise? Do *I* want to bring Napoleon back to life?" he asked in 1876, referring to paintings in the Salon. See Proust 1897, 201; (Caen, 1988; Paris, 1996), 43.

135 Berthe posed for *The Balcony* (Musée d'Orsay, Paris), shown at the Salon of 1869, and for *Repose* (Museum of the Rhode Island School of Design, Providence), shown at the Salon of 1873 together with *Le bon bock*.

136 The object on the floor, which has sometimes been described as a book, was identified when the studio was examined by this writer, with the kind cooperation of the present owners. When raised, the brass vents set into the parquet wood floor around the room reveal a row of curved rods that serve to shield the open vent.

137 Nina was married for a time to the journalist and man-about-town Hector de Callias, who wrote to Manet objecting to any public display of the portrait. Pierpont Morgan Library, New York (see Tabarant 1947, 239–240).

138 The habitués of Nina's *salon* included the engraver and painter Marcellin Desboutin (fig. 153), the poet and dramatist Jean Richepin, the eccentric musician Ernest Cabaner, the poet and inventor of color photography and the phonograph Charles Cros, and such more recognizable names as Auguste Villiers-de-l'Isle-Adam and Paul Verlaine.

139 The wood engraving is known in a few rare proofs. See Guérin 1944, no. 92; Harris 1970/1990, no. 76; *Bibliothèque nationale, Inventaire du fond français, Graveurs du XIXe siècle*, ed. Madeleine Barbin and Claude Bouret, 15 (Paris, 1985), 112 no. 80, 113 ill.

140 Letter from Cros to Manet, Pierpont Morgan Library, New York (see Tabarant 1947, 229).

141 Also published with *Civil War* was a lithograph of

The Urchin (Le Gamin), after one of Manet's paintings sold to Durand-Ruel in 1872 (see note 30). On the illustration for the Belgian journal *L'Europe*, see Paul Van den Abbeel and Juliet Wilson-Bareau, "Manet's *Au café* in a banned Brussels paper," *The Burlington Magazine* 131 (April 1989), 283–288.

142 One of only two known proofs from the original stone, this hand-colored version served as a guide for the color stones of the chromolithograph, published as a print "after Manet" (see checklist).

143 See Van den Abbeel and Wilson-Bareau 1989, 286–287.

144 Autograph letters from Stock to Manet, dated 22 May and 1 June 1874 (Musée du Louvre, Département des Arts graphiques, Paris, Album, nos. 7 and 8). The censors passed the print on condition that a slip be added on the nude by Carolus Duran (number 661 among the Salon pictures shown in the caricature).

145 For a description of this unpublished sheet, see the Checklist.

146 For the complex story of the publication of *Le Corbeau*, see Wilson-Bareau and Mitchell 1989, 258–307; Michael Pakenham, "A Couple of Feathers from a Raven's Tale," *Print Quarterly* 7 (December 1990), 434–436; the dossier compiled by Michael Pakenham in Edgar Poe, *Le Corbeau. Traduction de Stéphane Mallarmé, illustré par Edouard Manet* (Paris, Séguier, 1994); David Degener, "'Votre nom se mêle au sien': la première lettre connue de Mallarmé à Sarah Helen Whitman," *Revue d'histoire littéraire de la France* 96 (November-December 1996), 1166–1175. A comprehensive study of the Mallarmé-Manet-Poe publication by David Degener, Michael Pakenham, and Juliet Wilson-Bareau is in preparation. For the later project to illustrate Mallarmé's translations of the poems of Poe, see Wilson-Bareau and Mitchell 1989, 296–301; David Degener, *Mallarmé et Manet* (forthcoming).

147 Henri Mondor and Lloyd J. Austin, ed., *Les "gossips" de Mallarmé. "Athenaeum" 1875–1876* (Paris, 1962), 49. *The Athenaeum* of 11 December 1875 published the text, heavily edited, in an English translation by Arthur O'Shaughnessy.

148 On the publication of *L'Après-midi d'un faune*, see the references in Paris 1978, no. 90.

149 The description by Fervacques suggests an even more erotic image than is seen in the picture. However, examination of the painting in the Conservation department of the National Gallery of Art has revealed that, in spite of its densely worked surface, no substantial changes were made

in the course of work. For a discussion of the picture, see Linda Nochlin, "A Thoroughly Modern Masked Ball," *Art in America* 10 (November 1983), 188–201.

150 Duret 1906, 144–145.

151 Mallarmé 1874, 156.

152 Journalists, intrigued by the names of visitors and the public's remarks, noted further entries in their reports on the studio show.

153 The statement is reproduced in Wilson-Bareau 1991, 178 plate 132.

154 A set of twenty-four photographic prints by Godet had been registered with the Dépôt légal and announced in the *Bibliographie de la France* in April 1872. A photograph of *Le bon bock* was registered and announced in the *Bibliographie de la France* on 7 June 1873. The photographs of Manet's rejected pictures apparently remained unpublished and may also have fallen victim to censorship.

155 Note for an "Artistic Gossip" [21 November 1875] in Mondor and Austin, 1962, 42.

156 Mallarmé 1876, 119; San Francisco 1986, 30.

157 Proust 1897, 179; (Caen 1988, Paris 1996), 41–43. Proust's recollection of the 1876 studio exhibition is demonstrably vague, and his assertion that Alphonse Hirsch introduced Méry Laurent to Manet on that occasion would seem to be erroneous.

158 Méry Laurent, born Anne-Rose Louviot, had found an amiable protector in Thomas W. Evans, expatriate American dentist to the crowned heads of Europe and, before the fall of the Second Empire, an intimate of Napoleon and Eugénie. Méry's life and her relationship with Evans, Mallarmé, Manet, and finally Huysmans have been the subject of speculation and invention. The best documented account is that by Robert Goffin, *Mallarmé vivant* (Paris, 1956); see also Gerald Carson, *The Dentist and the Empress* (Boston, 1983). It was probably Evans who enabled Méry to take the relatively modest *entresol* apartment at 29 rue de Moscou, where the cadastre of 1873 recorded her presence. Mallarmé had moved with his family into the fourth-floor apartment in the same building the year before. AP: D1P⁴ 772 (1862): *4 [18]72 Stéphane Malarmé* and *Entresol [18]73 Mery Laurent d^{me}*. In 1875, Méry Laurent moved to a much grander first-floor apartment at 52 rue de Rome, on the corner of the rue de Constantinople (AP: D1P⁴ 973). In 1876, as Albert Fournier noted twenty years ago ("Retour à

Valvins," *Europe: revue littéraire mensuelle*, 564–565 (April–May 1976), 173–182), Mallarmé was recorded by the cadastre at number 87 (the building was later renumbered 89), some distance up the street in the section north of the boulevard des Batignolles. Fournier noted that Mallarmé's new fourth-floor apartment faced the courtyard, not the street, and that it overlooked not the railway cutting but the rather more prosaic rue Beudant.

159 Stéphane Mallarmé, "Edouard Manet," *Divagations* (Paris, 1897), 127–128. In his long autobiographical letter of 16 November 1885, Mallarmé told Paul Verlaine, "My best friends are Villiers and Mendès. And Manet whom I saw every day for ten years. I still can't believe he's gone." (Stéphane Mallarmé, *Correspondance complète 1862–1871, suivi de lettres sur la poésie 1872–1898 avec des lettres inédites*, ed. B. Marchal (Paris, 1995), 588.)

160 A number of photographs of Stéphane Mallarmé at his home on the rue de Rome show works by Manet besides his portrait of the poet (fig. 133) on the walls: the etching of *Lola de Valence* (Guérin 1944, no. 23; Harris 1970/1990 no. 33), and the pastel portrayal of *Faure in the role of Hamlet* (Rouart and Wildenstein 1975, 2: 2 no. P.4) that is closest to the impressionistic, life-size portrait in the Hamburger Kunsthalle (Rouart and Wildenstein 1975, 1: 208 no. 256).

161 Edmond Duranty, "Réflexions d'un bourgeois sur le Salon de peinture," *Gazette des Beaux-Arts*, 2e pér., 16 (1877), 70 reproduced, 67.

162 See J.-K. Huysmans, "La Nana de Manet," *L'Artiste* (Brussels, 13 May 1877), 148–149; Pierre Lambert, "Pages retrouvées. La Nana de Manet (1877) par J.-K. Huysmans," *Bulletin de la Société J.-K. Huysmans*, 8 (1965), 350–354. Huysmans identifies Manet's *Nana* with her namesake in the final episodes of Zola's novel *L'Assommoir*, just then published, and looks forward to the novelist's forthcoming work on the theme of "this kind of whore," of which he considered Manet's depiction a perfect example. See also J.-K. Huysmans, *Lettres à Théodore Hannon (1876–1886)*, ed. Pierre Cogny and Christian Berg (Saint-Cyr-sur-Loire 1985), 58–59; Riout 1989, 248; Huysmans's unpublished letter to Hannon of 6 May 1877, accompanying the text of the article, in *Cent précieux autographes*, sold Drouot Richelieu, 25 April 1997, lot 60. The names Nana, Nanette, Nini, Niniche were favorites with many prostitutes.

163 Zola's novel *Nana* was not published until 1879, and

he did not begin his research for the work until early in 1878, the year after Manet's *Nana* was exhibited. The episode in Zola's *Nana* in which the prince and his friends visit Nana in her dressing room, after her appearance in *La blonde Vénus*, is almost a translation into words of Manet's painting (Emile Zola, *Nana*, chapter 5). See Henri Mitterand, "Nana. Etude" in Emile Zola, *Les Rougon-Macquart. Histoire naturelle et sociale d'une famille sous le Second Empire*, (Paris, 1978), 2: 1653–1695. See also Werner Hofmann et al., *Nana: Mythos und Wirklichkeit* [exh. cat., Hamburger Kunsthalle] (Hamburg, 1973).

164 Proust 1897, 206; (Caen 1988; Paris 1996), 51; Wilson-Bareau 1991, 183.

165 Edmond Bazire, *Manet* (Paris, 1884), 100. Information concerning the manner of its execution and the many alterations that a surface examination suggests will appear in a forthcoming publication by the Kunsthalle. See the earlier study of the picture in Gisela Hopp, *Edouard Manet: Farbe und Bildgestalt* (Berlin 1968), 81.

166 X-radiographs of both paintings exist. For *Le bon bock*, see Theodor Siegl, "Conservation," *Philadelphia Museum of Art Bulletin*, 62 (Autumn 1966), 133–141. In *Plum Brandy*, the unpublished x-radiograph shows extensive alteration over the area of the hand holding a cigarette, and a tall glass that rises almost to shoulder height on the right; the girl may have held a cigarette close to her cheek with the other hand. Infra-red reflectography reveals that the decorative framing behind the girl's head was twice altered. I am grateful to the Conservation Department of the National Gallery of Art for making this material available.

167 Referring to *Laundry* and its depiction of an anonymous woman doing her washing, Manet mocked the success he might have had in depicting the Empress Josephine washing her dirty linen. See Proust 1897, 201; (Caen 1988; Paris 1996), 43.

168 To a sympathetic critic Manet confided that although many people were beginning to express support for his work "I feel that they don't have a very clear view of my underlying intentions. They don't really understand my innermost thoughts, or at least what I am trying to show" (Jacques de Biez, (Paris 1884), cited in Wilson-Bareau 1991, 171).

169 Proust 1901, 76; (Caen 1988; Paris 1996), 101; Wilson-Bareau 1991, 304.

CHECKLIST

Titles of works, indicating their topographical setting, may not accord with those found in existing catalogues. Dimensions are in centimeters, height by width, followed in parentheses by inches. Early history of works is followed to c. 1900.

ORIGINAL WORKS BY ARTISTS

1 JEAN BÉRAUD 1849–1936
The Place and Pont de l'Europe, c. 1876–1878
Private Collection (fig. 84)

Signed at lower right: *Jean Béraud*
Oil on canvas, 48.3 × 73.7 (19 × 29)

EARLY HISTORY: Henry Hilton (sale, American Art Galleries, New York, 13 February 1900, no. 77, as *La Place de l'Europe, Paris*).

SELECT BIBLIOGRAPHY: "Paris Reconstructed in Relief Show," *Art Digest* 18 (1 January 1944), 11, ill. Offenstadt 1987, 32–37. Offenstadt forthcoming, no. 3.

2 FÉLIX BRACQUEMOND 1833–1914
Siege of Paris in 1870. Five Etchings by Bracquemond, 1874
Bibliothèque nationale de France, Estampes, Paris (Qe291, 4°)
Exhibited Paris only (figs. 20, 21)

EARLY HISTORY: Given by the artist to Eugène Béjot (1867–1931), by whom given to the Bibliothèque nationale.

SELECT BIBLIOGRAPHY: *Bibliographie de la France*, 10 April 1875, *Livres*, 200 (*Dépôt légal* 20 March) no. 3406. *BN Inventaire*, 3, 1942, 380, nos. 364–368.

3 GUSTAVE CAILLEBOTTE 1848–1894
Preliminary Sketch for "The Pont de l'Europe," 1876–1877
Musée des Beaux-Arts, Rennes (62.18.1) (fig. 72)

Signature stamp at lower left: *G. Caillebotte*
Oil on canvas, 32.9 × 45.5 (12⅛ × 17¾)

SKETCH FOR: see fig. 68.

SELECT BIBLIOGRAPHY: Berhaut 1978, no. 39. Varnedoe 1987, 79 pl. 15u. Berhaut 1994, 82 no. 43, ill. 82. New York 1995, 105, ill. 105 fig. 1.

4 GUSTAVE CAILLEBOTTE 1848–1894
Final Sketch for "The Pont de l'Europe," 1876–1877
Private Collection (fig. 74)

Signed (by Martial Caillebotte) at lower left: *G. Caillebotte*; signature stamp at lower left: *G. Caillebotte*
Oil on canvas, 54 × 73 (21¼ × 28⅜)

SKETCH FOR: *The Pont de l'Europe*, exhibited in the third Impressionist exhibition, Paris, 1877, no. 2 (Musée du Petit Palais, Geneva), see fig. 68.

EARLY HISTORY: Eugène Daufresne, Paris. Martial Caillebotte (brother of the artist), Paris, by about 1896.

SELECT BIBLIOGRAPHY: Berhaut 1978, no. 40. Varnedoe 1987, 79 pl. 15s. Berhaut 1994, 82 no. 45, ill. 82. New York 1995, 98, ill. 98 fig. 14.

5 GUSTAVE CAILLEBOTTE 1848–1894
On the Pont de l'Europe, c. 1876–1880
Kimbell Art Museum, Fort Worth, Texas (AP 1982.01) (fig. 75)

Signature stamp at lower right: *G. Caillebotte*
Oil on canvas, 105 × 131 (41⅜ × 51⅛)

SELECT BIBLIOGRAPHY: Berhaut 1978, no. 46. Varnedoe 1987, 80–83 no. 16. Berhaut 1994, 86 no. 51, ill. 86. New York 1995, 107–109 no. 31, ill. 106.

6 GUSTAVE CAILLEBOTTE 1848–1894
Perspective Study for "Paris Street; Rainy Day," 1876–1877
Private Collection (fig. 78)

Graphite on paper, 30 × 46 (11¹⁵⁄₁₆ × 18⅛)

SELECT BIBLIOGRAPHY: Varnedoe 1987, 90, ill. fig. 18d. Wadley 1991, 160. New York 1995, 123 no. 39, ill. 123.

7 GUSTAVE CAILLEBOTTE 1848–1894
Sketch for "Paris Street, Rainy Day," 1876–1877
Musée Marmottan – Claude Monet, Paris (5062) (fig. 79)
Oil on canvas, 54 × 65 (20⁷/₈ × 25⁹/₁₆)

SKETCH FOR: *Rue de Paris; Temps de pluie,* exhibited in the third Impressionist exhibition, Paris, 1877, no. 1 (The Art Institute of Chicago), see fig. 76.

EARLY HISTORY: Given by the artist to Claude Monet (1840–1926), in whose possession it remained until his death.

SELECT BIBLIOGRAPHY: Berhaut 1978, no. 51. Varnedoe 1987, 95 pl. 18v. Berhaut 1994, 90 no. 56, ill. 90. New York 1995, 119–121 no. 36, ill. 119.

8 EDGAR DEGAS 1834–1917
Manet Standing, c. 1866–1868
Musée d'Orsay – Louvre, Arts graphiques, Paris (RF 41651)
Exhibited Paris only (fig. 9)
Graphite and ink wash on paper, 35 × 20 (13³/₄ × 7⁷/₈)

EARLY HISTORY: Probably given by Manet to his brother and sister-in-law Eugène Manet (1833–1892) and Berthe Morisot (1841–1895), Paris; by inheritance to their daughter, Julie Manet Rouart (1879–1967), Paris.

SELECT BIBLIOGRAPHY: Lafond 1918, 144. Boggs 1962, 23, 122. *De Manet à Matisse: Sept ans d'enrichissements au musée d'Orsay* [exh. cat., Musée d'Orsay] (Paris, 1990), 66. White 1996, 34.

9 EDGAR DEGAS 1834–1917
Manet Seated, Turned to the Right, c. 1866–1868
Bibliothèque nationale de France, Estampes, Paris (Dc 327dh, Rés.)
Exhibited Paris only (fig. 10)
Etching and drypoint, first state, platemark 19.5 × 13 (7¹¹/₁₆ × 5¹/₈)

SELECT BIBLIOGRAPHY: Delteil 1906–1926, no. 16. *BN Inventaire,* 6, 1953, 110 no. 15. Adhémar and Cachin 1973, no. 19. Boston 1984, 50, no. 18.

10 HENRI FANTIN-LATOUR 1836–1904
A Studio in the Batignolles, 1870
Musée d'Orsay, Paris (RF 729) (fig. 8)
Signed and dated at lower left: *Fantin – 70.*
Oil on canvas, 204 × 273.5 (80³/₈ × 107¹/₈)

EARLY HISTORY: Salon of 1870, Paris, no. 1000, *Un Atelier aux Batignolles.* Acquired by Edwin Edwards, Sunbury, 1871. *Society of French Artists,* 168 New Bond Street, London, 1872, no. 26. *Exhibition of the Society of Portrait Painters, Royal Institute of Painters in Water-colours,* Piccadilly, London, 1891, no. 225. Acquired by the Musée du Luxembourg, Paris, 1892. *Troisième exposition périodique d'estampes. Lithographies originales de Fantin-Latour,* Musée du Luxembourg, Paris, 1899, no. 78.

SELECT BIBLIOGRAPHY: Ottawa 1983, 203–214 no. 73, ill. 207.

11 NORBERT GOENEUTTE 1854–1894
The Pont de l'Europe at Night, 1887
Mr. and Mrs. Julian Sofaer Collection (fig. 87)
Signed and dated at lower right: *Norbert Goeneutte / Paris 1887.*
Oil on canvas, 46 × 37.5 (18¹/₈ × 14³/₄)

EARLY HISTORY: *Exposition Rétrospective d'Oeuvres de Norbert Goeneutte (1854–1894),* Ecole Nationale des Beaux-Arts, Paris, 1895, probably no. 54 or 35, 71, or 108.

SELECT BIBLIOGRAPHY: de Knyff 1978, 172–182, no. 54. Pontoise 1994, 75 no. 121.

12 NORBERT GOENEUTTE 1854–1894
The Pont de l'Europe and Gare Saint-Lazare, 1888
The Baltimore Museum of Art: George A. Lucas Collection (BMA 117)
Exhibited Washington only (fig. 89)
Signed and dated at lower right: *Norbert Goeneutte Paris 18[8]8*
Oil on canvas, 47.6 × 56.5 (18³/₄ × 22¹/₄)

EARLY HISTORY: George Aloysius Lucas (1824–1909), Paris, bought from Goeneutte 12 March 1888 for 200 francs, as *Pont de l'Europe. Exposition Rétrospective d'Oeuvres de Norbert Goeneutte (1854–1894),* Ecole Nationale des Beaux-Arts, Paris, 1895, no. 71, *Gare Saint-Lazare,* lent by Lucas.

SELECT BIBLIOGRAPHY: de Knyff 1978, 172–182. Lucas 1979, 2: 666, 12 and 16 March 1888. Washington 1982, 68 no. 16, ill. 69. Pontoise 1994, 75.

13 EDOUARD MANET 1832–1883
Portrait of Victorine Meurent, c. 1862
Museum of Fine Arts, Boston. Gift of Richard C. Paine in memory of his father, Robert Treat Paine 2nd (46.846)
Exhibited Paris only (fig. 11)
Signed at upper right: *Manet*
Oil on canvas, 42.9 × 43.7 (16⁷/₈ × 17¹/₄)

SELECT BIBLIOGRAPHY: Rouart and Wildenstein 1975, 1: 66 no. 57, ill. 67. New York 1983, 104–105 no. 31, ill. 104.

14 EDOUARD MANET 1832–1883
The Street Singer, c. 1862
Museum of Fine Arts, Boston. Bequest of Sarah Choate Sears in Memory of her husband Joshua Montgomery Sears (66.304)
Exhibited Washington only (fig. 12)
Signed at lower left: *éd. Manet*
Oil on canvas, 171.3 × 105.8 (67⁷⁄₁₆ × 41¹⁄₈)

EARLY HISTORY: Galerie Martinet, Paris, 1863, no. 65. *Manet*, Avenue de l'Alma, Paris, 1867, no. 19. (Durand-Ruel, Paris, purchased in 1872 for 2000 fr., listed in Manet's account book as "1872, Chanteuse des rues 2000 fr.") Sold (by Durand-Ruel) to Ernest Hoschedé (1827–1890), Paris and Montgeron, on 29 January 1877, for 4000 fr.; Hoschedé sale, Hôtel Drouot, Paris, 5–6 June 1878, no. 42, purchased by Jean-Baptiste Faure (1830–1914), Paris, for 450 fr. *Exposition des Oeuvres d'Edouard Manet*, Ecole des Beaux-Arts, Paris, 1884, no. 10.

SELECT BIBLIOGRAPHY: Rouart and Wildenstein 1975, 1: 60 no. 50, ill. 61. New York 1983, 106–109 no. 32, ill. 107.

15 EDOUARD MANET 1832–1883
Young Lady in 1866: Woman with a Parrot, 1866
The Metropolitan Museum of Art, New York, Gift of Erwin Davis, 1889 (89.21.3) (fig. 13)
Signed at lower left: *Manet*
Oil on canvas, 185.1 × 128.6 (72⁷⁄₈ × 50¹⁄₈)

EARLY HISTORY: *Manet*, Avenue de l'Alma, Paris, 1867, no. 15, *Jeune dame en 1866*. Salon of 1868, Paris, no. 1659, *Une jeune femme*. (Durand-Ruel, Paris, purchased in 1872 for 1500 fr., listed in Manet's account book as "1872, femme perroquet 1500 fr."). *Fifth Exhibition of the Society of French Artists*, Durand-Ruel, London, 1872, no. 49. Sold (by Durand-Ruel) to Ernest Hoschedé (1827–1890), for either 2000 fr. or 2500 fr. (see New York 1983, 258); Hoschedé sale, Hôtel Drouot, Paris, 5–6 June 1878, no. 44, to Albert Hecht. Hecht sold the painting to (Durand-Ruel), from whom it was acquired in 1881 by J. Alden Weir, acting as agent for Erwin Davis. *Pedestal Fund Art Loan Exhibition*, National Academy of Design, New York, 1883, no. 182. *Exposition des Oeuvres d'Edouard Manet*, Ecole des Beaux-Arts, Paris, 1884, no. 39 (not included in the Godet photographs of the exhibition, see Moreau-Nélaton 1926, 2: 132/133, and possibly not exhibited). Ortgies sale, New York, 19–20 March 1889, no. 99, bought in at $1350; given by Davis to The Metropolitan Museum of Art, New York, in 1889.

SELECT BIBLIOGRAPHY: Rouart and Wildenstein 1975, 1: 112 no. 115, ill. 113. New York 1983, 254–258 no. 96, ill. 255.

16 EDOUARD MANET 1832–1883
Effect of Snow at Petit-Montrouge – View of the Church of Saint-Pierre, 1870
National Museum & Gallery, Cardiff (NMW A 2468)(fig. 22)
Signed and dated at lower left: *Manet 28 Xᵇʳᵉ 1870*; inscribed at lower left: *à mon ami H. Charlet*
Oil on canvas, 61.6 × 50.4 (24¹⁄₄ × 19¹³⁄₁₆)

EARLY HISTORY: Possibly given by Manet to H. Charlet, Paris.

SELECT BIBLIOGRAPHY: Rouart and Wildenstein 1975, 1: 144 no. 159, ill. 145. Curtiss 1981, 378–389. London 1983, 34–39 no. 15, ill. 34. Lilley 1991, 107–110.

17 EDOUARD MANET 1832–1883
The Line in Front of the Butcher's Shop, c. 1871–1872
Paris: Bibliothèque nationale de France, Estampes, Paris (Dc 300a) (fig. 23)
Washington: S.P Avery Collection, Print Collection, The New York Public Library, Astor, Lenox and Tilden Foundations, New York
Etching, 23.9 × 16 (9³⁄₈ × 6⁵⁄₁₆)

SELECT BIBLIOGRAPHY: Guérin 1944, no. 58. Harris 1970, no. 70. Paris 1978, no. 64. Paris and New York 1983, 321–322 no. 123. *BN Inventaire* 15, 1985, 106 no. 47. Washington 1985, 91–92 no. 53. Harris 1990, 206–207 no. 70.

18 EDOUARD MANET 1832–1883
The Barricade, c. 1871–1873, printed 1884
Paris: Bibliothèque nationale de France, Estampes, Paris (Dc 300c, Rés.) (fig. 24)
Washington: The Baltimore Museum of Art: George A. Lucas Collection, Baltimore (1996.48.13694)
Crayon lithograph, 46.0 × 33.3 (18¹⁄₈ × 13¹⁄₈)

SELECT BIBLIOGRAPHY: Not included in the *Bibliographie de la France* (see New York 1983, 279). Guérin 1944, no. 76. Harris 1970, no. 71, fig. 144. Paris 1978, no. 80. Washington 1982, 206 no. 73. New York 1983, 326–328 no. 125. *BN Inventaire*, 15, 1985, 110 no. 66, 111 ill. Washington 1985, 93–94 no. 54. Harris 1990, 189–190 no. 71.

19 EDOUARD MANET 1832–1883
Civil War, c. 1871–1874, published 1874
Paris: Bibliothèque nationale de France, Estampes, Paris (Dc 300d, Rés.) (fig. 25)
Washington: The Baltimore Museum of Art: George A. Lucas Collection, Baltimore (1996.48.13693)
Crayon lithograph, 39.4 × 50.5 (15¹/₂ × 19⁷/₈)

EARLY HISTORY (Paris): *Dépôt légal* print, as authorized for publication.

SELECT BIBLIOGRAPHY: *Bibliographie de la France*, 28 February 1874, *Gravures . . . : Genre*, 108 no. 369). Guérin 1944, no. 75. Harris 1970, no. 72. Paris 1978, no. 79. Washington 1982, 212 no. 76. *BN Inventaire*, 15, 1985, 110 no. 65, 111 ill. Washington 1985, 94–95 no. 55. Harris 1990, 191–192 no. 72.

20 EDOUARD MANET 1832–1883
The Pont de l'Europe and Rue de Saint-Pétersbourg—Study for "The Railway," 1872
Jean-Claude Romand Collection (fig. 50)
Graphite on two sketchbook pages, one double sided
18.2 × 24.3 (7¹/₈ × 9⁹/₁₆)

STUDY FOR: see no. 21

EARLY HISTORY: Probably sold by Mme Manet (1830–1906) to Auguste Pellerin (1859–1929), Paris, date unknown.

SELECT BIBLIOGRAPHY: Rouart and Wildenstein 1975, 2: 124 no. D 321, ill. 125. Paris 1978, no. 12, ill. Martigny 1996, 189 no. 40, ill.

21 EDOUARD MANET 1832–1883
The Railway, also known as *Gare Saint-Lazare*, 1872–1873
National Gallery of Art, Washington, Gift of Horace Havemeyer in memory of his mother, Louisine W. Havemeyer (1956.10.1) (fig. 1)
Signed and dated at lower right: *Manet 1873*
Oil on canvas, 93.3 × 111.5 (36³/₄ × 45¹/₈)

EARLY HISTORY: Sold to Jean-Baptiste Faure (1830–1914), Paris, c. 1873 (no record of sale); Salon of 1874, Paris, 1874, no. 1260, *Le chemin de fer*, lent by Faure; sold by Faure c. 1881 to (Durand-Ruel, New York and Paris; according to New York 1983, 342, Faure sold the painting to Durand-Ruel after 1890). *Exposition de la Société des Impressionnistes*, London, 1883. *Exposition des Oeuvres d'Edouard Manet*, Ecole des Beaux-Arts, Paris, 1884, no. 68. *Paintings by Edouard Manet*, Durand-Ruel, New York, 1895, no. 25. Sold by (Durand-Ruel) in 1898 to Henry Osborne Havemeyer (1847–1907), New York, for 100,000 fr.

SELECT BIBLIOGRAPHY: Rouart and Wildenstein 1975, 1: 176 no. 207, ill. 177. Washington 1982, 56–57 no. 10, ill. 57, color ill. 8 pl. 3. New York 1983, 340–342 no. 133, ill. 341. Wilson-Bareau in Tokyo 1994.

22 EDOUARD MANET 1832–1883
The Railway, c. 1873
Courtesy of Durand-Ruel et Cie, Paris
Exhibited Paris only (fig. 53)
Stamped at lower left on mount: *E.M.*
Watercolor and gouache on albumen print by Jules-Michel Godet (fl. 1860s–1880s), 20 × 23 (7⁷/₈ × 9¹/₁₆)

EARLY HISTORY: Estate of the artist (not listed in the inventory but stamped with atelier stamp). Probably sold by Mme Manet (1830–1906) to (Camentron), Paris, date unknown.

SELECT BIBLIOGRAPHY: Rouart and Wildenstein 1975, 2: 126 no. D 322, ill. 127. Paris 1978, no. 13 ill. Washington 1982, 58 no. 11, ill. 59. New York 1983, 342–343 no. 134, ill. 343. Martigny 1996, 189 no. 41, ill.

23 EDOUARD MANET 1832–1883
Berthe Morisot with a Fan, 1872
Musée d'Orsay, Paris, Etienne Moreau-Nélaton Donation, 1906 (RF 1671)
Exhibited Paris only (fig. 134)
Signed at lower left: *Manet*
Oil on canvas, 60 × 45 (23⁵/₈ × 17³/₄)

EARLY HISTORY: *Exposition des Oeuvres d'Edouard Manet*, Ecole des Beaux-Arts, Paris, 1884, no. 65, lent by Georges de Bellio (1828–1894), Paris; by inheritance to Ernest Donop de Monchy, Paris. Anonymous sale, Paris, 27 March 1897.

SELECT BIBLIOGRAPHY: Rouart and Wildenstein 1975, 1: 160 no. 181, ill. 161.

24 EDOUARD MANET 1832–1883
Lady with Fans: Portrait of Nina de Callias, 1873–1874
Musée d'Orsay, Paris, Gift of M. and Mme Ernest Rouart, 1930 (RF 2850). (fig. 135)
Signed at lower right: *Manet*
Oil on canvas, 113.5 × 166.5 (44⁵/₈ × 65¹/₂)

EARLY HISTORY: Leenhoff register and Lochard photograph, no. 53. Manet estate inventory, 27–28 December 1883, no. 10. *Exposition des Oeuvres d'Edouard Manet*,

Ecole des Beaux-Arts, Paris, 1884, no. 77. Sale, *Succession Edouard Manet*, Hôtel Drouot, Paris, 4–5 February 1884, no. 13, to (Jacob), Paris. Eugène Manet (1834–1892); by inheritance to his wife, Berthe Morisot (1841–1895); by inheritance to their daughter, Julie Manet Rouart.

SELECT BIBLIOGRAPHY: Rouart and Wildenstein 1975, 1: 176 no. 208, ill. 177. Paris and New York 1983, 347–349 no. 137, ill. 348.

25 EDOUARD MANET 1832–1883
Portrait of Mme de Callias, Nina de Villard, 1873–1874
Musée d'Orsay – Louvre, Arts graphiques, Paris (RF 5177)
Exhibited Paris only (fig. 137)

Signed at lower left: *Manet* (in graphite, in reverse)
Gouache and graphite on a woodblock, 9.9 × 7.3 (3¾ × 2⅞)

EARLY HISTORY: Served as the basis for a wood engraving cut on another block by Alfred Prunaire (see below).

SELECT BIBLIOGRAPHY: Guérin 1944, cited under no. 92. Harris 1970, cited under no. 76. Rouart and Wildenstein 1975, 2: 148, no. D 399, ill. 149. *BN Inventaire* 1985, 15: 112, cited under no. 80. Harris 1990, 218, cited under no. 76. Wilson-Bareau 1991, 209, plate 159.

26 EDOUARD MANET 1832–1883
Masked Ball at the Opera, 1873
National Gallery of Art, Washington, Gift of Mrs. Horace Havemeyer in memory of her mother-in-law, Louisine W. Havemeyer (1982.75.1) (fig. 140)

Signed on dance card at lower right: *Manet*
Oil on canvas, 59 × 72.5 (23¼ × 28½)

EARLY HISTORY: Sold to Jean-Baptiste Faure (1830–1914), on 18 November 1873, for 6000 fr., *Bal masqué à l'Opéra* (Manet's account book). Refused by the jury for the Salon of 1874. (Faure sale, Hôtel Drouot, Paris, 29 April 1878, no. 40, bought in); Jean-Baptiste Faure until at least 1884. *Exposition des Oeuvres d'Edouard Manet*, Ecole des Beaux-Arts, Paris, 1884, no. 69. Faure sold it to (Durand-Ruel, New York and Paris) in 1894. *Paintings by Edouard Manet*, Durand-Ruel, New York, 1895, no. 29. (Durand-Ruel) sold 1895 to Henry Osborne Havemeyer (1847–1907), New York.

SELECT BIBLIOGRAPHY: Rouart and Wildenstein 1975, 1: 180 no. 216, ill. 181. Washington 1982, 122 no. 39, ill. 123 and color ill. 10 pl. 4. New York 1983, 349–352 no. 138, ill. 351.

27 EDOUARD MANET 1832–1883
Polichinelle, 1874
National Gallery of Art, Washington, Gift (Partial and Promised) of Malcolm Wiener (1990.65.1) (fig. 139)

Signed on stone at lower right: *Manet*
Gouache and watercolor over lithograph, 48 × 29.9 (18⅞ × 11¾), first state before letters, inscribed in red ink with couplet by Théodore de Banville

EARLY HISTORY: Salon of 1874, Paris, no. 2357. *Exposition des Oeuvres d'Edouard Manet*, Ecole des Beaux-Arts, Paris, 1884, no. 72. Mme Martinet, Paris, 1884.

SELECT BIBLIOGRAPHY: Guérin 1944, no. 79. Harris 1970, no. 80. Washington 1985, 103–104 no. 61. Harris 1990, 230–233 no. 80. Charles Moffett in *Art for the Nation: Gifts in Honor of the 50th Anniversary of the National Gallery of Art* [exh. cat., National Gallery of Art] (Washington, 1991), 170, ill. 171.

28 EDOUARD MANET 1832–1883
Polichinelle, 1874
Bibliothèque nationale de France, Estampes, Paris (Dc 300d, Rés.)
Exhibited Paris only

Signed on stone at lower right: *Manet*
Color lithograph, 48 × 32.3 (18⅞ × 12¾), fourth state with letters; with the *Dépot légal* stamp at lower right

EARLY HISTORY: *Dépôt légal* proof, as authorized for publication.

SELECT BIBLIOGRAPHY: *Bibliographie de la France*, 18 July 1874, *Gravures . . .: Genre*, 375 no. 1097, as *Polichinelle, d'après Manet*. Guérin 1944, no. 79. Harris 1970, no. 80. Paris 1978, no. 83. *BN Inventaire*, 15, 1985, 110 no. 69, 111 ill. Washington 1985, 103–104 no. 61. Harris 1990, 230–233 no. 80.

29 EDOUARD MANET 1832–1883
The Parisienne: Study of Ellen Andrée, 1874–1875
Nationalmuseum, Stockholm (2068)
Exhibited Paris only (fig. 15)

Signed at lower right: *Manet*
Oil on canvas, 192 × 125 (75⅛ × 49¼)

EARLY HISTORY: Intended for the Salon of 1876; replaced by *Le Linge* (*Laundry*), according to Mallarmé. Leenhoff register and Lochard photograph no. 38. Sold by Mme Manet (1830–1906) to (Paechter), Berlin, on 13 June 1898. Dr. Max Linde (1862–1940), Lübeck, by about 1902.

SELECT BIBLIOGRAPHY: Mondor and Austin 1962, 42. Rouart and Wildenstein 1975, 1: 196 no. 236, ill. 197. Wilson-Bareau 1991, 159, 312 no. 170, color ill. 220 no. 170.

30 EDOUARD MANET 1832–1883
Le Fleuve (The River), 1874
Bibliothèque nationale de France, Estampes, Paris (Ta 233, 1, in-4°, Rés.)
Exhibited Paris only (fig. 138)
Unbound book, numbered 41 (of the edition of 100)
Eight etchings in Charles Cros, *Le fleuve. Eaux-fortes d'Edouard Manet*, Librairie de l'Eau-forte, Paris, 1874.
SELECT BIBLIOGRAPHY: *Bibliographe de la France*, 27 February 1875, *Livres*, 108 no. 1852. Guérin 1944, no. 63. Harris 1970, no. 79. Leymarie and Melot 1971, no. 62. Paris 1978, no. 69. *BN Inventaire* 1985, 106 no. 52, 107 ill. Washington 1985, no. 64. Harris 1990, no. 79.

31 EDOUARD MANET 1832–1883
Le Corbeau (The Raven), 1875
Paris: Bibliothèque nationale de France, Estampes, Paris (Ef 100a, Rés.) (fig. 143–146)
Washington: S.P Avery Collection, Print Collection, The New York Public Library, Astor, Lenox and Tilden Foundations, New York
Four prints from *Le Corbeau The Raven poëme par Edgar Poe traduction française de Stéphane Mallarmé avec illustrations par Edouard Manet*, Paris, Richard Lesclide, 1875.
SELECT BIBLIOGRAPHY: Bibliographie de la France, 12 June 1875, *Livres*, 339 no. 6005. Guérin 1944, no. 86. Harris 1970, no. 83. Paris 1978, no. 89. New York 1983, 380–385 no. 151. BN Inventaire 15, 1985, 112 no. 74 (3–6), 112–113 ill. Washington 1985, 111–116 nos. 66–70. Wilson-Bareau and Mitchell 1989. Harris 1990, 212–218 no. 83. Pakenham 1994.

32 EDOUARD MANET 1832–1883
Portrait of Stéphane Mallarmé, 1876
Musée d'Orsay, Paris, Acquired with the assistance of the Société des Amis du Louvre and of D. David-Weill, 1928 (RF 2661) (fig. 133)
Signed and dated at lower left: *Manet 76*
Oil on canvas, 27 × 36 (10⁵/₈ × 14¹/₈)
EARLY HISTORY: Gift from the artist to Stéphane Mallarmé (1842–1898), Paris. *Exposition des Oeuvres d'Edouard Manet*, Ecole des Beaux-Arts, Paris, 1884, no. 87. *Portraits des écrivains et journalistes*, Georges Petit, Paris, 1893, no. 618. By inheritance to Mallarmé's daughter, Mme Geneviève Bonniot, and her husband Dr. Edmond Bonniot.
SELECT BIBLIOGRAPHY: Rouart and Wildenstein 1975, 1: 202 no. 249, ill. 203. Paris and New York 1983, 377–379 no. 149, ill. 378.

33 EDOUARD MANET 1832–1883
L'Après-midi d'un faune (Afternoon of a Faun), 1876
Bibliothèque nationale de France, Estampes, Paris (Ta 233,2,in-4°,Rés.)
Exhibited Paris only (fig. 147)
Four wood engraved designs, possibly engraved by Alfred Prunaire
SELECT BIBLIOGRAPHY: *Bibliographie de la France*, 20 May 1876, *Livres*, 275 no. 4754. Guérin 1944, no. 93. Harris 1970, no. 84. Leymarie and Melot 1971, no. 92. Paris 1978, no. 90. *BN Inventaire* 15, 1985, 112 no. 81, 113, ill. Harris 1990, no. 84.

34 EDOUARD MANET 1832–1883
Nana, 1877
Hamburger Kunsthalle, Hamburg (2376) (fig. 160)
Signed and dated at lower left: *Manet 77*
Oil on canvas, 154 × 115 (60³/₄ × 45¹/₂)
EARLY HISTORY: Refused by the jury for the Salon of 1877. Exhibited, Boutique Giroux, Boulevard des Capucines, Paris, 1877. Leenhoff register no. 452. Manet estate inventory, 27–28 December 1883, no. 6. Sale, *Succession Edouard Manet*, Hôtel Drouot, Paris, 4–5 February 1884, no. 11, sold for 3000 fr. to Dr. Albert Robin (1847–1928), Paris. Robin sold it to (Durand-Ruel) for 8000 fr., from whom it was bought by Henri Garnier for 15000 fr.; Garnier sale, Paris, 3–4 December 1894, no. 61, bought by (Durand-Ruel) for 9000 fr. *Paintings by Edouard Manet*, Durand-Ruel, New York, 1895, no. 2. *Oeuvres de Manet*, Durand-Ruel, Paris, 1896.
SELECT BIBLIOGRAPHY: Hofmann 1973. Rouart and Wildenstein 1975, 1: 210 no. 259, ill. 211. Paris and New York 1983, 392–396 no. 157, ill. 395.

35 EDOUARD MANET 1832–1883
Faure in the Role of Hamlet, 1877
Private Collection
Exhibited Paris only (fig. 159)
Pen and black ink with white gouache on paper, 26.5 × 17.5 (10⁷/₁₆ × 6⁷/₈)
EARLY HISTORY: Executed for reproduction in Edmond Duranty, "Réflexions d'un Bourgeois sur le Salon de Peinture," *Gazette des Beaux-Arts* s. 2, 16 (July 1877): 70, ill. 67.
SELECT BIBLIOGRAPHY: Rouart and Wildenstein 1975, 2: 172 no. D 476, ill. 173.

36 EDOUARD MANET 1832–1883
Plum Brandy, c. 1877–1878
National Gallery of Art, Washington, Collection of Mr. and Mrs.

Paul Mellon (1971.85.1) (fig. 162)

Signed on tabletop at lower left: *Manet*

Oil on canvas, 73.6 × 50.2 (29 × 19³/₄)

EARLY HISTORY: "Nouvelles Oeuvres d'Edouard Manet", *La Vie Moderne*, Paris, 1880, no. 4, *La Prune*. Sold by the artist in 1881, to Charles Deudon (1832–1914) for 3500 fr. (according to Manet's account book). *Exposition des Oeuvres d'Edouard Manet*, Ecole des Beaux-Arts, Paris, 1884, no. 86, *La Prune*, lent by Charles Deudon.

SELECT BIBLIOGRAPHY: Rouart and Wildenstein 1975, 1: 224 no. 282, ill. 225. Washington 1982, 76 no. 18, ill. 77 and color ill. 72 pl. 8. New York 1983, 407–409 no. 165, ill. 408. Distel 1989, 156–160, ill. 156. Wilson-Bareau 1991, 241, ill. 191 (the 1880 exhibition catalogue).

37 EDOUARD MANET 1832–1883

Woman in a Tub, c. 1878–1879

Musée d'Orsay, Paris (RF 35.739)

Exhibited Paris only (fig. 158)

Signed on chair at lower right: *Manet*

Pastel on canvas, 55 × 45 (21⁵/₈ × 17³/₄)

SELECT BIBLIOGRAPHY: Rouart and Wildenstein 1975, 2: 10 no. P 24, ill. 11. New York 1983, 432–434 no. 179.

38 EDOUARD MANET 1832–1883

Rue Mosnier with Streetlamp, 1878

The Art Institute of Chicago, Gift of Mrs. Alice H. Patterson in memory of Tiffany Blake (4515)

Exhibited Washington only (fig. 118)

Atelier stamp at lower right: *E.M.*

Graphite and lithographic ink tusche on *papier végétal* (tracing paper) laid down on wove paper, 27.8 × 44 (10¹⁵/₁₆ × 17⁵/₁₆)

EARLY HISTORY: Estate of the artist (not listed in the inventory but stamped with atelier stamp).

SELECT BIBLIOGRAPHY: Rouart and Wildenstein 1975, 2: 126 no. D 327, ill. 127. Washington 1982, 238 no. 87, ill. 239. New York 1983, 401 no. 160, ill. 401.

39 EDOUARD MANET 1832–1883

Rue Mosnier in the Rain, 1878

Szépmüvészeti Müzeum, Budapest (1935–2735) (fig. 125)

Signed at upper right: *M*

Brush and lithographic ink tusche over graphite on *papier végétal* (tracing paper) laid down on wove paper, 19 × 36 (7¹/₂ × 14¹/₈)

SELECT BIBLIOGRAPHY: Rouart and Wildenstein 1975, 2: 126 no. D 328, ill. 127. New York 1983, 400 no. 159, ill. 400. *Leonardo to Van Gogh – Master Drawings from Budapest, Museum of Fine Arts, Budapest* [exh. cat., National Gallery of Art, Washington; The Art Institute of Chicago; and Los Angeles County Museum of Art] (Chicago, 1985), 1985, 212 no. 98, 213 ill. Distel 1989, 156–160, ill. 156 Geskó, Judit and Josef Helfenstein. *Zeichen ist Sehen: Meisterwerke von Ingres bis Cézanne aus dem Museum der Bildenden Künste Budapest und aus Schweizer Sammlungen*, Ostfildern-Ruit bei Stuttgart, 1996, 172–173, ill.

40 EDOUARD MANET 1832–1883

Knife Grinder and Streetlamp, Rue Mosnier, 1878

Philadelphia Museum of Art: Bequest of Charlotte Dorrance Wright (1978.1.20) (fig. 123)

Oil on canvas, 40.6 × 32.7 (16 × 12⁷/₈)

EARLY HISTORY: Leenhoff register, and Lochard photograph, no. 104: *bec de gaz*. Sale, *Succession Edouard Manet*, Hôtel Drouot, Paris, 4–5 February 1884, listed as no. 57 (replaced by another work in the sale).

SELECT BIBLIOGRAPHY: Rouart and Wildenstein 1975, 1: 216 no. 268, ill. 217.

41 EDOUARD MANET 1832–1883

Rue Mosnier Decorated with Flags, 1878

The J. Paul Getty Museum, Los Angeles (fig. 119)

Signed and dated at lower left: *Manet / 1878*

Oil on canvas, 64.8 × 80 (25¹/₂ × 31¹/₂)

EARLY HISTORY: Sold by Manet to Roger de Pourtalis (d. 1912) in 1879 for 500 francs (according to Manet's account book). Jean-Baptiste Faure (1830–1914), Paris. *Paintings by Edouard Manet*, Gallery Durand-Ruel, New York, 1895, no. 20, lent by Faure. Sold by Faure in January 1898 to (Durand-Ruel), Paris, who sold it in June 1898 to Auguste Pellerin (1859–1929), Paris.

SELECT BIBLIOGRAPHY: Rouart and Wildenstein 1975, 1: 216 no. 270, ill. 217. Washington 1982, 236–237 no. 86, color ill. 232. Clark 1984, 24. Kasl 1985, 49–58. Farr 1986, 97–109, color ill. 96. Herbert 1988, 30–32, 40. Roos 1988, 372–407. *Landscapes of France: Impressionism and Its Rivals*, catalogue by John House *et al.* [exh. cat., Hayward Gallery and Boston Museum of Fine Arts] (London, 1995).

42 CLAUDE MONET 1840–1926
The Gare d'Argenteuil, 1872
Conseil Général du Val-d'Oise (8865) (fig. 93)

Oil on canvas, 48 × 71 (18⅞ × 28)

EARLY HISTORY: (Durand-Ruel), bought from Monet in 1872; perhaps returned to the artist (not in the Durand-Ruel ledgers, according to Wildenstein 1996, 2: 106). Georges de Bellio (1828–1894), Paris, acquired in June 1876; by inheritance to Ernest Donop de Monchy, Paris.

SELECT BIBLIOGRAPHY: Wildenstein 1974, 1: 216 no. 242, ill. 217. Wildenstein 1996, 2: 106 no. 242, color ill. 106.

43 CLAUDE MONET 1840–1926
Album of Sketches (Carnet Marmottan I), c. 1865–1914
Musée Marmottan – Claude Monet, Paris (5128) (fig. 97)

Graphite on paper, 25.5 × 34 (10 × 13⅜): page 23 verso

SELECT BIBLIOGRAPHY: Wildenstein 1974, 5: 81 no. D 125 (sketchbook is 79–83 nos. D 105 to D 139). House 1986, 228–229. Wadley 1991, 154–155 no. 36. Vienna 1996, 66–71.

44 CLAUDE MONET 1840–1926
Album of Sketches (Carnet Marmottan II), c. 1874–1880
Musée Marmottan – Claude Monet, Paris (5130)
(figs. 95, 96, 105, 109, and 110)

Graphite on paper, 24 × 31 (9⁷⁄₁₆ × 12³⁄₁₆): pages 11–15

SELECT BIBLIOGRAPHY: Wildenstein 1974, 5: 85 nos. D 150–153 and 86 no. D 154 (sketchbook is 83–86 nos. D 140 to D 159). House 1986, 229. Wadley 1991, 154. Chicago 1995, 49 no. 26. Vienna 1996, 66–71.

45 CLAUDE MONET 1840–1926
Interior View of the Gare Saint-Lazare: the Auteuil Line, 1877
Musée d'Orsay, Paris, Gustave Caillebotte Bequest, 1894 (RF 2775)
(fig. 94)

Signed and dated at lower right: *1877 Claude Monet*
Oil on canvas, 75.5 × 104 (29¾ × 41)

EARLY HISTORY: *3ᵉ Exposition de peinture*, 6, rue Le Peletier, Paris, 1877, probably no. 102, *Vue intérieure de la gare St-Lazare* (according to the description cited in Berson). Bought in 1878 by Gustave Caillebotte (1848–1894), Paris. *The*

Impressionists of Paris, American Art Galleries and National Academy of Design, New York, 1886, no. 203. Caillebotte bequest to the French state, entered the Musée du Luxembourg, Paris, 1896.

SELECT BIBLIOGRAPHY: Wildenstein 1974, 1: 304 no. 438, ill. 305. San Francisco 1986, 227 no. 54. Distel in New York 1995, 328. Tucker 1995, 92–99, color ill. 94 pl. 105. Berson 1996, 1: 169, col. 1; 2: 76. Vienna 1996, 66–71. Wildenstein 1996, 2: 177–178 no. 438, color ill. 177.

46 CLAUDE MONET 1840–1926
Gare Saint-Lazare, Arrival of a Train, 1877
Fogg Art Museum, Harvard University Art Museums, Cambridge, Massachusetts, Collection of Maurice Wertheim, Class of 1906 (1951.53)
Exhibited Washington only (fig. 98)

Signed and dated at lower left: *Claude Monet 77*
Oil on canvas, 81.9 × 101 (32¼ × 39¾)

EARLY HISTORY: Ernest Hoschedé (1837–1891), Paris, bought from Monet in March 1877 for Charles Deudon (1832–1914), Paris. *3ᵉ Exposition de peinture*, 6, rue Le Peletier, Paris, 1877, no. 100, *La gare Saint-Lazare, arrivée d'un train*, lent by Hoschedé.

SELECT BIBLIOGRAPHY: Wildenstein 1974, 304 no. 439, ill. 305. San Francisco 1986, 205. Distel 1989, 95–107, 157–160. Tucker 1995, 92–99. Vienna 1996, 66–71. Wildenstein 1996, 178–179, no. 439, ill. 179.

47 CLAUDE MONET 1840–1926
Arrival of the Normandy Train, Gare Saint-Lazare, 1877
The Art Institute of Chicago, Mr. and Mrs. Martin A. Ryerson Collection (1933.1158) (fig. 99)

Signed and dated at lower left: *Claude Monet 77*
Oil on canvas, 59.6 × 80.2 (23½ × 31½)

EARLY HISTORY: Ernest Hoschedé (1837–1891), Paris, bought from Monet in March 1877. *3ᵉ Exposition de peinture*, 6, rue Le Peletier, Paris, 1877, no. 97, *Arrivée du train de Normandie, gare St-Lazare*, lent by Hoschedé. Georges de Bellio (1828–1894), Paris, by 1878; by inheritance to Ernest Donop de Monchy, Paris. *6ᵉ Exposition internationale*, Georges Petit, Paris, 1887, h.c. *Monet-Rodin*, Georges Petit, Paris, 1889, no. 33. *Exposition centennale de l'art français*, Exposition universelle, Paris, 1900, no. 484.

SELECT BIBLIOGRAPHY: Wildenstein 1974, 1: 304 no. 440, ill. 305. Chicago 1995, 73 no. 50. Tucker 1995, 92–99. Vienna 1996, 66–71. Wildenstein 1996, 2: 179–180 no. 440, color ill. 178.

48 CLAUDE MONET 1840–1926

Gare Saint-Lazare: View of the Normandy Line, 1877

The National Gallery, London (6479) (fig. 100)

Signed in red at lower right: *Claude Monet*

Oil on canvas, 54.3 × 73.6 (21⅜ × 29)

EARLY HISTORY: Probably *3ᵉ Exposition de peinture*, 6 rue Le Peletier, Paris, 1877, no. 116, 117, or 118, all as *Intérieur de la gare Saint-Lazare, à Paris*. Auguste Pellerin, Paris. (Bernheim-Jeune), Paris, 1900. Lazare Weiller, Paris, 1900; sale, Hôtel Drouot, Paris, 29 November 1901, no. 31, to Oscar Schmitz, Dresden.

SELECT BIBLIOGRAPHY: Wildenstein 1974, 1: 306 no. 441, ill. 307. *Art in the Making: Impressionism*, catalogue by David Bomford, Jo Kirby, John Leighton, and Ashok Roy [exh. cat., The National Gallery] (London, 1990), 166–171 no. 10. Chicago 1995, 49 no. 26. Tucker 1995, 92–99, color ill. 94 pl. 106. Vienna 1996, 66–71. Wildenstein 1996, 2: 180 no. 441, color ill. 178–179.

49 CLAUDE MONET 1840–1926

Gare Saint-Lazare: The Western Region Goods Sheds, 1877

Private Collection (fig. 102)

Signed at lower right: *Claude Monet*

Oil on canvas, 60 × 80 (23⅝ × 31½)

EARLY HISTORY: Probably *3ᵉ Exposition de peinture*, 6 rue Le Peletier, Paris, 1877, no. 116, 117, or 118, all as *Intérieur de la gare Saint-Lazare, à Paris*.

SELECT BIBLIOGRAPHY: Wildenstein 1974, 1: 308 no. 446, ill. 309. Tucker 1995, 92–99, color ill. 95 pl. 107. Vienna 1996, 66–71. Wildenstein 1996, 2: 181 no. 446, ill. 178–179.

50 CLAUDE MONET 1840–1926

The Pont de l'Europe, Gare Saint-Lazare, 1877

Musée Marmottan – Claude Monet, Paris (4015) (fig. 103)

Signed and dated at lower left: *Claude Monet 77*

Oil on canvas, 64 × 81 (25¼ × 31⅞)

EARLY HISTORY: Bought from Monet by Georges de Bellio (1828–1894), Paris, in March 1877. *3ᵉ Exposition de peinture*, 6 rue Le Peletier, Paris, 1877, no. 98, *Le pont de Rome (gare St-Lazare)*, lent by de Bellio. *Monet*, Durand-Ruel, Paris, 1883, no. 17. *Monet-Rodin*, Georges Petit, Paris, 1889, no. 34; by inheritance to Ernest Donop de Monchy, Paris. *Exposition centennale de l'art français*, Exposition universalle, Paris, 1900, no. 480.

SELECT BIBLIOGRAPHY: Wildenstein 1974, 1: 306 no. 442, ill. 307. San Francisco 1986, 205. Tucker 1995, 92–99, color ill. 95 pl. 108. Vienna 1996, 66–71. Wildenstein 1996, 2: 180 no. 442, color ill. 179.

51 CLAUDE MONET 1840–1926

Gare Saint-Lazare: The Normandy Line Viewed from Beneath the Pont de l'Europe, 1877

Private Collection, courtesy of Galerie Brame et Lorenceau (fig. 106)

Signed at lower right: *Claude Monet*

Oil on canvas, 64 × 81 (25¼ × 31⅞)

EARLY HISTORY: Probably *3ᵉ Exposition de peinture*, 6 rue Le Peletier, Paris, 1877, no. 116, 117, or 118, all as *Intérieur de la gare Saint-Lazare, à Paris*. Bought on 10 March 1878, by Gustave Caillebotte (1848–1894), Paris; bequest to the French state, refused in 1896.

SELECT BIBLIOGRAPHY: Wildenstein 1974, 1: 308 no. 447, ill. 309. House 1986, 183, ill. fig. 196. Distel 1989, 245–262. Distel in New York 1995, 328. Tucker 1995, 92–99, color ill. 94 pl. 105. Vienna 1996, 66–71. Wildenstein 1996, 2: 181 no. 447, ill. 179.

52 CLAUDE MONET 1840–1926

Gare Saint-Lazare: View Toward the Normandy Line, with Track Signals, 1877

Niedersächsisches Landesmuseum, Hannover

Exhibited Paris only (fig. 107)

Signed at lower left: *Cl. M.*

Oil on canvas, 65.5 × 82 (25¾ × 32¼)

EARLY HISTORY: Perhaps *3ᵉ Exposition de peinture*, 6 rue Le Peletier, Paris, 1877, according to Rivière's description, "Un autre tableau ne contient que des disques" (Another picture is a mass of disks), cited in Berson. Bought 10 March 1878, by Gustave Caillebotte (1848–1894), Paris; bequest to the French state, refused in 1896.

SELECT BIBLIOGRAPHY: Wildenstein 1974, 1: 308 no. 448, ill. 309. San Francisco 1986, 205. Distel in New York 1995, 328. Chicago 1995, 49 no. 26. Tucker 1995, 92–99, color ill. 97 pl. 110. Berson 1996, 1: 187, col. 1. Vienna 1996, 66–71. Wildenstein 1996, 2: 181–182 no. 448, color ill. 179.

53 CLAUDE MONET 1840–1926

Gare Saint-Lazare: Tracks and a Signal in Front of the Station Roofs, 1877

Private Collection, Japan

Exhibited Paris only (fig. 108)

Signed at lower right: *Cl. M.*

Oil on canvas, 60 × 80 (23⅝ × 31½)

EARLY HISTORY: Ernest Hoschedé (1837–1891). Paris, bought from Monet in

March 1877. Perhaps *3ᵉ Exposition de peinture*, 6 rue Le Peletier, Paris, 1877. Hoschedé sale, Hôtel Drouot, Paris 18 February 1878, no. 53, purchased by Georges de Bellio (1828–1894); by inheritance to Ernest Donop de Monchy, Paris.

SELECT BIBLIOGRAPHY: Wildenstein 1974, 1: 308 no. 445, ill. 309. Chicago 1995, 74 no. 52. Tucker 1995, 92–99, color ill. 97 pl. 109. Berson 1996, 1: 187, col. 1. Wildenstein 1996, 2: 181–182 no. 448, color ill. 179.

54 CLAUDE MONET 1840–1926
Outside the Gare Saint-Lazare: View Toward the Batignolles Tunnels, 1877
Private Collection (fig. 111)

Signed and dated at lower right: *Cl. M. 77*
Oil on canvas, 60 × 72 (23⅝ × 28⅜)

EARLY HISTORY: Not identifiable in *3ᵉ Exposition de peinture*, 6 rue Le Peletier, Paris, 1877. Sale, *Tableaux Modernes, Aquarelles, Pastels et Dessins*, Hôtel Drouot, Paris, 29 May 1897, no. 47, to (Durand-Ruel), Paris and New York, for 2000 francs.

SELECT BIBLIOGRAPHY: Wildenstein 1974, 1: 306 no. 444, ill. 307. Tucker 1995, 92–99, color ill. 94 pl. 105. Vienna 1996, 66–71. Wildenstein 1996, 2: 181 no. 444, ill. 178.

55 CLAUDE MONET 1840–1926
Outside the Gare Saint-Lazare: View of the Batignolles Tunnels in Sunshine, 1877?
Private Collection
Exhibited Washington only (fig. 112)

Signed and dated (at a later date) at lower right: *Claude Monet 78*
Oil on canvas, 61 × 80.5 (24 × 31¹¹⁄₁₆)

EARLY HISTORY: Probably painted in 1877 and misdated by the artist he sold the painting (or painted a year after the original group). Baron Franchetti. (Durand-Ruel), Paris, in 1897. *Monet, Pissarro, Renoir et Sisley*, Durand-Ruel, Paris, 1899, no. 7.

SELECT BIBLIOGRAPHY: Wildenstein 1974, 1: 306 no. 443, ill. 307. Tucker 1995, 92–99, color ill. 94 pl. 105. Vienna 1996, 66–71. Wildenstein 1996, 2: 180–181 no. 443, color ill. 179.

56 BERTHE MORISOT 1841–1895
Woman and Child on a Balcony, c. 1871–1872
Private Collection (fig. 33)

Signed at lower right: *B Morisot*

Oil on canvas, 60 × 50 (23⅛ × 19⅝)

SELECT BIBLIOGRAPHY: Bataille and Wildenstein 1961, 25 no. 24, ill. pl. 7. New York 1987, 44–45, 217 no. 13, color ill. 46 pl. 13. Kathleen Adler, "The Spaces of Everyday Life: Berthe Morisot and Passy," *Perspectives on Morisot*, ed. Teri J. Edelstein (New York, 1990), 35–44, color ill. pl. 6.

57 ALFRED PRUNAIRE 1837–c. 1900, after Edouard Manet 1832–1883
The Railway, c. 1873–1874
Bibliothèque nationale de France, Estampes, Paris (Dc300d, Rés.) (fig. 52)

Signed in the block at lower left: *PRUNAIRE*; inscribed at lower right: *Manet*
Wood engraving 18.8 × 22.8 (7⅜ × 9)

SELECT BIBLIOGRAPHY: Guérin 1944, no. 89. Leymarie and Melot 1971, no. 88. *BN Inventaire*, 15, 1985, 112, no. 77, ill. 113. Harris 1990, 263 no. 91.

58 ALFRED PRUNAIRE 1837–c. 1900, after Edouard Manet 1832–1883
A Parisienne (Mme de Callias), 1873–1874
Bibliothèque nationale de France, Imprimés, Paris (Z. 58904)
Exhibited Paris only (fig. 136)

Wood engraving 10 × 15.3 (4 × 6), second state
Signed in the block lower left: *PRUNAIRE SC.*; inscribed lower right: *Manet*

EARLY HISTORY: In *Revue du monde nouveau, littéraire, artistique, scientifique* (15 February 1874), 30, as *Une Parisienne, par Manet. Gravé par A. Prunaire*.

SELECT BIBLIOGRAPHY: Guérin 1944, no. 91. Harris 1970, no. 78. Leymarie and Melot 1971, no. 90. *BN Inventaire* 15, 1985, 112, no. 79, ill. 113. Harris 1990, 221 no. 78.

59 PIERRE PUVIS DE CHAVANNES 1824–1898
Hope, 1871–1872
Musée d'Orsay, Paris (INV. 20117)
Exhibited Paris only (fig. 29)

Signed at lower left: *P. Puvis de Chavannes*.
Oil on canvas, 70.5 × 82 (27¾ × 32¼)

EARLY HISTORY: (Durand-Ruel), Paris, *Exposition de Tableaux, Pastels, Dessins par M. Puvis de Chavannes*, Durand-Ruel, Paris, 1887, no. 30. Henri Rouart, Paris, at least after 1887. *Salon des artistes français*, Paris, 1889, no. 19.

SELECT BIBLIOGRAPHY: Ottawa 1977, 113 no. 91, ill. 115. Johnston, William R. *The Nineteenth Century Paintings in the Walters Art Gallery*. Baltimore, 1982, 146–147.

60 PIERRE PUVIS DE CHAVANNES 1824–1898
Hope, 1872
The Walters Art Gallery, Baltimore (37.156)
Exhibited Washington only (fig. 28)
Signed and dated at lower left: *1872 / P. Puvis de Chavannes.*
Oil on canvas, 102.5 × 129.5 (40⅜ × 50⅞)

EARLY HISTORY: (Durand-Ruel), Paris, acquired for 7000 fr. Salon of 1872, Paris, no. 1282, *L'Espérance.* (Durand-Ruel), sold to Patou, Paris, for 3000 fr.; sold back to (Durand-Ruel) for 2000 fr. *Exposition de Tableaux, Pastels, Dessins par M. Puvis de Chavannes*, Durand-Ruel, Paris, 1887, no. 19. *Exposition centennale de l'art français,* Exposition universelle, Paris, 1889, no. 5616. (Durand-Ruel), sold to Erwin Davis, New York, in 1890 for 7000 fr. *Paintings, Pastels, Decorations by Puvis de Chavannes*, Durand-Ruel, New York, 1894, no. 14. E.F. Miliken sale, New York, 14 February 1902, to Henry Walters.

SELECT BIBLIOGRAPHY: Ottawa 1977, 112–113 no. 90, ill. 114. Johnston, William R. *The Nineteenth Century Paintings in the Walters Art Gallery.* Baltimore, 1982, 146–147.

61 AUGUSTE TRICHON 1813–1898, after Edouard Manet
The Artist, 1876
Bibliothèque nationale de France, Estampes, Paris (Dc300a)
Exhibited Paris only (fig. 153)
Signed in the block lower right: *TRICHON*
Wood engraving, 29.5 × 20.8 (11 ⅛ × 8 ¼)

EARLY HISTORY: From *L'Univers illustré*, 13 May 1876, with text, "PORTRAIT D'UN ARTISTE, tableau de M. MANET, refusé au Salon de 1876 (d'après une photographie de M. Godet). Collection Debrousse."

SELECT BIBLIOGRAPHY: Gérôme, Jean-Léon, in *Courrier de Paris*, 306. Béraldi 12 (1892). Wilson-Bareau 1989, 32, ill.

62 EMILE VERNIER, fl. c. 1844–1884, after Pierre Puvis de Chavannes, 1824–1898
The Besieged City of Paris Entrusts Its Appeal to France to the Skies: The Balloon, 1870
Bibliothèque nationale de France, Estampes, Paris (Ef 399)
Exhibited Paris only (fig. 26)
Lithograph on grey paper laid on wove, 40.5 × 25 (16 × 9⅞)

EARLY HISTORY: *Dépôt légal* print dated 1870, as authorized for publication.

SELECT BIBLIOGRAPHY: *Bibliographie de la France*, 24 December 1870, *Gravures...: Genre*, 475 no. 1259.

63 EMILE VERNIER, fl. c. 1844–1884, after Pierre Puvis de Chavannes, 1824–1898
Having Eluded the Enemy, the Long-Awaited Message Raises the Spirits of the Proud City: The Pigeon, 1871
Bibliothèque nationale de France, Estampes, Paris (Ef 399)
Exhibited Paris only (fig. 27)
Lithograph on grey paper laid on wove, 40.2 × 25 (15⁹⁄₁₆ × 9⅞)

EARLY HISTORY: *Dépôt légal* print dated 1871, as authorized for publication.

SELECT BIBLIOGRAPHY: *Bibliographie de la France*, 25 February 1871, *Gravures...: Genre*, 32 no. 79: *Le Pigeon.*

MAPS AND VIEWS OF PARIS

64 HILAIRE GUESNU 1802–c. 1880
Souvenir of the New Paris / Its Monuments, Promenades, Boulevards, and Principal Thoroughfares. / Simplified Plan for Finding One's Way About Paris Unaided., 1864
Bibliothèque nationale de France, Cartes et Plans, Paris (DL39/1864)
(fig. 56)
Lithographed engraving with coloring, 44.5 × 57 (17 ½ × 22 ½)

EARLY HISTORY: *Dépôt légal* print, as authorized for publication

SELECT BIBLIOGRAPHY: Vallée 1908, 252 no. 1964

65 AVRIL FRÈRES (CHARLES and EUGÈNE)
General Map of the City of Paris 1866 *Plate 3: The Europe District*
Bibliothèque historique de la Ville de Paris, Paris (Rés. F° M° 67)
Exhibited Paris only (fig. 6)
Album of 21 engraved plates with watercolor, 92 × 67.8 (36 ¼ × 26 ¾) double page

EARLY HISTORY: Acquired at the sale of Baron Haussmann's effects, June 1893.

66 HILAIRE GUESNU 1802–c. 1880
Getting Around Paris on Foot: New Pedestrian Guide, 1867
Bibliothèque historique de la Ville de Paris, Paris (A.796) (fig. 57)
Engraving on paper, 31 × 45 (12 ¼ × 17 ¾)

EARLY HISTORY: *Dépôt légal* print, as authorized for publication in 1867.

67 PAUL FAURÉ fl. mid-19th century
Paris Fortified: Exact Perspective View of Paris and Its Surroundings, Based on the Ordnance Survey Map, Drawn up by P. Fauré, Architect, 1871
Bibliothèque nationale de France, Cartes et Plans, Paris (Ge AA 1162) (fig. 17)
Lithograph, 30 × 100 (11 ¾ × 39 ⅜)
EARLY HISTORY: *Dépôt légal* print, as authorized for publication
SELECT BIBLIOGRAPHY: *Bibliographie de la France,* February 25, 1871, *Gravures . . . : Cartes et Plans,* 32 no. 75.

68 ANONYMOUS NINETEENTH-CENTURY PHOTOGRAPHER
The Façade of 4 Rue de Saint-Pétersbourg, c. 1870
Bibliothèque nationale de France, Estampes, Paris (Va282, 5: H66038) (fig. 42)
Albumen print, 39.8 × 34 (15 ⅛ × 13 ⅜)
The source of this photograph and a number of similar architectural views is unknown. Not known to have been published previously. The house was built in 1864.

69 STUDIO OF L. WUHRER
Paris in 1871. The Roads built between 1854 and 1871 are marked in yellow and red. (The year given is the date of completion.), 1889
Bibliothèque historique de la Ville de Paris, Paris (A1026, 12) (fig. 77)
Colored engraving 61 × 76.5 (24 × 30 ¼)
EARLY HISTORY: Executed for the set of *Travaux de Paris 1789–1889* by L. Wuhrer, printed by Monrocq, Paris, 1889, Plate XII.

THE GARE SAINT-LAZARE AND THE PONT DE L'EUROPE

70 VICTOR HUBERT 1786–
Paris–Saint Germain Railway, Side View. Place de l'Europe, Paris, 1837
Bibliothèque nationale de France, Estampes, Paris (Va 282a, 1: H 66116) (fig. 59)
Signed and dated in the stone at lower right: *V. Hubert 1837*
Crayon lithograph on paper, 24.6 × 35.6 (9 ⅛ × 14)
EARLY HISTORY: *Dépôt légal* proof, as authorized for publication

71 AFTER EUGÈNE FLACHAT 1802–1873
Plan Showing the Arrangement of the Gare Saint-Lazare, whose Overall Organization is now almost Complete, and Outlining the Original Station of 1837, 1853
Bibliothèque nationale de France, Cartes et Plans, Paris (Ge D 2538)
Exhibited Paris only (fig. 61)
Lithograph with watercolored outlines, 26.8 × 49.4 (10 ½ × 9 ½)
EARLY HISTORY: Published as a separate sheet with the *Journal des chemins de fer,* 12, no. 672, 23 July 1853, 579 (see the article by G. Lenoir, from which the title is extracted).

72 BARON GEORGES HAUSSMANN 1809–1891
Surroundings of the Place d'Europe (From the Map Attached to the Decree of June 30, 1859), 1859
Bibliothèque historique de la Ville de Paris (B 734)
Not exhibited (fig. 62)
Pen and ink and watercolor on paper, 98 × 65 (38 ⅛ × 25 ⅝)

73 AUGUSTE LAMY active mid-19th century?
Paris. Bridge Erected on the Place de l'Europe, over the Western Region Railway, 1868
Musée Carnavalet, Paris (L'Esprit, XIII)
Exhibited Paris only (fig. 64)
Signed in block at lower right: *A. LAMY.*
Wood engraving, 27 × 38.3 (10 ⅛ × 15 ⅛)
EARLY HISTORY: From *L'Illustration, Journal Universel,* April 11, 1868, 236, accompanying the article signed C.P.D., "Le Pont métallique de la place de l'Europe," 235.
SELECT BIBLIOGRAPHY: Washington 1982, 53 fig. 28.

74 HÉLIOS STUDIO active 1870s
The Pont de l'Europe Seen from the Gare de l'Ouest et de Versailles in the Gare Saint-Lazare, 1868
Bibliothèque historique de la Ville de Paris (G.P. XXXII, 23)
Exhibited Paris only (fig. 55, see also fig. 66)
Albumen print mounted on card, 24.7 × 38.7 (9 ¾ × 15 ¼)

75 ADOLPHE NORMAND active 1870s
EMILE TILLY 1837–1909 and/or AUGUSTE TILLY 1840–1898
Bird's-Eye View of the New Gare Saint-Lazare Now Under Construction,
1886
Musée Carnavalet, Paris (Topo GC XXXVI A)
Exhibited Paris only (fig. 67)
Signed in block at lower left: *A. NORMAND*; in block at lower right: *E.A. TILLY SC.*
Wood engraving on paper, 35 × 53 (13 ³/₄ × 20 ⁷/₈)
EARLY HISTORY: From *L'Illustration, Journal Universel,* 17 July 1886, 40–41,
accompanying the article by Ch. T., "La Nouvelle Gare Saint-Lazare," 34.

SALON CARICATURES 1874

76 CHAM (AMÉDÉE DE NOÉ, known as) 1819–1879
The Lighter Side of the Salon, by Cham, 1874
Bibliothèque d'art et d'archéologie Jacques Doucet, Paris (H 265)
(fig. 46)
Relief block illustration in *Le Salon pour rire par Cham,* album of caricatures of the
Salon of 1874. Originally published in *Le Charivari,* 15 May 1874.
SELECT BIBLIOGRAPHY: *Bibliographie de la France,* 30 May 1874, *Gravures...:*
Caricatures, 275 no. 786

77 BERTALL (CHARLES ALBERT D'ARNOUX, known as) 1820–1882
Bertall's Tour of the Salon of 1874 (Part III), 1874
Bibliothèque nationale de France, Estampes, Paris (Tf 319, pet. fol.)
(fig. 45)
Line block illustrations on paper, 33.5 × 21.5 (13 ¹/₄ × 8 ¹/₂), from an album
composed of Salon caricatures
EARLY HISTORY: From *L'Illustration,* 23 May 1874, 341: caricatures of twelve Salon
paintings.

78 CHAM (AMÉDÉE DE NOÉ, known as) 1819–1879
Cham's Comical Critique, 1874
Bibliothèque nationale de France, Estampes, Paris (Tf 319, pet. fol.)
(fig. 47)
Line block illustrations on paper, 33.5 × 23 (13 ¹/₄ × 9 ¹/₈), from an album
composed of Salon caricatures, 1867–1876

EARLY HISTORY: From *Le Monde illustré,* 6 June 1874, 357: caricatures of eight
Salon paintings and four sculptures.

79 STOP (LOUIS PIERRE GABRIEL BERNARD MOREL-RETZ, known
as) 1825–1899
The Salon of 1874, by Stop, 1874
Bibliothèque nationale de France, Estampes, Paris (Tf 319, pet. fol.)
(fig. 44)
Line block illustrations on paper, 40.5 × 26 (16 × 10 ¹/₄), from an album
composed of Salon caricatures, 1867–1876
EARLY HISTORY: From *Le Journal amusant,* No. 928, 13 June 1874, 3: caricatures of
seven Salon paintings.

80 HENRY CHARLES STOCK 1826–1885
Review of the Salon by Stock, 1874
Bibliothèque nationale de France, Estampes, Paris (Tf 319, pet. fol.)
(fig. 141)
Single-sheet caricature with autographs recto and verso, watercolored relief
block illustration, 36.8 × 41.3 (14 ¹/₂ × 16 ¹/₄), from an album composed of Salon
caricatures, 1867–1876.
SELECT BIBLIOGRAPHY: *Bibliographie de la France,* 27 June 1874, *Gravures...*
Caricatures, 332 no. 965.

MANET'S STUDIO, RUE DE SAINT-PÉTERSBOURG

81 *4 Rue de Saint-Pétersbourg – Cadastral register of 1862,* 1862–1875
Archives de Paris, Paris (D1 P⁴ 1054 – 1862)
Exhibited Paris only (fig. 129)
Document recording the construction of the house in 1864.
Printed form with manuscript annotations, 30 × 23 (11 ⁷/₈ × 9 ¹/₈).

82 *4 Rue de Saint-Pétersbourg – Cadastral register of 1876,* 1876–1899
Archives de Paris, Paris (D1 P⁴ 1054 – 1876)
Exhibited Paris only (fig. 130)
Document showing that the house belonged to Debasseux until he sold it in 1883.
Printed form with manuscript annotations, 30 × 23 (11 ⁷/₈ × 9 ¹/₈).

83 *Invitation to Manet's studio exhibition, addressed by the artist to Monsieur Stéphane Mallarmé,* 1876
Musée départemental Stéphane Mallarmé, Vulaines-sur-Seine (INV.989.1.16)
Exhibited Paris only (fig. 151)
Engraved invitation on card
SELECT BIBLIOGRAPHY: Wilson-Bareau 1991, 177, fig. 131.

84 JULES-MICHEL GODET fl. 1860s–1880s
Laundry, after Edouard Manet 1832–1883, 1876
Pierpont Morgan Library, Tabarant Collection, New York.
Purchased as the gift of Mrs. Charles W. Engelhard and children in loving memory of Charles W. Engelhard, 1974 (MA 3950).
Exhibited Paris only (fig. 152)
Albumen print, on original blue card support, from the collection of mounted photographs taken by Godet for the artist.
EARLY HISTORY: Edouard Manet; by descent to his wife and her son Léon Leenhoff. Acquired by Adolphe Tabarant, probably before 1928.

85 *Edouard Manet's file of press clippings on his studio exhibition at 4 Rue de Saint-Pétersbourg,* 1876
Pierpont Morgan Library, Tabarant Collection, New York.
Purchased as the gift of Mrs. Charles W. Engelhard and children in loving memory of Charles W. Engelhard, 1974 (MA 3950).
Exhibited Paris only (fig. 154)
EARLY HISTORY: Edouard Manet; by descent to his wife and her son Léon Leenhoff. Acquired by Adolphe Tabarant, probably before 1928.

86 *Signatures and comments of the visitors to Manet's studio exhibition at 4 Rue de Saint-Pétersbourg on 22 April* 1876
Pierpont Morgan Library, Tabarant Collection, New York.
Purchased as the gift of Mrs. Charles W. Engelhard and children in loving memory of Charles W. Engelhard, 1974 (MA 3950).
Exhibited Paris only (fig. 155)
A folded sheet, two pages of paper, each 31 × 20.5 (12 ¼ × 8 ⅛),

EARLY HISTORY: Edouard Manet; by descent to his wife and her son Léon Leenhoff. Acquired by Adolphe Tabarant, probably before 1928.
SELECT BIBLIOGRAPHY: A. Tabarant, "Autour de Manet," *L'Art vivant* 79 (1928).

87 *Le Type. Weekly Journal of Caricature, Satire and Finance,* 1876
Bibliothèque nationale de France, Imprimés, Paris (Fol. Z. 84)
Exhibited Paris only (fig. 148)
Dépôt légal stamp at upper center; numbered 3 in pen and ink.
Front page of the ephemeral *Journal Hebdomadaire, Caricaturiste, Satirique, Financier,* bound volume, sheets 33 × 25 (13 × 9 ⅞)
EARLY HISTORY: *Dépôt légal* copy, as authorized for publication on 21 April 1876.
SELECT BIBLIOGRAPHY: *Bibliographie de la France,* 6 May 1876, *Nouvelles publications périodiques,* no. 103. Not included in the *Catalogue collectif des périodiques* of the Bibliothèque nationale (see the manuscript "Fichier des almanachs"). See Etienne Moreau-Nélaton 1906, reprinted in Guérin 1944, 20. For the brush drawing by Manet, compare Rouart and Wildenstein 1975, 2: 184 nos. 519 and 520, ill. 185.

88 *Galerie contemporaine, littéraire, et artistique. Issue on Manet in the series on "Artists and Sculptors,"* 1876
Bibliothèque nationale de France, Imprimés, Paris (Fol. G. 16)
Exhibited Paris only (fig. 156)
Four-page issue, no. 12, dated April 1876, 34 × 29 (13 ⅜ × 11 ⅜) in a bound volume.

89 *Money order for 1000 francs from Edouard Manet to Claude Monet,* 1878
Pierpont Morgan Library, Tabarant Collection, New York.
Purchased as the gift of Mrs. Charles W. Engelhard and children in loving memory of Charles W. Engelhard, 1974 (MA 3950).
Exhibited Paris only (fig. 115)
Ink on paper, 10 × 25 (4 × 9 ⅞).
EARLY HISTORY: Probably Edouard Manet; by descent to his wife and her son Léon Leenhoff. Acquired by Adolphe Tabarant, probably before 1928.
SELECT BIBLIOGRAPHY: Adolphe Tabarant, "Autour de Manet," *L'Art vivant* 79 (April 1, 1928), 349, ill.

BIBLIOGRAPHY OF WORKS CITED

Adhémar and Cachin 1973
Adhémar, Jean, and Françoise Cachin. *Degas: The Complete Etchings, Lithographs and Monotypes*, trans. Jane Brenton. New York, 1974.

Adler 1990
Adler, Kathleen. "The Spaces of Everyday Life: Berthe Morisot and Passy." In *Perspectives on Morisot*, ed. Teri J. Edelstein. New York, 1990, 35–44.

Bataille and Wildenstein 1961
Bataille, Marie-Louise, and Georges Wildenstein. *Berthe Morisot: catalogue des peintures, pastels et aquarelles*. Paris, 1961.

Bazire 1884
Bazire, Edmond. *Manet*. Paris, 1884.

Béraldi
Béraldi, Henri. *Les graveurs du xix^e siècle*. 8 vol. Paris, 1885.

Berhaut 1978
Berhaut, Marie. *Caillebotte, sa vie et son oeuvre*. Paris, 1978.

Berhaut 1994
Berhaut, Marie. *Gustave Caillebotte: catalogue raisonné des peintures et pastels*. Rev. ed. Paris, 1994.

Berson 1996
Berson, Ruth, Editor. *The New Painting: Impressionism 1874–1886: Documentation*. 2 vol. San Francisco, 1996.

Bibliographie de la France
Bibliographie de la France. Journal général de l'Imprimerie et de la Librairie.

Biez 1884
Biez, Jacques de. "E. Manet: Conférence…" Paris, 1884, 8, as cited in

Wilson-Bareau, Juliet, Editor. *Manet by Himself*. London, 1991, 171.

BN Inventaire
Bibliothèque nationale. Inventaire du fonds français. Graveurs du xixe siècle. Various authors, 15 vol. (in progress). Paris.

Boggs 1962
Boggs, Jean Sutherland. *Portraits by Degas*. Berkeley, 1962.

Boston 1984
Edgar Degas: The Painter as Printmaker, catalogue by Sue Welsh Reed and Barbara Stern Shapiro [exh. cat., Museum of Fine Arts, Boston] (Boston, 1984).

Bowie 1987
Bowie, K. "Les Grandes gares parisiennes: historique." In *Les Grandes gares parisiennes au XIX siècle*. Paris, 1987.

Brettell 1986
Brettell, Richard R. "The Third Exhibition, 1877: The 'First' Exhibition of Impressionist Painters." In *The New Painting: Impressionism 1874–1886* [exh. cat., The Fine Arts Museums of San Francisco and National Gallery of Art, Washington] (San Francisco, 1986), 189–202.

Brombert 1996
Brombert, Beth Archer. *Edouard Manet: Rebel in a Frock Coat*. Boston, New York, Toronto, and London, 1996.

Brown 1985
Brown, Marilyn. "Manet, Nodier, and Polichinelle." *Art Journal* 45 (Spring 1985): 43–48.

Burchall 1971
Burchall, S.C. *Imperial Masquerade: The Paris of Napoleon III*. New York, 1971.

Carson 1983
Carson, Gerald. *The Dentist and the Empress*. Boston, 1983.

Chicago 1995
Claude Monet 1840–1926, catalogue by Charles F. Stuckey [exh. cat., The Art Institute of Chicago] (Chicago, 1995).

Clark 1984
Clark, Timothy J. *The Painting of Modern Life: Paris in the Art of Manet and His Followers*. Princeton, 1984.

Courthion 1953
Courthion, Pierre, editor, *Manet raconté par lui-même et par ses amis*. 2 vol. Geneva, 1953.

Curtiss 1981
Curtiss, Mina. "Letters of Edouard Manet to his wife during the Siege of Paris 1870–1871." *Apollo* 113 (June 1981, 378–389).

Darragon 1989
Darragon, Eric. *Manet*. Paris, 1989.

Darragon 1991
Darragon, Eric. *Manet*. Paris, 1991.

Delteil 1906–1926
Delteil, Loys. *Le Peintre-Graveur illustré*. Paris, 1906–1926, 31 vol.; vol. 9, *Degas*.

Distel 1989
Distel, Anne. *Les Collectionneurs des impressionnistes: Amateurs et marchands*. Düdingen, 1989.

Dugast and Parizet
Dugast, Anne, and Isabelle Parizet, *Dictionnaire par noms d'architectes des constructions élevées à Paris aux XIXe et XXe siècles*, ed Michel Fleury. 4 vol. Paris.

Duranty 1876
Duranty, Edmond. *La nouvelle peinture. Apropos du groupe d'artistes qui expose dans les galeries Durand-Ruel*. Paris, 1876. Reprinted San Francisco, 1986, 477–484 (and in translation 37–47); Caen, 1988; Riout, 1989, 108–134.

Duranty 1877a
Duranty, Louis Emile Edmond. "Réflexions d'un bourgeois sur le Salon de peinture." *Gazette des Beaux-Arts* s. 2, 15–16 (June 1877 and July 1877), 547–581, 48–82.

Duranty 1877b
Duranty, Louis Emile Edmond. "Post-Scriptum au Salon de peinture." *Gazette des Beaux-Arts* s. 2, 16 (October 1877), 355–367.

Duret 1906
Duret, Théodore. *Histoire de Edouard Manet et do son oeuvre*. Paris, 1906.

Farr 1986
Farr, Dennis. "Edouard Manet's *La Rue Mosnier aux Drapeaux*." In *Essays In Honor of Paul Mellon: Collector and Benefactor*. ed. John Wilmerding. Washington, 1986, 97–109.

Fervacques 1873
Fervacques [Léon Duchemin]. "L'Hiver à Paris." *Le Figaro* (25 December 1873), 1.

Fierro 1996
Fierro, A. *Histoire et dictionnaire de Paris*. Paris, 1996.

Gautier 1871
Gautier, Théophile. "L'Art pendant le siège." republished as *Tableaux de siège, Paris, 1870–1871*. Paris, 1871.

Goedorp 1967
Goedorp, Jacques. "'L'Olympia' n'était pas montmartroise." *Journal de l'amateur d'art* no. 385 (10–25 February 1967), 7; no. 387 (10–25 March 1967), 7.

Goffin 1956
Goffin, Robert. *Mallarmé vivant*. Paris, 1956.

Guérin 1944
Guérin, Marcel. *L'Oeuvre gravé de Manet*. Paris, 1944.

Hamilton 1969
Hamilton, George Heard. *Manet and His Critics*. New York, 1969.

Hanson 1977
Hanson, Anne Coffin. *Manet and the Modern tradition*. New Haven and London, 1977.

Harris 1970
Harris, Jean C. *Edouard Manet: Graphic Works. A Definitive Catalogue Raisonné*. New York, 1970.

Harris 1990
Harris, Jean C. *Edouard Manet: Graphic Works: A Definitive Catalogue Raisonné*. rev. ed. San Franscico, 1990.

Herbert 1988
Herbert, Robert. *Impressionism: Art, Leisure and Parisian Society*. New Haven and London, 1988.

Hofmann 1973
Hofmann, Werner. *Nana: Mythos und Wirklichkeit*. Cologne, 1973.

Hopp 1968
Hopp, Gisela. *Edouard Manet: Farbe und Bildgestalt*. Berlin 1968.

House 1986
House, John. *Monet, Nature into Art*. New Haven and London, 1986.

Huysmans 1884
Huysmans, Joris-Karl. *A Rebours*. Paris, 1884.

Joanne 1871
Joanne, Adolphe. *Paris illustré en 1870*. Paris, 1871.

Kasl 1985
Kasl, Ronda. "Edouard Manet's 'Rue Mosnier': 'Le pauvre a-t-il une patrie?'" *Art Journal* 45 (Spring 1985), 49–58.

de Knyff 1978
de Knyff, Gilbert. *L'Art libre au XIXᵉ siècle ou la vie de Norbert Goeneutte*. Paris, 1978.

Lafond 1918
Lafond, Paul. *Degas*. Paris, 1918–1919.

Leenhoff circa 1883
Leenhoff, Léon. Manuscript register of works by Edouard Manet (circa 1883) Bibliothèque nationale de France, Paris, Departement des estampes (Yb³ 4649, 8°, Rés.).

The register was accompanied by four volumes of photographs by Fernand Lochard annotated by Leenhoff (one in the Bibliothèque nationale, three in the Pierpont Morgan Library, New York).

Leenhoff circa 1910
Leenhoff, Léon. Manuscript "copie pour Moreau-Nélaton de documentation sur Manet (circa 1910)." Bibliothèque nationale de France, Paris, Département des Estampes (Yb³ 2401. 8°. Rés.).

Lightstone 1994
Lightstone, Rosanne H. "Gustave Caillebotte's oblique perspective: a new source for 'Le Pont de l'Europe'." *The Burlington Magazine* 136 (November 1994), 759–762.

Lilley 1991
Lilley, Edward. "Manet's 'Modernity' and *Effet de Niège à Petit-Montrouge*." *Gazette des Beaux-Arts*, s. 6, 108 (September 1991), 107–110.

London 1983
Manet at Work, catalogue by Michael Wilson [exh. cat., National Gallery] (London, 1983).

London 1986
The Hidden Face of Manet, catalogue by Juliet Wilson-Bareau [exh. cat., Courtauld Institute Galleries] (London, 1986). In *The Burlington Magazine* 128 (April 1986), supplement.

London 1990
Art in the Making: Impressionism, catalogue by David Bomford, Jo Kirby, John

Leighton, and Ashok Roy [exh. cat., The National Gallery] (London 1990).

London 1992
Manet: the Execution of Maximilian: Painting, Politics and Censorship, catalogue by Juliet Wilson-Bareau [exh. cat., The National Gallery] (London, 1992).

London 1996
Gustave Caillebotte: the unknown impressionist, catalogue by Anne Distel *et al.* [exh. cat., Royal Academy of Arts] (London, 1996).

Lucas 1979
Lucas, George A. *The Diary of George A. Lucas: American Art Agent in Paris, 1857–1909.* Trans. and ed., Lilian M. C. Randall. Princeton, 1979.

Lugt 1921
Lugt, Frits. *Les Marques de collection de dessins et d'estampes.* Amsterdam 1921.

Mainardi 1993
Mainardi, Patricia. *The End of the Salon. Art and the State in the Early Third Republic.* Cambridge, 1993.

Mallarmé 1874
Mallarmé, Stéphane. "Le Jury de peinture pour 1874 et M. Manet." *La Renaissance littéraire et artistique* (12 April 1874), 155–157.

Mallarmé 1876
Mallarmé, Stéphane. "The Impressionists and Edouard Manet." *The Art Monthly Review and Photographic Portfolio* 1 (9) (30 September 1876), 117–122. Reprinted in San Francisco 1986, 27–34. For "retranslations" into French see Riout 1989, 88, note 4.

Mallarmé 1897
Mallarmé, Stéphane. "Edouard Manet," *Divagations.* Paris, 1897.

Mallarmé 1995
Mallarmé, Stéphane. *Correspondance complète 1862–1871, suivi de Lettres sur la poésie 1872–1898 avec des lettres inédites*, Paris 1995.

Manet 1996
Manet, Edouard. *Lettres du siège de Paris.* Paris, 1996.

Martigny 1996
Manet, catalogue by Ronald Pickvance [exh. cat., Fondation Pierre Gianadda] (Martigny, 1996).

Melot 1996
Melot, Michel. *The Impressionist Print.* New Haven and London, 1996.

Milner 1988
Milner, John. *The Studios of Paris: the capital of art in the late nineteenth century.* New Haven and London, 1988.

Mitterand 1986
Mitterand, Henri. *Carnets d'enquêtes. Une ethnographie inédite de la France par Emile Zola.* Paris, 1986.

Mondor and Austin 1962
Mondor, Henri and Lloyd J. Austin, *Les "gossips" de Mallarmé. "Athenaeum" (1875–1876).* Paris, 1962.

Monneret 1978
Monneret, Sophie. *L'Impressionnisme et son époque.* Paris, 1978.

Moreau-Nélaton 1926
Moreau-Nélaton, Etienne. *Manet raconté par lui-même.* 2 vol. Paris, 1926.

New York 1943
Paris: A Loan Exhibition [exh. cat., Coordinating Council of French Relief Societies] (New York, 1943).

New York 1983
Manet: 1832–1883, catalogue by Françoise Cachin, Charles S. Moffett, and Juliet Wilson-Bareau [exh. cat., Galeries Nationales du Grand Palais and The Metropolitan Museum of Art] (New York, 1983).

New York 1987
Berthe Morisot: Impressionist, catalogue by Charles F. Stuckey and William P. Scott [exh. cat., National Gallery of Art, Washington, Kimbell Art Museum, Fort Worth, and Mount Holyoke College Art Museum] (New York, 1987).

New York 1995
Gustave Caillebotte: Urban Impressionist [exh. cat., Galeries nationaux du Grand Palais, The Art Institute of Chicago, and Los Angeles County Museum of Art] (New York, 1995).

Nord 1989
Nord, Philip. "Manet and Radical Politics," *Journal of Interdisciplinary History* 19 (Winter 1989), 447–480.

Offenstadt 1987
Offenstadt, Patrick. "Le Paris disparu de Jean Béraud." *L'Oeil* 380 (March 1987), 32–37.

Offenstadt forthcoming
Offenstadt, Patrick. *Jean Béraud: catalogue raisonné.* Paris, forthcoming.

Ottawa 1977
Puvis de Chavannes 1824–1898, catalogue by Louise d'Argencourt *et al.* [exh. cat., The National Gallery of Canada and Galeries nationales du Grand Palais] (Ottawa, 1977).

Ottawa 1983
Fantin-Latour, catalogue by Douglas Druick and Michel Hoog [exh. cat., Galeries nationales du Grand Palais, National Gallery of Canada, and California Palace of the Legion of Honor] (Ottawa, 1983).

Paris 1867
Manet [exh. cat., avenue de l'Alma] (Paris, 1867).

Paris 1880
Nouvelles Oeuvres d'Edouard Manet [exh. cat., La Vie Moderne] (Paris, 1880).

Paris 1884
Exposition des Oeuvres d'Edouard Manet [exh. cat., Ecole des Beaux-Arts] (Paris, 1884).

Paris 1895
 Exposition Rétrospective d'Oeuvres de Norbert Goeneutte (1854–1894) [exh. cat., Ecole Nationale des Beaux-Arts] (Paris, 1895).

Paris 1936
 Jean Béraud: peintre de la vie parisienne [exh. cat., Musée Carnavalet] (Paris, 1936–1937).

Paris 1978
 Manet: Dessins, Aquarelles, Eaux-Fortes, Lithographies, Correspondence, catalogue by Juliet Wilson [Bareau] [exh. cat., Galerie Huguette Berès] (Paris, 1978).

Paris 1991
 Paris – Haussmann, catalogue by Jean des Cars and Pierre Pinon [exh. cat., Pavillon de l'Arsenal] (Paris, 1991).

Paris 1992
 Henri Gervex, 1852–1929 [exh. cat., Galeries des Beaux-Arts, Bordeaux, Musée Carnavalet, and Musée des Beaux-Arts, Nice] (Paris, 1992).

Paris 1993
 Les Femmes Impressionnistes: Mary Cassatt, Eva Gonzalès, Berthe Morisot [exh. cat., Musée Marmottan] (Paris, 1993).

Paris 1997
 Berthe Morisot ou L'Audace raisonnée, catalogue by Marianne Delafond and Caroline Genet-Bourdeville [exh. cat., Musée Marmottan – Claude Monet] (Paris, 1997).

Paris (n.d.)
 La Naissance des gares, catalogue by Marie-Laure Crosnier Leconte [exh. cat., Musée d'Orsay] (Paris, n.d.).

Pinkney 1958
 Pinkney, David H. *Napoleon III and the Rebuilding of Paris.* Princeton, N.J., 1958.

Poe 1994
 Poe, Edgar A. *Le Corbeau. Traduction de Stéphane Mallarmé, illustré par Edouard Manet*, ed. Michael Pakenham. Paris 1994.

Pontoise 1994
 Norbert Goeneutte 1854–1894, catalogue by Christophe Duvivier [exh. cat., Musée de Pontoise] (Pontoise, 1994).

Price 1977
 Price, Aimée Brown. "«L'Allégorie réele» chez Pierre Puvis de Chavannes." *Gazette des Beaux-Arts* ser. 6, 89 (January 1997), 27–44.

Pronteau 1958
 Pronteau, Jeanne. "Construction et aménagement des nouveaux quartiers de Paris." *Histoire des Entreprises* no. 2 (November 1958).

Proust 1897
 Proust, Antonin. "Edouard Manet. Souvenirs." *La Revue blanche* 44 (1 February, 15 February and 1 March 1897); reprinted Caen, 1988; rev. ed. Paris, 1991.

Proust 1901
 Proust, Antonin. "L'art d'Edouard Manet." *The Studio / Le Studio* (15 January 1901); reprinted Caen, 1988, rev. ed. Paris 1991 (see Proust 1897).

Rand 1987
 Rand, Harry. *Manet's Contemplation at the Gare Saint-Lazare.* Berkeley, 1987.

Reff 1988
 Reff, Theodore. "Manet and the Paris of His Time." *Kunst um 1800 und die Folgen: Werner Hofmann zu Ehren.* ed. Christian Beutler. Munich, 1988, 247–262.

Riout 1996
 Riout, Denys. *Les écrivains devant l'impressionisme.* Paris, 1996.

Roos 1988
 Roos, Jane Mayo. "Within the 'Zone of Silence:' Monet and Manet in 1878." *Art History* 11 (September 1988), 372–407.

Roos 1996
 Roos, Jane Mayo. *Early Impressionism and the French State.* Cambridge, 1996.

Rouart and Wildenstein 1975
 Rouart, Denis, and Daniel Wildenstein. *Edouard Manet: Catalogue raisonné.* 2 vol. Lausanne and Paris, 1975.

San Francisco 1986
 The New Painting: Impressionism 1874–1886 [exh. cat., The Fine Arts Museums of San Francisco and National Gallery of Art, Washington] (San Francisco, 1986).

Seibert 1986
 Seibert, Margaret Mary Armbrust. "A Biography of Victorine-Louise Meurent and Her Role in the Art of Edouard Manet." PhD. diss., The Ohio State University, 1986.

Stuckey 1983
 Stuckey, Charles F. "Manet Revised: Whodunit?" *Art in America* 71 (November 1983): 158–77, 239–41.

Tabarant 1928
 Tabarant, Adolphe. "Autour de Manet," *L'Art vivant* 79 (1 April 1928).

Tabarant 1931
 Tabarant, Adolphe. *Manet, histoire catalographique.* Paris, 1931.

Tabarant 1947
 Tabarant, Adolphe. *Manet et ses oeuvres.* Paris, 1947.

Térade 1991–92
 Térade, A. "Le nouveau quartier de l'Europe et la gare Saint-Lazare." *Revue d'Histoire des chemins de fer* nos. 5–6 (1991–1992), 237–260.

Tokyo 1986
 Edouard Manet (1832–1883), catalogue by Charles S. Stuckey and Juliet Wilson-Bareau [exh. cat., Isetan Museum of Art, Tokyo; Fukuoka Art Museum, and Osaka Municipal Museum of Art] (Tokyo, 1986).

Tokyo 1994
 Paris en 1874: L'Année de l'Impressionisme [exh. cat., National Museum of Western Art] (Tokyo, 1994).

Tucker 1995
 Tucker, Paul Hayes. *Claude Monet: life and art*. New Haven and London, 1995.

Vallée 1908
 Vallée, Léon. *Bibliothèque nationale. Catalogue des plans de Paris conservés à la Section des Cartes et Plans*. Paris, 1908.

Van den Abbeel and Wilson-Bareau 1989
 Van den Abbeel, Paul and Juliet Wilson-Bareau. "Manet's *Au Café* in a banned Brussels paper." *The Burlington Magazine* 131 (April 1989), 283–288.

Varnedoe 1987
 Varnedoe, Kirk. *Gustave Caillebotte*. New Haven and London, 1987.

Varnedoe and Galassi 1976
 Varnedoe, Kirk, and Peter Galassi. "Caillebotte's Space." In *Gustave Caillebotte* [exh. cat., Museum of Fine Arts, Houston, and Brooklyn Museum of Art] (New Haven and London, 1976).

Vienna 1996
 Claude Monet [exh. cat., Österreichische Galerie, Belvedere] (Vienna, 1996).

Wadley 1991
 Wadley, Nicholas. *Impressionist and Post-Impressionist Drawings*. New York, 1991.

Walter 1979
 Walter, Rodolphe. "Saint-Lazare l'impressionniste." *L'Oeil* no. 292 (November 1979), 48–55.

Ward 1991
 Ward, Martha. "Impressionist Installations and Private Exhibitions." *The Art Bulletin* 73 (December 1991), 599–622.

Washington 1982
 Manet and Modern Paris, catalogue by Theodore Reff [exh. cat., National Gallery of Art] (Washington, 1982).

Washington 1985
 The Prints of Edouard Manet, catalogue by Jay McKean Fisher [exh. cat., The Detroit Institute of Arts, University Art Museum, Berkeley, The St. Louis Art Museum, Huntsville Museum of Art, and Art Gallery of Ontario, Toronto] (Washington, 1985).

White 1996
 White, Barbara Ehrlich. *Impressionists Side by Side: Their Friendships, Rivalries, and Artistic Exchanges*. New York, 1996.

Wildenstein 1974
 Wildenstein, Daniel. *Claude Monet: Biographie et catalogue raisonné*. 5 vol., Lausanne and Paris, 1974–1991.

Wildenstein 1996
 Wildenstein, Daniel. *Monet ou le triomphe de l'impressionnisme: Catalogue Raisonné – Werkverzeichnis*. 4 vol., Cologne, 1996.

Wilson-Bareau 1989
 Wilson-Bareau, Juliet. "L'Année impressionniste de Manet: Argenteuil et Venise en 1874," *Revue de l'art* 86 (1989).

Wilson-Bareau and Mitchell 1989
 Wilson-Bareau, Juliet and Breon Mitchell. "Tales of a Raven. The Origins and Fate of *Le Corbeau* by Mallarmé and Manet." *Print Quarterly* 6 (September 1989).

Wilson-Bareau 1991
 Wilson-Bareau, Juliet, Editor. *Manet by Himself*. London, 1991.

Wilson-Bareau 1994
 Wilson-Bareau, Juliet. "Manet en 1874," in Tokyo 1994 (French texts edition).

Zola 1867
 Zola, Emile. *Ed. Manet. Etude biographique et critique* (Paris, 1867).

Zola 1874
 Zola, Emile. In *Le Sémaphore de Marseille* (3–4 June 1874).

Zola 1878–1880
 Zola, Emile. *Nana*. Paris, 1878–1880.

Zola 1888–1889
 Zola, Emile. *La Bête humaine*. Paris, 1888–1889, trans. L. Tancock, London, 1977.

Zola 1986
 Zola, Emile. *Carnets d'enquêtes; une ethnographie inedite de la France*. Ed. Henri Mitterand. Paris, 1986.

Zola 1991
 Zola, Emile. *Ecrits sur l'art*, ed. Jean-Pierre Leduc-Adine. Paris, 1991.

Zurich 1990
 The Passionate Eye: Impressionist and Other Master Paintings from the Collection of Emil G. Bührle, Zurich [exh. cat., National Gallery of Art, The Montreal Museum of Fine Arts, Yokahama Museum, and Royal Academy of Arts, London] (Zurich, 1990).